D0603627

LOOKING AT
ANSEL ADAMS

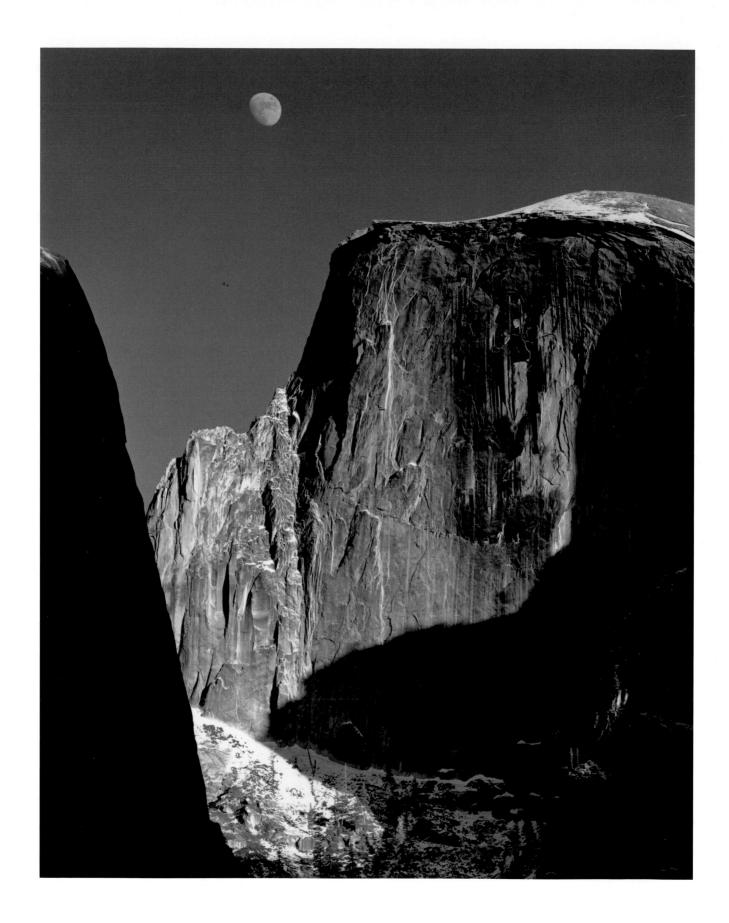

LOOKING AT
ANSEL ADAMS

The Photographs and the Man

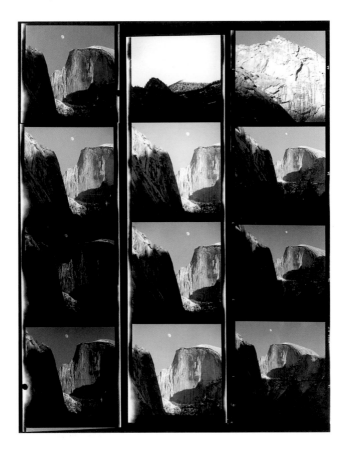

Andrea G. Stillman

LITTLE, BROWN AND COMPANY NEW YORK • BOSTON • LONDON

In 1976, Ansel Adams selected Little, Brown and Company as the sole authorized publisher of his books, calendars, and posters. At the same time, he established The Ansel Adams Publishing Rights Trust in order to ensure the continuity and quality of his legacy—both artistic and environmental.

As Ansel Adams himself wrote, "Perhaps the most important characteristic of my work is what may be called print quality. It is very important that the reproductions be as good as you can possibly get them." The authorized books, calendars, and posters published by Little, Brown have been rigorously supervised by The Trust to make certain that Adams' exacting standards of quality are maintained.

Only works published by Little, Brown and Company can be considered authentic representations of the genius of Ansel Adams.

Text copyright © 2012 by Andrea G. Stillman
Photographs by Ansel Adams copyright © 2012 by The Ansel Adams Publishing Rights Trust

Additional text and image credits can be found on page 249.

All rights reserved. In accordance with the U.S. Copyright Act of 1976, the scanning, uploading, and electronic sharing of any part of this book without the permission of the publisher constitute unlawful piracy and theft of the author's intellectual property. If you would like to use material from the book (other than for review purposes), prior written permission must be obtained by contacting the publisher at permissions@hbgusa.com. Thank you for your support of the author's rights.

Little, Brown and Company
Hachette Book Group
237 Park Avenue, New York, NY 10017
littlebrown.com

First Edition: September 2012

Little, Brown and Company is a division of Hachette Book Group, Inc., and is celebrating its 175th anniversary in 2012. The Little, Brown name and logo are trademarks of Hachette Book Group, Inc.

The publisher is not responsible for websites (or their content) that are not owned by the publisher.

The Hachette Speakers Bureau provides a wide range of authors for speaking events. To find out more, go to www.hachette speakersbureau.com or call (866) 376-6591.

Library of Congress Cataloging-in-Publication Data
Stillman, Andrea Gray.
 Looking at Ansel Adams : the photographs and the man / Andrea G. Stillman.
 p. cm.
 Includes bibliographical references and index.
 ISBN 978-0-316-21780-4
 1. Adams, Ansel, 1902–1984. 2. Photographers—United States—Biography. I. Title.
 TR140.A3S775 2012
 770.92—dc23
 [B] 2012014692

10 9 8 7 6 5 4 3 2 1

MOND

Printed in Italy

Design by Lance Hidy

HALF TITLE: *Self-Portrait,* Monument Valley, Utah, 1958

FRONTISPIECE: *Moon and Half Dome,* Yosemite National Park, California, 1960

TITLE PAGE: Proof sheet for *Moon and Half Dome*

For Adrienne and Leland

Contents

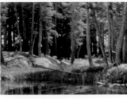
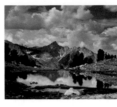
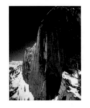
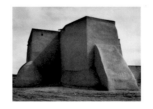
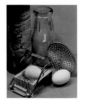
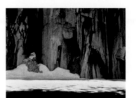

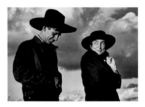
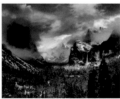

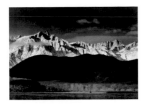

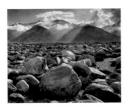
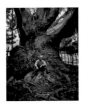
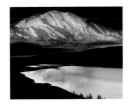
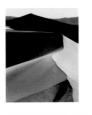
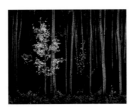
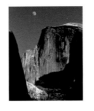

Cast of Characters

Ansel Adams (1902–1984)—Ansel was shaped by his environment—first the relatively wild area west of San Francisco, where he lived as a child, and then Yosemite and the High Sierra, which became his second home. He could have been a competent pianist, but he chose instead to become a stellar photographer, which meshed perfectly with his efforts to inspire others to protect America's wild places. He is revered as both one of the greatest photographers of the twentieth century and one of the environmental movement's most eloquent spokesmen.

Charles Hitchcock Adams (1868–1951)—Charles was a loving father who understood his son's gifts and arranged for Ansel's unusual schooling: private tutors and a year at the Panama-Pacific International Exposition in 1915. He was the first of several strong male figures in Ansel's life, followed by Albert Bender, Edward Weston, Alfred Stieglitz, and Edwin Land.

Jane Elizabeth Trainor Adams (1879–1972)—Aunt Beth, as she was called, was married to Ansel's uncle, William Adams. Trained as a nurse, she accompanied Ansel on camping trips in the High Sierra.

Michael Adams (b. 1933)—Ansel's son, Michael is a retired internist, fighter pilot, and a major general in the U.S. Air Force. He and his wife, Jeanne, live in Ansel and Virginia's former home in Carmel. Michael lectures about and Jeanne curates exhibitions on Ansel's works. Their children manage The Ansel Adams Gallery in Yosemite National Park.

Olive Bray Adams (1862–1950)—Ansel's mother was a stern individual for whom Ansel felt a more dutiful than loving attachment. Her unmarried sister, Mary Bray, lived with the family.

Virginia Best Adams (1904–2000)—Virginia and Ansel met in Yosemite in 1921. After a long engagement, they were married in Yosemite in 1928. From her father, Virginia inherited Best's Studio, now The Ansel Adams Gallery. After 1936 she and Ansel lived full-time in Yosemite Valley with their two children. Virginia collected Native American pottery, baskets, weavings, and jewelry, as well as books on California and the West.

Mary Austin (1868–1934)—Austin was an American writer who specialized in texts related to the Southwest, with a particular emphasis on Native Americans. She met Ansel in 1929 in Santa Fe, and in 1930 they published *Taos Pueblo*, with her text and twelve original photographs by Ansel.

Albert Bender (1866–1941)—Bender was a San Francisco businessman, art patron, and collector. He met Ansel in 1926 and immediately became a supporter of his photography and, eventually, an intimate friend. He made it possible financially for Ansel to publish his first portfolio and his first book, and he introduced Ansel and his photographs to collectors in the Bay Area.

Imogen Cunningham (1883–1976)—Cunningham joined with Edward Weston, Ansel, and a few others to establish Group f/64 in 1932. She participated in the group's exhibitions and went on to a distinguished career as a photographer. She and Ansel traded photography tips and had a strong mutual admiration.

Jules Eichorn (1912–2000)—Accomplished mountaineer, musician, and music teacher, Eichorn was one of Ansel's first piano students. Their friendship blossomed through their membership in the Sierra Club and mutual love of Yosemite and the High Sierra, where the minarets that bear their names are situated close together.

Patricia English Farbman (1914–2010)—Patsy, as she was known, served as a model for Ansel in Yosemite in 1936. She acted as his photographic assistant while he prepared for a show at Alfred Stieglitz's gallery, An American Place, in New York that fall. Their relationship threatened Ansel's marriage, but he decided in the end to stay with Virginia. Patsy married photographer Nate Farbman.

Francis P. Farquhar (1887–1974)—Farquhar served as the editor of the *Sierra Club Bulletin*, which published many of Ansel's photographs, and the president of the club. A champion of Ansel's photography, he was also a close personal friend. They spent many weeks together on the annual Sierra Club High Trips in the late 1920s and early 1930s.

Sara Bard Field (1882–1974)—Field, a poet, and her husband, Charles E. S. Wood, were literary figures in the Bay Area. Ansel was drawn to their intellectual community of friends and often visited them at their home, The Cats, south of San Francisco.

Edwin Grabhorn (1899–1968) and Robert Grabhorn (1900–1973)—The Grabhorn brothers founded the Grabhorn Press in 1920 in San Francisco. It quickly became known as one of the premier printers in the country. They printed the text for Ansel's first book, *Taos Pueblo,* as well as the printed matter for Ansel's first portfolio, *Parmelian Prints of the High Sierras*.

Anne Adams Helms (b. 1935)—Ansel's daughter, Anne grew up in Yosemite. She lives with her husband, Ken Helms, in Salinas, California, and often speaks about Ansel and his work. She managed 5 Associates, a family business that prints notes and postcards with photographs by Ansel and others. The company, now named Museum Graphics, is managed by her daughter.

Frank Holman (1856–1944)—Uncle Frank, as he was called, retired and spent his summers in Yosemite. He became known as the "mountain sage." He took Ansel on his first hikes in the Yosemite High Sierra and taught him the rudiments of camping.

Katherine Kuh (1904–1994)—Kuh trained as an art historian and in 1935 opened a gallery in Chicago, where she showed Ansel's photographs in 1936. While Ansel visited Chicago to see the exhibition, Kuh obtained portrait sittings for him plus an assignment to photograph corsets and women's lingerie for Stein & Co.

Edwin H. Land (1909–1991)—Ansel met Land, the inventor of Polaroid Land Instant Photography, in 1948 and subsequently acted as a paid advisor to the company. He greatly admired Polaroid Land instant films and used them often in his last years. He chose a massive 20 x 24 inch Polaroid camera to make President Carter's formal portrait in 1979.

Dorothea Lange (1895–1965)—Lange was one of the most admired documentary photographers in America, and Ansel was deeply impressed by both her photographs and her dedication. She and Ansel collaborated on several photographic projects, and although they had different political beliefs, they remained devoted friends.

Mabel Dodge Lujan (1879–1962)—A wealthy American writer and patron of the arts, Mabel gathered artists and writers, including Ansel, at her Taos compound. It was there that Ansel met Georgia O'Keeffe, John Marin, and Paul Strand.

Tony Lujan (1879–1963)—A native of Taos Pueblo, he

was married to Mabel Dodge. He arranged for Ansel to gain access to the pueblo to make photographs for *Taos Pueblo,* the book Ansel and Mary Austin published in 1930.

John Marin (1870–1953)—Marin was one of the stars of Alfred Stieglitz's American modernist stable of artists, along with Georgia O'Keeffe, Marsden Hartley, and Arthur Dove. Ansel met Marin in Taos in 1929 and was greatly impressed by his paintings.

David Hunter McAlpin (1897–1989)—American philanthropist, investment banker, and art collector, he met Ansel through Alfred Stieglitz in 1936 and became one of Ansel's most generous patrons and closest friends. He bankrolled the founding of the first museum department of photography at New York's Museum of Modern Art. McAlpin traveled with Ansel to the Southwest in 1937 and the High Sierra in 1938.

Beaumont Newhall (1908–1993) and Nancy Parker Newhall (1908–1975)—Beaumont and Nancy were Ansel's closest friends and professional colleagues. They met Ansel in New York in 1939. Beaumont was the first curator of the new department of photography at the Museum of Modern Art; he later assumed the directorship of the George Eastman House in Rochester, New York. He wrote the highly influential first history of photography that is still consulted today. Nancy was a writer who worked with Ansel on a wide variety of projects, including picture books of the Tetons, Death Valley, and Mission San Xavier, and the seminal volume *This Is the American Earth.* In addition she wrote *The Eloquent Light,* a biography covering Ansel's life from 1902 to 1938. Ansel established The Beaumont and Nancy Newhall Fellowship at the Museum of Modern Art in their honor.

Dorothy Norman (1905–1997)—Although she was married, Norman maintained a long-term affair with Alfred Stieglitz. She has been described as "the keeper of the flame" of Stieglitz's work and beliefs, and she published

a definitive biography, *Alfred Stieglitz: An American Seer,* in 1973. She met Ansel at Stieglitz's gallery, An American Place.

Georgia O'Keeffe (1887–1986)—One of the twentieth century's most famous painters, O'Keeffe was married to Alfred Stieglitz. She visited Ansel in Yosemite and Carmel, and he visited her in the Southwest. He photographed her on several occasions, and the photograph he made of her with Orville Cox at Canyon de Chelly is probably his most admired portrait.

Rondal Partridge (b. 1917)—The son of photographer Imogen Cunningham, Ron worked for Ansel as his assistant in Yosemite from 1937 to 1939. He recalled that he arrived at Ansel's door in Yosemite and refused to leave until he was given a job. He is a photographer of distinction.

Alan Ross (b. 1948)—Alan worked as Ansel's photographic assistant from 1974 to 1979. Since 1975 Alan has printed the Special Edition prints for The Ansel Adams Gallery from Ansel's original negatives. His creative work is exhibited at galleries and museums, he teaches photographic workshops, and he continues to take limited commercial assignments.

John Sexton (b. 1953)—John was Ansel's photographic assistant and then his technical consultant from 1979 to 1984. He has published numerous books, exhibited at museums and galleries, consulted for Kodak and other photographic manufacturers, and runs an active workshop program—all in addition to making creative photographs.

Wallace Stegner (1909–1993)—Called "the Dean of Western Writers," Stegner won the Pulitzer Prize in 1972 for his novel *Angle of Repose.* He and Ansel were close friends, drawn together by their love of the natural world and dedication to the preservation of the environment.

He wrote forewords for two of Ansel's books (*Ansel Adams: Letters and Images 1916–1984* and *Ansel Adams: Images, 1923–74*).

Mrs. Sigmund Stern (1869–1956)—Rosalie Meyer Stern was one of San Francisco's most generous patrons of the arts and culture. She was an early supporter of Ansel's work, and she purchased multiple copies of both his first portfolio and first book. Ansel presented to her as a Christmas gift a print of *Frozen Lake and Cliffs, Sierra Nevada, California* (Chapter 6).

Alfred Stieglitz (1864–1946)—Stieglitz was a champion of modern art, particularly modern American masters such as John Marin, Marsden Hartley, Arthur Dove, Paul Strand, and Georgia O'Keeffe, who became his wife. Ansel met Stieglitz in 1933 and was honored with an exhibit of his photographs at Stieglitz's gallery, An American Place, in 1936. Ansel considered it the most important exhibition of his life. Stieglitz's dual role as an artist and a proponent of modern American art inspired Ansel.

Paul Strand (1890–1976)—Ansel met Paul Strand in Taos in 1929 and saw his negatives there the following year. Ansel was overcome by the power of Strand's seeing, and in later years Ansel claimed this was the moment he realized that photography—not music—was to be his life's path. Although Strand and Ansel had very different political views, they shared a mutual respect for each other's work.

John Szarkowski (1925–2007)—Without doubt John Szarkowski was the most respected museum curator of photography in the world, as well as a brilliant writer and a fine photographer. He was the curator and then the director of the department of photography at New York's Museum of Modern Art from 1962 to 1991. He curated two exhibitions of Ansel's photographs: "Ansel Adams and the West" in 1979 and "Ansel Adams at 100" in 2001. His writing about Ansel and his photographs remains the gold standard. Szarkowski was probably the only curator of photographs who enjoyed Ansel's unalloyed approval.

William A. Turnage (b. 1940)—Yale University invited Ansel to visit as a Chubb Fellow in 1970, where he met Bill Turnage, a graduate student in the school of forestry. Ansel was immediately impressed with Turnage's intellect and passion for the environment and suggested that they work together to bring order to Ansel's finances and photographic career and to champion the protection of America's wilderness. In 1979 Turnage became the executive director of The Wilderness Society in Washington, D.C.; he and Ansel continued to work closely together to affect America's land use policies, including joint meetings with Presidents Carter, Ford, and Reagan. Turnage was appointed by Ansel as a trustee of the trust that continues to oversee all facets of the use of his photographs.

Edward Weston (1886–1958)—Edward was probably Ansel's closest friend among the many photographers he knew, and he felt that Edward was one of the great photographers of the twentieth century. In his last years Edward suffered from Parkinson's disease, and Ansel was especially solicitous, assisting with sales of Edward's photographs plus the publication of a book of his photographs of Point Lobos.

Cedric Wright (1889–1959)—Cedric was Ansel's closest friend in the 1920s. Like Ansel, Cedric was both a musician (a violinist) and a photographer. They were drawn together by their love of music, photography, and Yosemite and the High Sierra. Cedric accompanied Ansel on photographic trips and was there in 1941 when Ansel made his seminal photograph, *Moonrise, Hernandez, New Mexico*.

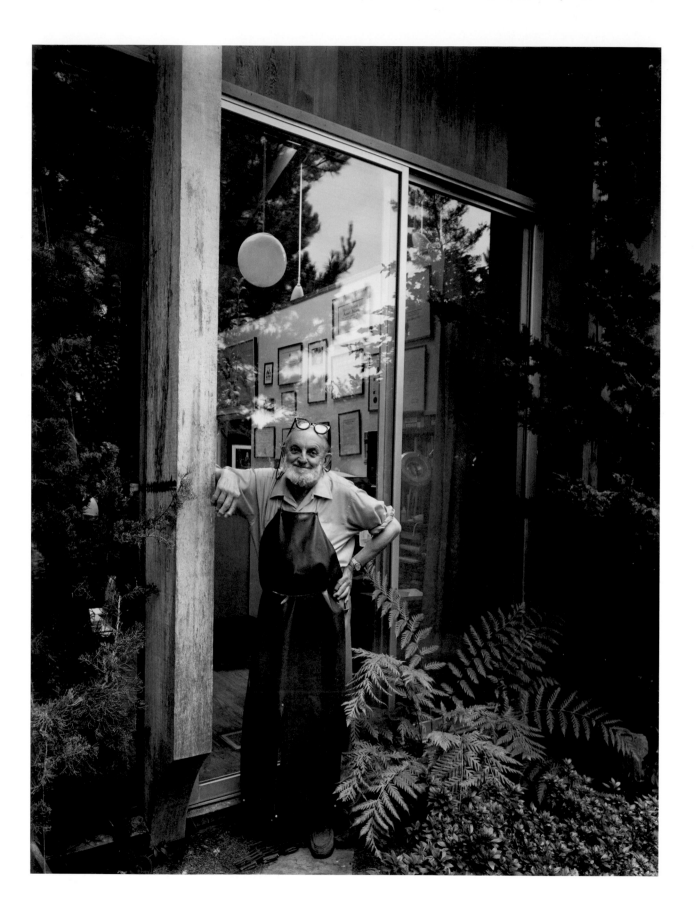

Introduction

IF YOU HAD STOPPED by Ansel's home at nine o'clock in the morning, the place would have looked deserted. His office and workroom would be empty. You would see a small green light glowing just to the right of the closed door to the darkroom, with a sign that said TRESPASSERS WILL BE VIOLATED. Behind the door, you would hear the muffled drone of a metronome and the gurgle of water. Finally, around ten o'clock, the door would slide open and Ansel would emerge, beaming. He always wore a long brown rubber apron, and his glasses were usually perched on his forehead. In his right hand he would hold up a dripping wet print and announce, "I think I got it." This is how I most vividly remember Ansel. To glimpse him "up close and personal," as I knew him, look at his photographs. They and their stories reveal both the man and the artist.

Based on several criteria, I selected twenty of Ansel's photographs to explore in this book and developed a chapter around each. I asked myself whether the photograph was one of Ansel's best. Did it have a compelling story, preferably told by Ansel? Did it illuminate some facet of his life—either personal or artistic?

Ten of the twenty are among what I call Ansel's "greatest hits." Naturally this includes *Moonrise,*

Hernandez, New Mexico, starring in a chapter that is longer and has more illustrations than any other. There are also less familiar images—such as *Grass and Water, Tuolumne Meadows*—that illuminate other aspects of his creative work. My overarching desire was to bring Ansel to life and to encourage people to look at his photographs anew and with a fuller understanding of the artist behind them.

Since Ansel and his wife, Virginia, were savers, there was an enormous cache of information to sort through. I read thousands of Ansel's letters (from family, friends, and the rich and famous). Then I delved into the extraordinary body of Ansel's published writing—his autobiography, picture books, technical manuals, articles, and lectures. Among the most important letters were hundreds from the 1940s to the 1970s between Ansel and his closest friends and cohorts, Nancy and Beaumont Newhall. They wrote each other almost every day, sometimes several times in one day; Nancy once wrote, "A day without an Ansel-mogram is like a day without breakfast."[1]

I also mined Ansel's archive at the Center for Creative Photography at the University of Arizona for the ephemera that he and Virginia had saved—including old newspaper articles and myriad photographs of Ansel. There were things in my own files—notes from Ansel to me, a mock baseball card of Ansel as a pitcher, an inscribed copy of *Time* magazine with Ansel on the cover, even one of the earliest prints of his photograph *Lodgepole*

OPPOSITE: Ansel in the garden outside his office wearing his darkroom apron, Carmel, California, 1976. Photograph by Arnold Newman.

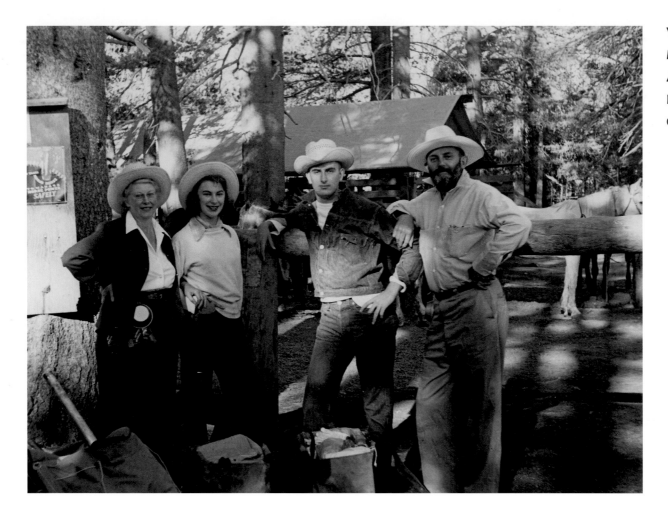

Virginia, Anne,
Michael and
Ansel in Yosemite
National Park,
California, 1952

Pines. The difficulty was not to find enough material but to decide what would make the cut.

One of the subjects I hoped to explore was the difference in the way Ansel printed a negative over the course of his lifetime. He said that every time he went into the darkroom to print a negative, he tried to relive the experience of standing out of doors with his camera. Naturally, his interpretations changed over time, influenced by his mood, how he was feeling physically, and also by his materials (principally the photographic paper available). Luckily his archive contains thousands of prints, including many from the same negative and made over a long period of time.

This brings me back to the darkroom. For Ansel,

the darkroom was the heart of the house, where he made every fine (or exhibition) print himself, relying on his photographic assistant in the darkroom only for help in the washing, fixing, toning, and subsequent processing steps. For most of his life he worked in a small, inefficient darkroom in the basement of his San Francisco home. The decision in 1960 to move to Carmel and build a house provided the opportunity to create the darkroom of his dreams. For the last twenty-three years of his life, it was the place he spent almost every morning. Weekends didn't interfere, and even holidays were only a mild interruption, since the darkroom offered a respite from visiting family, especially noisy grandchildren.

Not that family was unimportant to Ansel. He was married to Virginia for almost fifty years, and they had two children, Michael and Anne, plus five grandchildren. He loved people and was extremely gregarious. Nothing suited him better than holding forth at a party—especially one fueled by liquor. The proverbial life of the party, he had an inexhaustible fund of stories and jokes, many of them risqué. But the laughter and high spirits may have masked a fear of getting too close to people—of letting them see inside. There was little intimacy in his marriage, and his inability to connect with people on a deep level added to his sense of loneliness. He was ultimately a very private man.

One way Ansel coped was with constant hard work. His energy seemed inexhaustible, and his schedule would have overwhelmed most people. Ron Partridge, Ansel's photographic assistant from 1937 to 1939, said that he "had the energy to work from daylight on. Many times the stars were still out and he would knock on my door and say, 'Come on, let's go.'"[2] Ansel's life was filled with photography. He photographed, printed, published, taught, wrote, curated, and lectured. He played a key role in founding the world's first museum department of photography at New York's Museum of Modern Art. He worked as a commercial photographer on assignments from *Life, Fortune,* Kodak, and IBM, to name only a few of his employers. In his "spare time" he acted as a consultant to Polaroid.

Another of Ansel's myriad roles was as an active leader and, in his later years, an elder statesman of the modern environmental movement. His writing was nearly as eloquent as his photographs in raising national awareness of the need to protect America's wild lands. As Bill Turnage, former president of The Wilderness Society and before that Ansel's business manager, wrote, "If Henry David Thoreau was the philosopher of the wilderness movement and John Muir its popularizer, Ansel Adams was its artist."[3] Ansel was a member of the board of the Sierra Club for more than thirty years, and he alone among environmentalists had the ear of almost everyone in Washington, including presidents.

Ansel was happy working seven days a week, and "vacation" was not a concept he acknowledged. In 1946 he suggested a trip for Virginia and Michael that he characterized as the "first chance for a real vacation in a long time."[4] Judging from the itinerary, it was not a typical family holiday:

This is a combined functional trip as follows:
Kodachromes for Standard Oil
Kodachromes and Ektachromes for Eastman Kodak Company
Black and Whites for FORTUNE
A Sniff at some Guggenheim material
A vacation for Virginia and Mike

My schedule is as follows:
Yellowstone National Park Sept 27–28 Wyoming
Glacier National Park September 29th– October 6th Montana
San Francisco, October 13th

Another way Ansel coped was with alcohol. Every afternoon at five o'clock at Ansel and Virginia's house, drinks were served (always a good gin or bourbon), followed by wine with dinner. The more uncomfortable he felt in a social situation— often at a museum opening or a celebration in his

honor—the more he drank. But a "touch of the flu" or feeling "a little under the weather" the next morning rarely interfered with his work.

Most people think of Ansel as a rich, successful artist who spent his life photographing the national parks. Far from it. All his life he worried about money and the lack thereof. In the 1940s and 1950s, when art collectors were not yet buying photographs, Ansel relied on income from commercial work—income that was erratic and often inadequate.

Not until 1970, when he was sixty-eight years old, could he afford to turn away commercial assignments and dedicate his time exclusively to his own photography. Indeed, it is truly remarkable that Ansel was able to produce so many memorable images. Two projects allowed him to travel to areas he had not previously visited. Harold Ickes, Franklin Roosevelt's secretary of the interior, conceived a "Mural Project" that in 1941–1942 allowed Ansel to travel to western parks and monuments that he had not previously visited. The goal was to create huge murals of Ansel's photographs for the Interior Department's new office building in Washington, but the war derailed the project. Guggenheim Fellowships, in 1947 and 1948, underwrote travel to even more areas of the country, including Alaska, the Pacific Northwest, and the East Coast.

Ansel created an extraordinary and geographically diverse body of work. In general, an artist needs to be intimately familiar with a place in order to create an iconic body of work about it, like Ansel with Yosemite and the High Sierra, Henry David Thoreau with Walden Pond, or Georgia O'Keeffe with the Southwest. Because of his innate relationship with wilderness and his intuitive grasp of composition, Ansel was an exception.

Ansel clowning around, c. 1930. Ansel recalled that Virginia clicked the shutter.

He arrived in Alaska for the first time in June 1947, traveled to a site overlooking Mount McKinley and Wonder Lake in Denali National Park, set up his camera, and photographed the massif below the moon and gorgeous clouds. Within six hours he made a second legendary exposure at dawn (see Chapter 16).

Laughter was another outlet for Ansel. He was delighted when people called to tell him jokes. The best were often unsuitable for mixed company—as were his limericks. There are relatively few that could be reproduced here without some embarrassment! His letters were hilarious. Even those

dealing with his perennially difficult financial situation were filled with humor: "My letters and bills have piled up like Mount Blanc. My bank balance is acting like an ideal peneplane. I gotta get a beeg deal soon or go into the ready-made clothing business,"[5] he wrote to his best friend Nancy Newhall. He crafted funny messages, like the note I found on my desk one morning asking me what negatives to print.

In early years music was Ansel's

5/9/79

Dear Shining Light:

 Prythee faire maydone, guide thy slave
to the hallowed sequence of producing images?
Is everything listed on the Sacred Scrolls??

 St. Anselm the Curd

A message Ansel left on my chair, May 9, 1979, signed with one of many humorous pen names he concocted.

first love. Until 1930 he spent countless hours practicing on and playing his beloved Mason & Hamlin grand piano. Photography ultimately supplanted music as a career—to the disappointment of his mother, who believed that "the camera cannot express the human soul."[6] However, music remained central to Ansel's lifework. He believed that the discipline of constant practice at the piano translated to the discipline to learn technical proficiency with the camera. He continually compared music with photography, and one of his favorite sayings was, "The negative is the equivalent of the composer's score, and the print is the performance."

Indeed the unforgettable beauty of Ansel's photographs is analogous to the memorable tone he sought to produce on the piano—what he called "divine clarity."[7] The painter John Marin recalled his reaction to Ansel's piano playing when they met in Taos in 1930: "In came a tall, thin man with a big black beard. Laughing, stamping, making noise. All the other people crowded around him. Made even more noise. I said to myself, I don't like this man. I wish he'd go away. Then all the other people hauled him to the piano—and he sat down and struck one note. One note. And even before he began to play I knew I didn't want him to go away. Anybody who could make a sound like that I wanted for my friend always."[8]

Above all Ansel had a compelling need to communicate. He wrote a dozen profoundly influential books on photographic technique, some still in print today; he wrote numerous articles on photography; he wrote and delivered hundreds of lectures all over the United States; he typed literally thousands of letters—often many a day—transporting his manual typewriter even to remote national parks; he taught countless students at his annual workshops in Yosemite.

Yet in spite of thousands of words both spoken and written, Ansel communicated most eloquently through his photographs. They make the grandeur of the west even grander. His peaks seem higher, his clouds more glorious, the sun brighter. Through photography Ansel illustrated one of his favorite concepts—that of "wilderness mystique"—the notion that even if we never experience wilderness, we need to know it exists. Ansel once voiced an unusual idea: the state of Wyoming should be fenced, all people removed, and no one allowed in. Thus a piece of wilderness would remain inviolate forever.

Beaumont Newhall and his wife, Nancy, sometimes traveled with Ansel while he photographed America's national parks and monuments. Beaumont recalled how he felt when he awoke one memorable morning at the rim of the Grand Canyon after many days of spartan living on the road: "What, Nature Again?"[9] Then, in a more contemplative frame of mind, he reflected on what Ansel was pursuing: "I realized that through nature you speak, and for that I am deeply grateful. For what you have to say in your photographs interests me more than the subject. In your photographs I see your vision of the world. I stood beside you and with my eyes saw Lake Tenaya and the green firs rising sheer behind the deep blue water. But the experience I will always remember is finding on the ground glass of your camera something which I could not see myself. And you put that vision of yours on paper so that it is held forever, always there for me to see."[10]

Nowhere was Ansel's ability to communicate more acute than in Yosemite and the High Sierra,

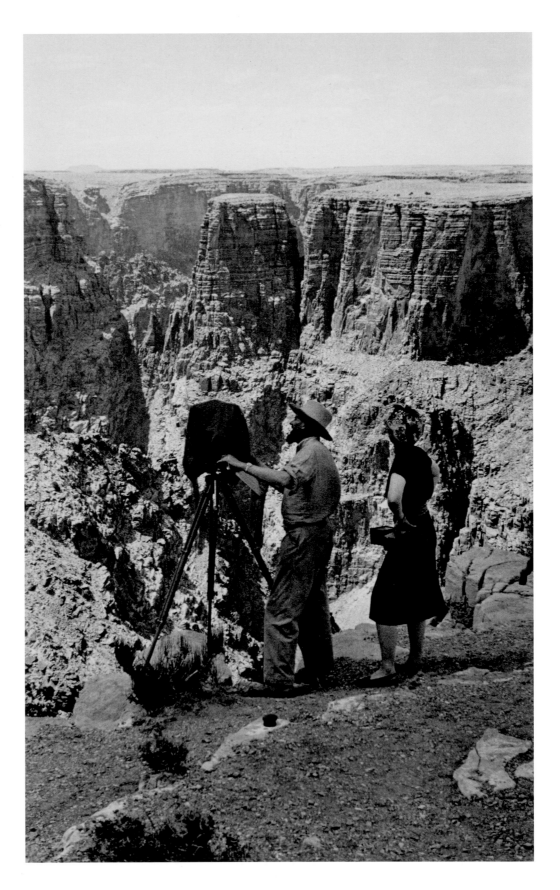

Ansel and Nancy Newhall at the Grand Canyon, Arizona, c. 1951. Photograph by Beaumont Newhall.

his "home place." Ansel first visited Yosemite in 1916, when he was fourteen years old. He later wrote, "I *knew* my destiny when I first experienced Yosemite."[11]Once he had explored Yosemite Valley, he began to hike and climb in the High Sierra—"my paradise,"[12] as he called it. He wrote rapturously of his early trips: "I remember my mountains, my old clothes, my pack-donkeys, my first funny plate camera (6½ x 8½ with glass plates) that I animal-packed and back-packed over unimaginable miles of rocks and roughness and pointed at amazed landscapes. The results, photographically, were terrible, but the life bent and tempered something that I can never unbend and untemper in this existence—even if I wanted to. There is too much clear sky and clean rock in my memory to wholly fall into self-illusion."[13]

Over the course of almost seventy years Ansel made more than twenty thousand photographs in Yosemite and the High Sierra. It is by far the single largest body of work in his archive. But it is not so much the number of photographs that is important as their ability to penetrate beneath the appearance of nature and record what the Celts call "thin places" where, according to theologian Peter Gomes, "the visible and invisible in the world come

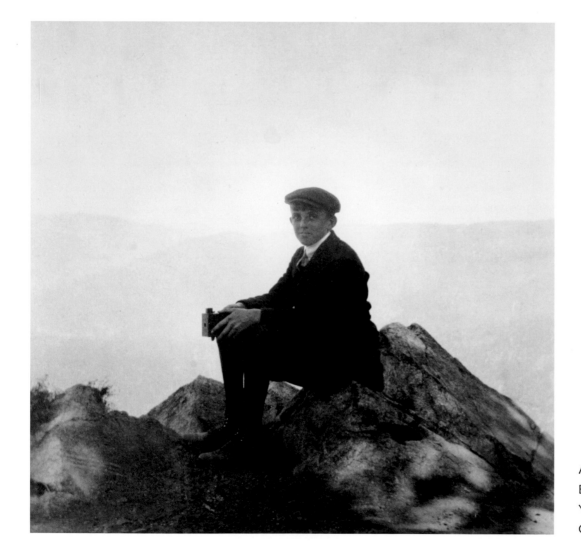

Ansel holding his No. 1 Box Brownie camera, Yosemite National Park, California, 1916.

into their closest proximity."[14] This is what makes Ansel's photographs of Yosemite Valley or Mount McKinley or Half Dome exceptional. They express more than what he saw.

It is impossible to consider Ansel's photographs without considering Ansel the man—so in tune are they with each other. Katherine Kuh met him in 1936 when a show of his photographs opened at her Chicago gallery. She said he "wasn't difficult the way some artists are.... I liked him immediately."[15] Nancy Newhall characterized him as "all the fine old words; you are good—I have never known you do a mean or cruel thing, though sometimes wild and useless ones—you are generous, noble, and a gentleman from head to heels."[16] Ansel was not perfect, of course. His friend David McAlpin wrote to Virginia, "He's certainly a most unusual person...sometimes I get terribly annoyed and aggravated with him. And so does everyone else I know. But they laugh and shrug and say, 'Well, that's Ansel. What an extraordinary fellow he is!'"[17]

The Ansel I knew was funny, sweet, charming, full of laughter and jokes, addicted to work, unable to hurt anyone's feelings, and thought the best of everyone until proven otherwise. He was a very modest man, yet in a group he was the natural center of attention. He dedicated his life to the highest ideals, and I believe that his nobility of spirit is reflected in his photographs.

Alfred Stieglitz expressed a sentiment that many who knew Ansel shared, when he wrote, "It's good for me to know that Ansel Adams is loose somewhere in this world of ours."[18] Ansel no longer climbs Half Dome or strides the High Sierra, but his presence resonates in every one of his photographs.

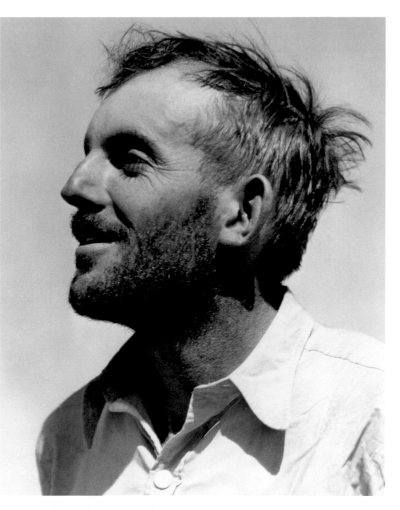

Ansel in the High Sierra, California, c. 1936.
Photograph by Cedric Wright.

1 Lodgepole Pines, Lyell Fork of the Merced River, Yosemite National Park, California, 1921

IN SEPTEMBER, 1921, I had the pleasure of making a ten day excursion into the Lyell Fork of the Merced River,"[1] Ansel wrote to his father. "It was a private pack trip with a donkey and a couple of friends."[2] He was nineteen, and the friends were his widowed aunt, Beth Adams, and Francis Holman, known as Uncle Frank, a seasoned mountaineer who led the small group. The donkey carrying their gear was Mistletoe, purchased as a "fine investment"[3] for twenty dollars for Ansel's first extensive trip into the Yosemite High Sierra the previous year.

The summer of 1921 Ansel served for the second year as the caretaker of the Sierra Club's LeConte Memorial Lodge, where he welcomed club members and visitors and led hikes in the valley. The association with the Sierra Club would last his lifetime. He would become perhaps the Club's most recognized spokesman, and his photographs argued powerfully for the preservation of America's wild places. That summer he also met his future wife, Virginia, who was in Yosemite for the summer with her father, the painter Harry Cassie Best. Virginia had appealing looks and a lovely contralto voice, and her father's studio featured a piano. Ansel was taken with both the piano and Virginia.

He wrote Virginia from camp near Merced Lake: "You cannot imagine what a really delightful time we are having up here in the wilderness.... Tomorrow we start for the Lyell Fork Canyon (of the Merced), and will spend perhaps five days thereabouts. This lofty valley is one of the most remarkable

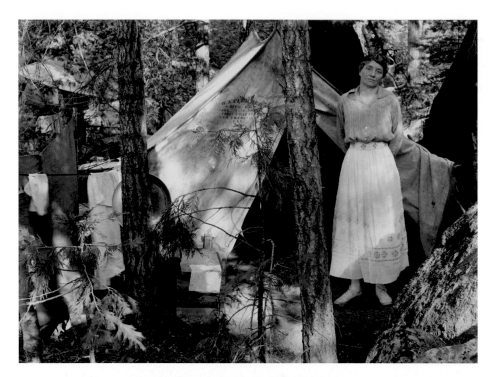

Aunt Beth Adams in the High
Sierra, California, c. 1921

Ansel at LeConte Lodge, Yosemite
Valley, California, c. 1921 (Collection
of Michael and Jeanne Adams)

Virginia Best with a friendly bear, Yosemite
Valley, California, c. 1925 (Collection
of Michael and Jeanne Adams)

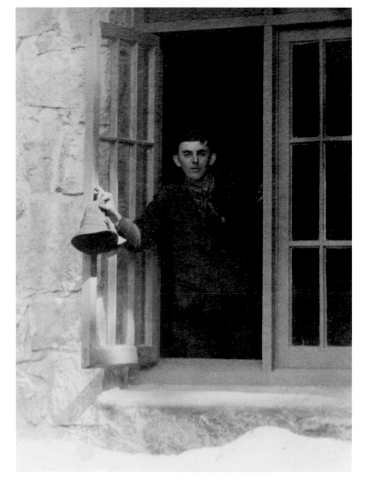

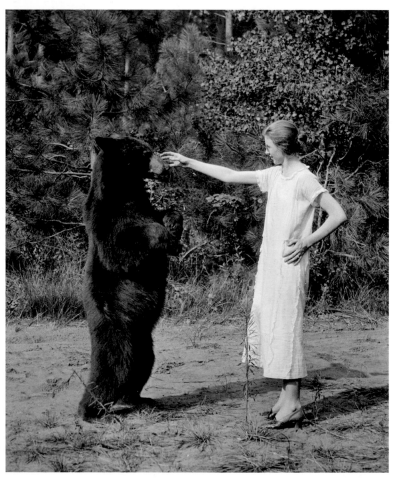

Lodgepole Pines, Lyell Fork of the Merced River, Yosemite National Park, California, 1921. This is the same group of trees as in the photograph on page 22, but taken from a slightly different angle. (David H. Arrington Collection, Midland, Texas)

regions of the park, and the grandeur of Rodgers Peak, the ascent of which is our main objective, cannot be described. We are also planning to climb Florence, Electra and possibly Lyell."[4]

They lacked proper climbing rope but nonetheless climbed nearby peaks with window sash cord that Ansel described in retrospect as, at best, dangerous and ineffective. When he wasn't climbing,

he made photographs. From his first camera, a simple No. 1 Box Brownie, he had graduated to more sophisticated equipment and photographed with a 3¼ x 4¼ inch Zeiss Mirrorflex. Occasionally he used a soft-focus lens on the camera and explained, "I was experimenting a lot in the early 1920s with soft focus and various other manipulations.... The softness produced with these lenses

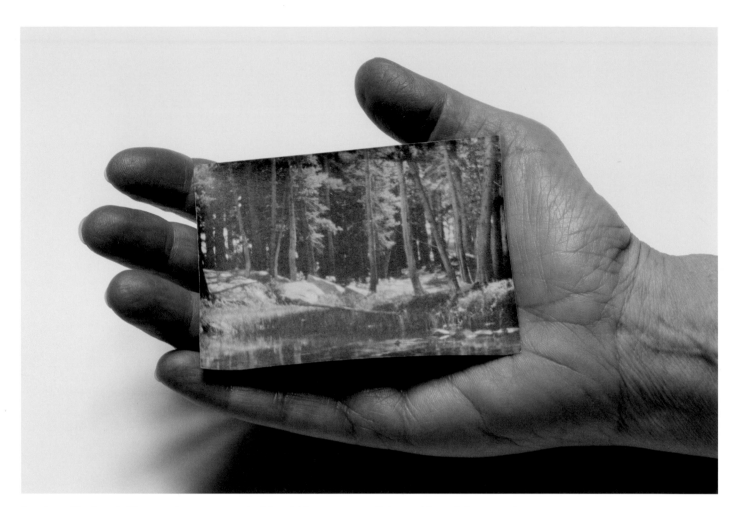

A print of *Lodgepole Pines* made c. 1921, probably within one year of the making of the negative.

on the camera is noticed mostly in the flare of light from the high values.... The illusion can be one of shimmering light."[5] The best photograph from the trip was a view of lodgepole pines in which the soft-focus lens heightens the feeling of radiant dawn light.

Many of Ansel's important photographs were made at dawn or dusk, when shadows bring the landscape alive. John Szarkowski, the distinguished director of the department of photography at New York's Museum of Modern Art, wrote of Ansel's ability to describe "the difference between the twilight of early morning and that of evening, or between the warm sun of May and the hot sun

of June" so that the viewer knows what it feels like "to stand in such a spot at such a moment."[6] Indeed, Ansel said that when he looked at one of his photographs he could recall not only the technical details but also the feeling of standing there beside his camera with the wind on his cheek.

The first prints Ansel made from the negative of *Lodgepole Pines* are very different from his large, glossy black-and-white photographs in circulation today. The early prints measure only 3¼ x 4¼ inches and are printed on matte surface, cream-colored paper. One sits on my library shelf, given to me by Ansel in 1980. Many years ago I camped among lodgepole pines in the Lyell Fork. At dawn

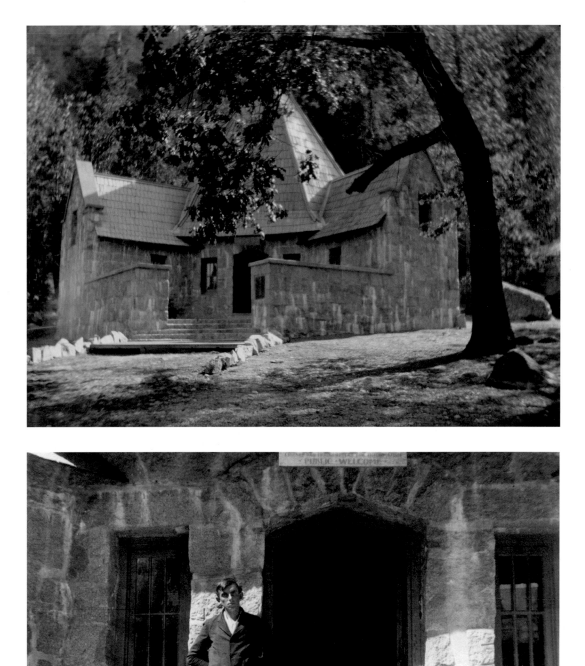

LeConte Memorial Lodge,
Yosemite Valley, California, c. 1921

Ansel at LeConte Lodge,
Yosemite Valley, California,
c. 1921 (Collection of Michael
and Jeanne Adams)

A bromoil print of *Path near Muir Woods National Monument*, California, 1924

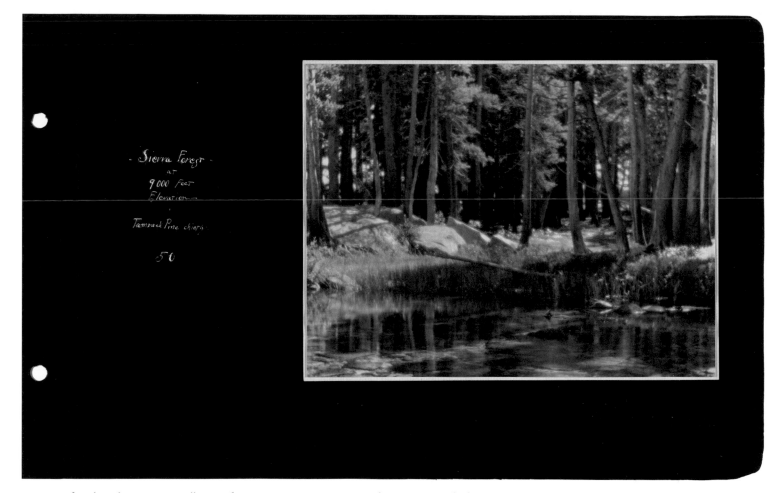

A print of *Lodgepole Pines* in an album of Yosemite views, c. 1926. The image is titled *Sierra Forest at 9000 Feet Elevation—Tamarack Pine Chiefly*. (David H. Arrington Collection, Midland, Texas)

I stepped out of a tent into the golden light of the High Sierra and was face-to-face across a stream with a deer and her fawn. I am reminded of that moment every time I look at Ansel's photograph.

In the 1920s Ansel continued to make photographs using his soft-focus lens, but most of the negatives were destroyed in a fire in his Yosemite darkroom in 1937, and only a few remain. One shows LeConte Memorial Lodge where he continued as caretaker for two more years. Another shows a path near Muir Woods where he often

walked. Not content with the gauzy, romantic quality produced by the soft-focus lens, he made a bromoil[7] print that looks more like a charcoal drawing or an etching than a photograph. He proudly framed and presented it to his mother on her birthday, inscribed on the back.

By 1930 Ansel rejected what he called "fuzzy wuzzy" photography and claimed that it was "foreign to my basic style!"[8] But his affection for the photograph of lodgepole pines was undimmed. He referred it as "one of my most beautiful early

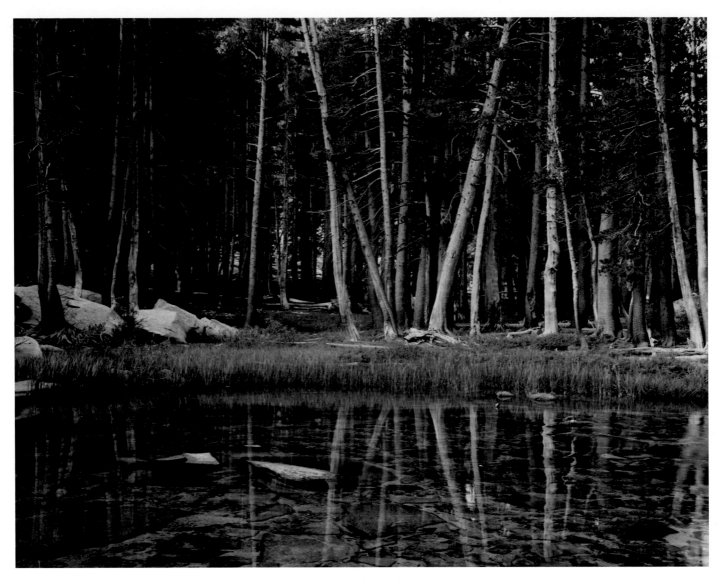

Lodgepole Pines, Lyell Fork of the Merced River, Yosemite National Park, California, 1938

images"[9] and included it in exhibitions, books, and the sets of photographs that he produced for museums at the end of his life. However, it is the only one of his few extant soft-focus images so honored.

In the summer of 1938, Ansel returned to the site where he had made *Lodgepole Pines.* This time he photographed the scene in sharp focus and from a slightly different vantage point. The white rocks on the left and the distinctive leaning tree near the center are recognizable, but the image lacks the magical light of Ansel's early vision.

The story of Ansel's trip into the Lyell Fork (with a reproduction of *Lodgepole Pines*) was published in 1922 in the *Sierra Club Bulletin.* In the article, Ansel

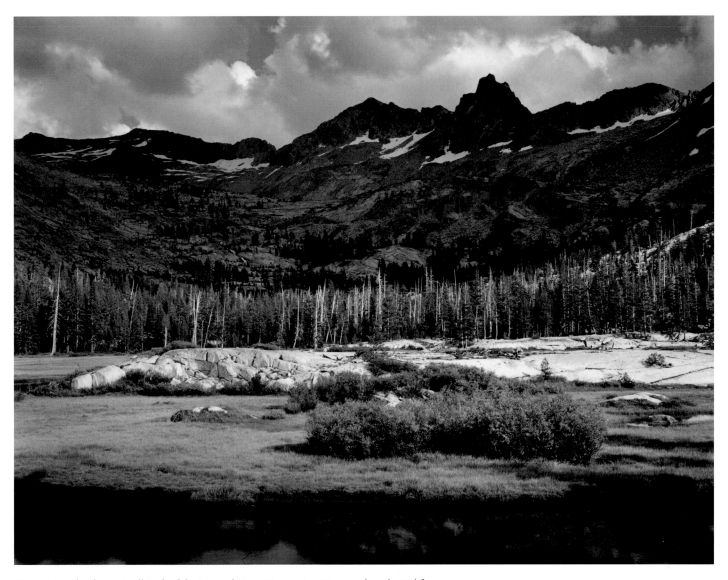

Mount Ansel Adams, Lyell Fork of the Merced River, Yosemite National Park, California, c. 1935

wrote that the terrain in the Lyell Fork "loses its ruggedness and opens into a fine level meadow.... The accompanying photograph may give an idea of the extraordinary beauty of the scene that presents itself when these meadows are reached. The great rock-tower bears no name, and is undoubtedly inaccessible."[10]

Ansel died on April 22, 1984. One year later the "rock-tower" was officially designated Mount Ansel Adams by the U.S. Board of Geographic Names. Shortly thereafter, Ansel's family scattered his ashes near the summit, which is located on the boundary of Yosemite National Park and the Ansel Adams Wilderness within the Sierra National Forest. *Lodgepole Pines* was taken nearby.

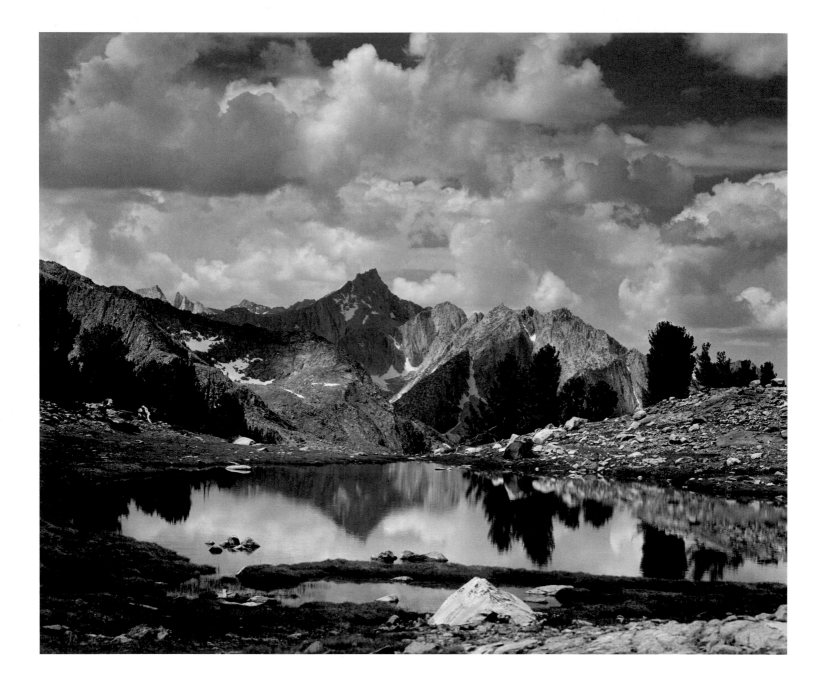

2 Mount Clarence King, Pool, Kings Canyon National Park, California, 1925

Sunday, August 3, 1925

My dearest Virginia,

This lake is the most beautiful I have ever seen: it cannot be described. The several days we shall pass here will be a fitting climax to a wonderful trip. It is my hope that my pictures will give a little of the beauty and atmosphere of this delightful place.... My deepest love to you and to all,

Your Own,

Ansel

IN THE SUMMER of 1925, when Ansel wrote this letter to his fiancée, Virginia Best, he was on a pack trip into the rugged Kings River country in the southern Sierra. He hiked with Professor Joseph LeConte II[1] and his children, Little Joe and Helen, plus two mules. In 1908 LeConte pioneered the High Sierra route that became the fabled John Muir Trail.

Of the many pictures Ansel made that summer, *Mount Clarence King, Pool* is by far the best. Ansel was able to record cloud-filled skies in his pictures thanks to panchromatic film. Fairly new on the market, the film was sensitive to all colors of the spectrum. At the same time, he also continued to

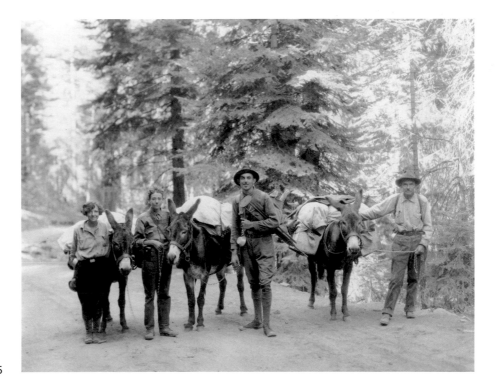

Helen LeConte, Joseph LeConte II, Ansel, and Joseph LeConte, Jr., and three mules in Giant Forest, Kings Canyon National Park, California, 1925

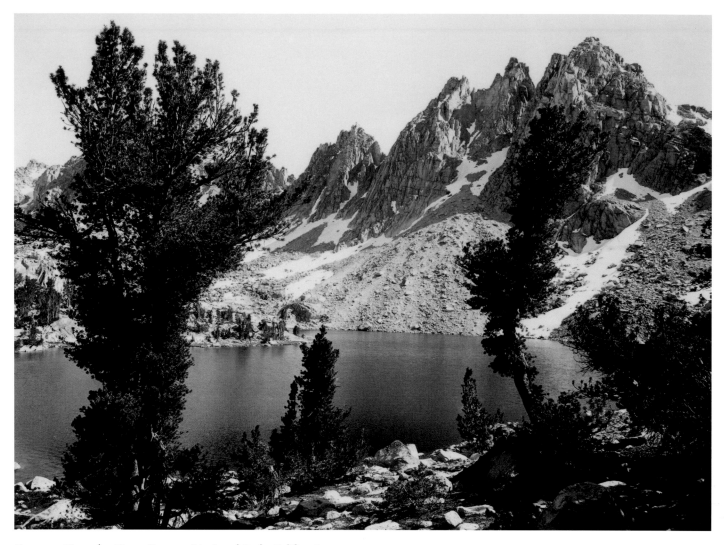

Kearsarge Pinnacles, Kings Canyon National Park, California, 1925

use the older, less expensive orthochromatic film that was sensitive only to blue and green light, which rendered the blue sky as white or a very light shade of gray. Compare the rich sky above Mount Clarence King with the blank white sky in a photograph of the Kearsarge Pinnacles made on the same trip. For a few years Ansel used both until panchromatic film became more affordable.

With his camera Ansel recorded every cloud type imaginable, but his photographs of billowing cumulus clouds are among the most dramatic. They are a daily sight on summer afternoons in the High Sierra, and even late in life Ansel recorded their towering glory—as in this view of Unicorn Peak in Tuolumne Meadows.

In the early 1920s Ansel dabbled at writing poems, including one in 1923 about clouds that began, "The Clouds are the cool voices of the sky and winds."[2] According to Ansel clouds are a photographer's ally: "When the clouds and storms appear the skies and the cloud-shadows on the mountain bring everything to life; shapes and

Unicorn Peak and Thunderclouds, Yosemite National Park, California, 1967

Sunset, Ghost Ranch, New Mexico, 1937. Ansel recalled that Paul Strand observed, "There is a certain valid moment for every cloud."[3]

planes appear that were hitherto unseen."[4] From New Mexico he ebulliently reported on a day's work: "It's a swell world for Mr. Adams—heaps of thunder clouds just crying to be photographed. I think I have done some marvelous stuff." He added a postscript: "I made 40 pictures today—mostly clouds."[5]

But clouds are also a challenge to photograph. Ansel wrote: "The emotional 'impact' of brilliant clouds can never be conveyed to the spectator by relying on the mere white of the photographic paper to indicate the brightest parts of the cloud-image; there must be some indication of *substance*, of texture, even in the brightest areas of the image."[6]

The Kings River watershed where Ansel hiked with the LeContes in 1925 became one of his favorite parts of the Sierra Nevada. Much of it is remote

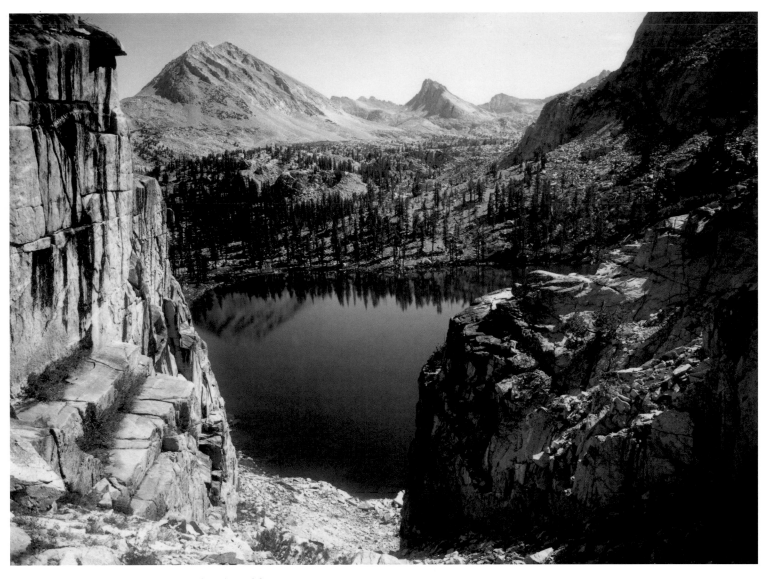

Marion Lake, Kings Canyon National Park, California, 1925

and largely inaccessible except by foot or horse trails. Compared with Yosemite National Park to the north, the landscape is somewhat barren, with steep canyons and rocky ridges devoid of trees and foliage. Nevertheless it is very beautiful, and it was Ansel's favorite wilderness region in the Sierra Nevada. Dotted among the granite gorges are alpine lakes, including Marion Lake, which Ansel

photographed on the trip with the LeContes.

In the 1920s and 1930s, when Ansel hiked in the remote region that is now Kings Canyon National Park, it lacked the protection afforded by national park and wilderness status. Around the time that he was first elected to the board of the Sierra Club in 1934, the Club mounted a campaign for its designation as a national park. Francis Farquhar, the

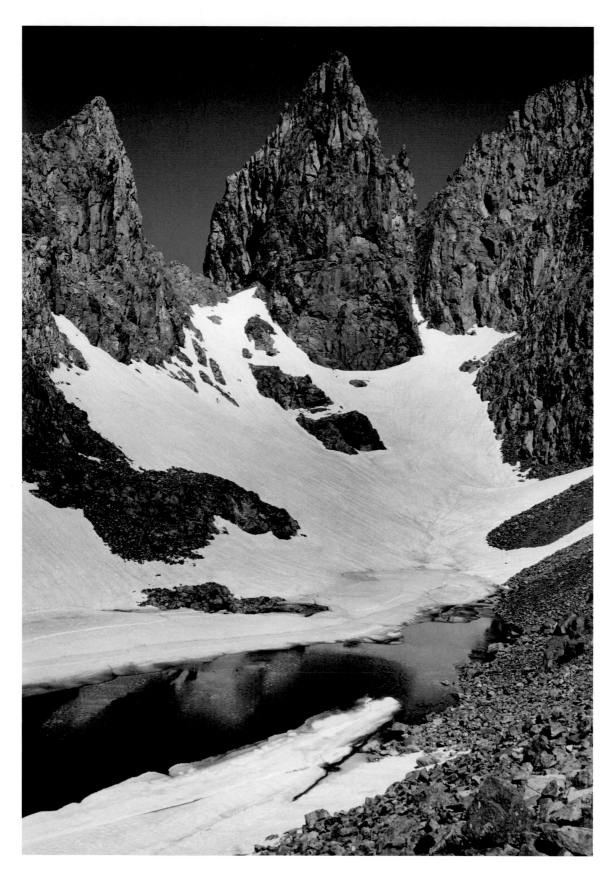

Michael Minaret,
Sierra Nevada,
California, c. 1935

president of the Club, arranged for Ansel and his photographs to visit Washington, D.C., in January to help convince Congress of the wisdom of national park designation. With what he described as "total naïveté," Ansel buttonholed members of Congress, showed his pictures, and "proclaimed the glories of the High Sierra."[6] He left a week later, the outcome uncertain.

A few years later Ansel published many of his views of the unspoiled wilderness in the southern Sierra in a volume entitled *Sierra Nevada: The John Muir Trail.*[8] The book included forty-nine photographs taken in the area along the John Muir Trail over the previous fifteen years. It was a spectacular presentation, bound in white cloth and illustrated with reproductions tipped in by hand. To a remarkable degree they looked more like original photographs than perhaps anything previously published. The book was large—16½ x 12⅜ inches—and weighed more than ten pounds. At the time, the price of fifteen dollars was costly for a book, although it seems very little compared to the ten thousand dollars that a copy in mint condition brings today. Only five hundred signed and numbered copies were produced.

The book was a memorial from Walter A. Starr to his son Walter Jr.—known as Pete—who died in a fall in 1933 from Michael Minaret. The Minarets are a series of seventeen "granite spires" that "in sharpness far surpass"[9] any other peaks in the Sierra. They are famously difficult to negotiate, as Charles Michael makes clear in the description of his ascent of the minaret that bears his name: "With nothingness on one side and a sheer wall on the other, I had the feeling as I crossed the ledge that the wall might give me a little shove on the shoulder and tip me into nothingness."[10] It was

legendary explorer-geologist Clarence King who christened them the Minarets in 1866 when he viewed them from the peak that would one day bear his name, Mount Clarence King. Just to the right of Michael Minaret in this image is Adams Minaret, named for Ansel.

Ansel sent a copy of the book to the director of the National Park Service, who was so impressed that he forwarded it to the secretary of the interior, who in turn presented it to President Franklin D. Roosevelt. In 1940 Roosevelt signed legislation creating Sequoia and Kings Canyon National Parks. Arno B. Cammerer, the director of the National Park Service, wrote Ansel, "I realize that a silent but most effective voice in the campaign was your own book, *Sierra Nevada: The John Muir Trail.* So long as that book is in existence, it will go on justifying the park."[11]

The book has long been admired as one of the finest of the forty-plus volumes of Ansel's photographs. Even Alfred Stieglitz, Ansel's idol who was not given to hyperbole, was impressed:

> You have literally taken my breath away. The book arrived an hour ago.—Such a grand surprise. O'Keeffe[12] rushed over to see it. I had phoned her at once—Congratulations is such a dumb word on an occasion like this. What perfect photography. Yours. And how perfectly preserved in the "reproductions."—I'm glad to have lived to see this happen.[13]

In 2006 Little, Brown and Company published a new edition[14] of the original volume in both regular and deluxe limited editions.

When Ansel hiked in the southern Sierra with the LeConte family, he was twenty-three years

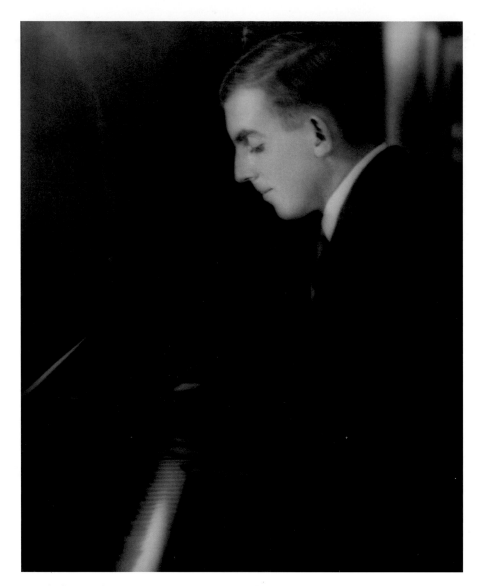

Ansel playing the piano, San Francisco, California, c. 1922

old and expected to pursue a career as a pianist. He had begun to play the piano when he was twelve and exhibited such a natural gift that his parents arranged music lessons. Music and the piano became his passions, with photography and the Sierra Nevada a close second.

His 1925 hiking companion, Helen LeConte, knew Ansel's photographs well—she had been there when he made many of the images in *Sierra Nevada: The John Muir Trail*. Helen also heard him play the piano in the 1920s. When I spoke with her at age seventy-six in 1980, she said that his piano playing was "like his photography"—"crystal clear, just like Bach."[15] Jules Eichorn was also Ansel's frequent hiking companion (the minaret that bears his name—Eichorn Minaret—is to the left of Michael Minaret in the image on page 38) as well as his piano student from 1925 to 1929. Eichorn recalled that Ansel's playing was "bell like," with "fantastic tonal quality."[16]

Gradually the battle between music and photography became so intense that Ansel had to choose. He felt that his small "violin hands" and his relatively late start—at age twelve—learning the musical repertoire would limit his career to that of an accompanist, and he would never have a career as a solo pianist. In any event, the choice was more or less made for him in 1928 when he suddenly earned several thousand dollars selling portfolios of his photographs. But that's a story for the next chapter.

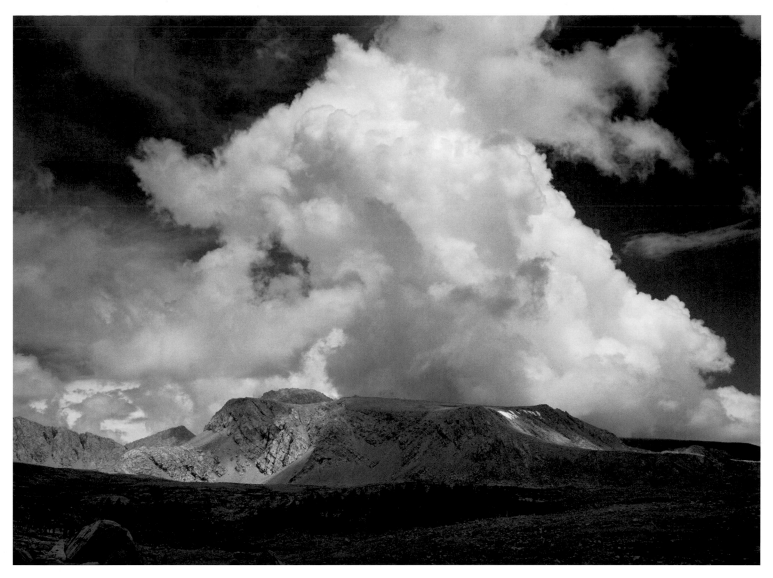

Afternoon Clouds near the Kings-Kern Divide, Sequoia National Park, California, c. 1936

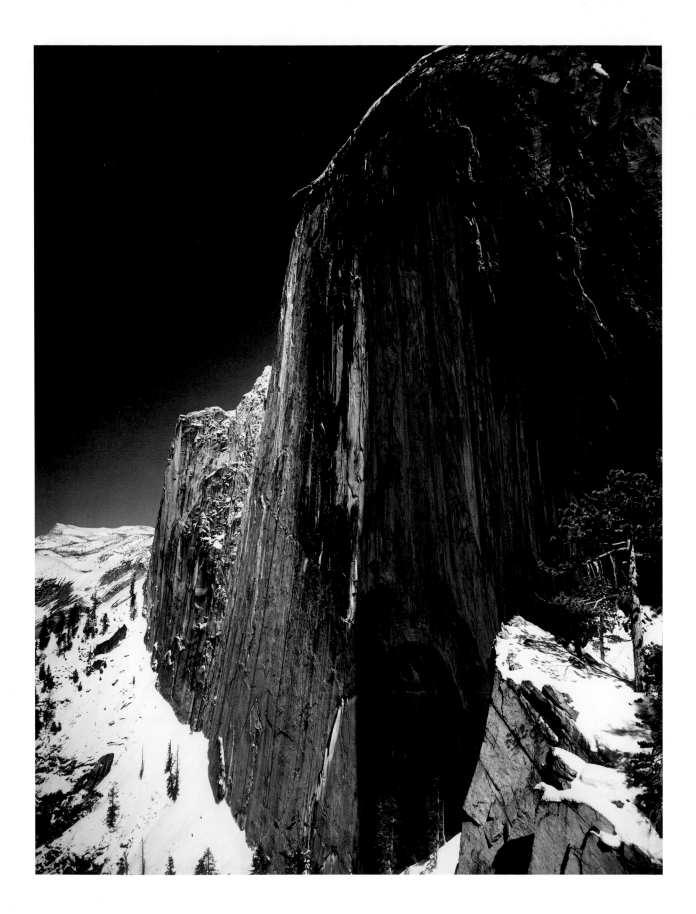

3 Monolith, the Face of Half Dome, Yosemite National Park, California, 1927

A PARTY OF DARING hikers have just returned from a thrilling climb," reported the *San Francisco Chronicle* on April 18, 1927. Their destination was the Diving Board, a spur of granite perched precariously three thousand five hundred feet above the floor of Yosemite Valley. The hikers included Ansel, his fiancée, Virginia Best, and three friends. The climb was difficult and dangerous, made more so by the supplies they carried: Ansel's 6½ x 8½ inch Korona View camera and twelve heavy Wratten Panchromatic glass plates,[1] plus two lenses, two filters, and a wooden tripod. In addition, Virginia brought a movie camera. From this breathtaking vantage point Ansel planned to photograph the sheared-off face of Half Dome.

They started from Yosemite Valley early in the morning. Unseasonable cold, combined with a residue of snow and the heavy gear, made the going tough, and parts of the climb were so steep they had to boost each other up. As they ascended, Ansel made several exposures, including a view of Mount Galen Clark, a favorite peak that he climbed innumerable times.

The group reached the Diving Board just before noon. The face of Half Dome loomed above them, still in shade. While they waited for the sun, they ate lunch, washed down with water from melting snow. Ansel "made one photograph of Virginia

standing on the brink of the rock edge, a tiny figure in a vast landscape."[2] Finally the light was right, and Ansel looked for a place to put his camera. It was difficult to find: "I did not have much space to

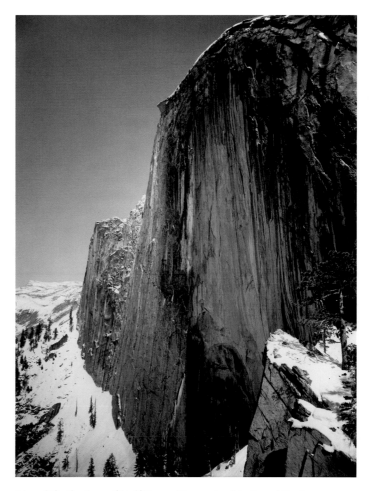

Monolith, the Face of Half Dome, Yosemite National Park, California, 1927; made with a Wratten No. 8 (K2) yellow filter.

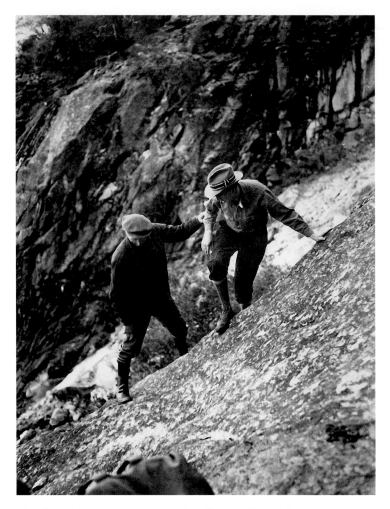

Charlie Michael and Ansel on the climb to the Diving Board, Yosemite National Park, California, 1927. Note Ansel's Keds basketball shoes, his preferred hiking footgear; at the time, they had leather uppers.

Mount Galen Clark, from Grizzly Peak Ridge, Yosemite National Park, California, 1927

move about in: an abyss was on my left, rocks and brush on my right."[3]

He made one exposure using a Wratten No. 8 (K2) yellow filter but immediately realized that the resulting image "would not express the particular mood of overwhelming grandeur" of the experience. "I visualized a dark sky, deeper shadows, and a crisp horizon in the distance."[4] He replaced the yellow filter with a Wratten No. 29 deep red filter, increased the exposure slightly, and with his last glass plate made the five-second exposure. Afterward, they packed up and carefully descended to the valley.

Ansel wrote, "I felt I had accomplished something, but did not realize its significance until I developed the plate that evening. I had achieved my first true visualization! I had been able to realize a desired image: not the way the subject appeared in reality but how it *felt* to me and how it must appear in the finished print. The sky had actually been a light, slightly hazy blue and the sunlit areas of Half Dome were moderately dark

On the Heights, Yosemite National Park, California, 1927. Virginia Best posed at the end of the granite spur.

gray in value. The red filter dramatically darkened the sky and the shadows on the great cliff."[5] Ansel had acquired the deep red filter two years before; pleased with his new piece of equipment, he had written to Virginia, "I have purchased a red filter. It will give a black sky and the snow peaks set against such a sky will produce a startling effect."[6]

For Ansel that first visualization was "one of the most exciting moments of my photographic career."[7] It would influence his approach to making every photograph thereafter. So central was this to his vision that he shared the principle with myriad others through thousands of hours teaching, lecturing, and writing technical books. In *The Camera,* volume one in the Ansel Adams Photography Series, the first chapter, titled "Visualization," begins with these words: "The term *visualization* refers to the entire emotional-mental process of creating a photograph, and as such, it is one of the most important concepts in photography."[8] Ansel

1927 SAN FRANCISCO CHRONICLE

World's Highest Diving Board, 'Half Dome,' Feature Attraction at Yosemite Valley

Virginia Best standing behind the "diving board."

Stupendous Peak Above Mirror Lake Fails to Lure Most Intrepid Artist to Take Leap

YOSEMITE, April 17.—The world's highest diving board, built by nature near the south side of Half Dome, 3000 feet above Yosemite valley, is not expected to be used by even the most intrepid of natatorial artists during the coming summer. Projecting into thin air several thousand feet above the placid waters of Mirror lake, that vividly reflect the features of Half Dome, the "diving board" has long been a popular attraction for sightseers, not swimmers.

A party of daring hikers have just returned from a thrilling climb to the "board," among them Arnold Williams, who describes the trip.

TELLS OF CLIMB

"The party, consisting of Virginia Best, Charles Michael, Ansel Adams, Cedric Wright and I, departed from Yosemite valley early in the morning by way of the Glacier Point long trail. This was followed only a short way when we turned to the Sierra Point trail, only to leave the latter after climbing

about a mile. From this point on we followed a rocky dry water course off the beaten paths. Later our party turned toward Half Dome. Here progress became increasingly difficult, necessitating the use of ropes as we approached the diving board.

LIKE DIVING BOARD

"This peculiar shaped rock abutting the south side of Half Dome looks exactly like a diving board. So sheer was the drop from this rock that some members of the party were well content to remain on substantial footing without venturing on the rock, as it projects out 200 feet from the sheer ledge. All of our party agreed the diving board was even more of a thriller than the famous Overhanging Rock on top of Glacier Point."

The party returned here with some of the first photographs ever taken in that section. They show the relation of the diving board to Yosemite valley, Half Dome and the distant High Sierra region.

The *San Francisco Chronicle,* April 18, 1927, with the story of Ansel's hike to the Diving Board

also emphasized that a photographer must first master the craft of photography—its "nuts and bolts" as he used to say—in order to successfully translate a visualization into a finished photograph.

When I lecture on *Monolith,* I first show the image made with the yellow filter. Seduced by the forceful composition, the audience responds with an "oh" of recognition and admiration. Then I change to a slide of *Monolith* made with the red filter, the one that adheres to Ansel's visualization, and they exclaim "ah" even louder. The wonder for me is that Ansel could make an image that most photographers would be proud to call their own and then, simply by changing a filter, transform a good photograph into a truly great photograph.

A year before, in the spring of 1926, Ansel's friend and fellow musician Cedric Wright invited Ansel to a party in Berkeley with instructions to bring some pictures. Cedric was eager for Ansel to meet one of the guests, Albert Bender, a San Francisco businessman and art collector. Ansel recalled, "It was a musical evening, but Cedric said, 'Show Albert Bender some of your mountain pictures.'"[9] Bender was so taken with both the young man and his photographs that he insisted they meet the next day.

Ansel typed a list of the first day's sales of *Parmelian Prints of the High Sierras* and added notations in pencil.

```
Books sold first day:
            My Own              10
Albert Bender               10
Walter Haas                 10.
Dan Koshland                10.
John O'Shea                 1
Harry Hart                  4.
Gilbert Colby               1.
Cora Felton                 1.
Mrs. Rosenberg              1
    Felix Kahn              7
    Trejidden               1        (56)
                    verbatim et literatum vires
                    acquirit eundo.!!!!!!!!!!!!

                    and that aint the 1/1000 of it
```

After the second viewing, Bender enthusiastically proposed the publication of a portfolio of eighteen of Ansel's views of the High Sierra in a limited edition of one hundred fifty copies. He committed to buy ten portfolios at fifty dollars each and picked up the phone and called wealthy friends whom he convinced to take multiple copies. (Today the portfolio sells at auction for seventy-five thousand dollars and up.) In one morning he secured commitments for the purchase of fifty-six portfolios.

This was a momentous step for Ansel. The several thousand dollars he earned from the portfolios propelled him further toward a career with a camera, not a piano. In contrast, the piano generated only a few dollars an hour from lessons to neighborhood children. And, after an on-again-off-again engagement of six years, the money provided the financial security for him to marry Virginia Best the following January. *Monolith* was one of the eighteen images he included in the portfolio; the most "modern" by far, it presaged the direction his photography would take in the future.

Bender enlisted the services of Jean Chambers Moore as publisher, though it is difficult to know what she contributed, other than perhaps the decision not to use the word *photograph* in the title. She claimed that photographs would not sell because they were not considered works of art, and therefore the portfolio was titled *Parmelian Prints of the High Sierras*. The title forever embarrassed Ansel for two reasons: the word *Sierra* is plural and needs no *s*, and he felt he should have stuck to his guns and used the word *photograph*. He recalled that in 1930 photographer Paul Strand even asked him, "Well, why don't you *call* them photographs?" [10]

There were a daunting twenty-seven hundred

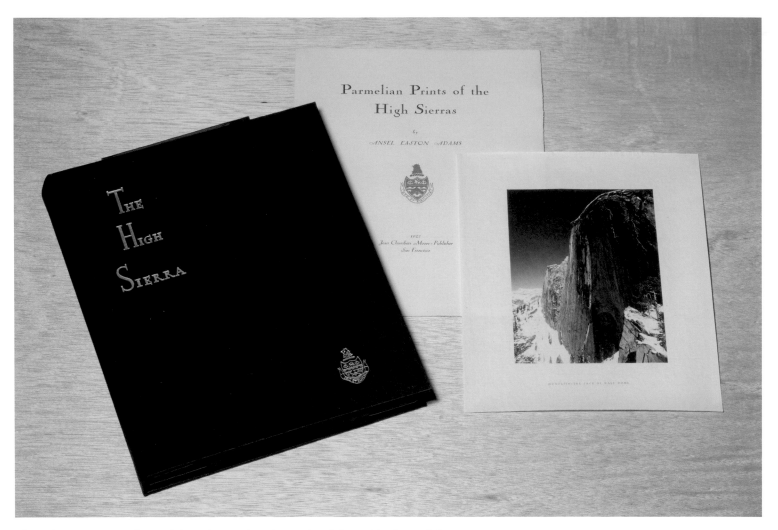

The title page, print of *Monolith,* and a modern facsimile of the original portfolio case

photographs to make for the portfolio. For the prints Ansel chose a Kodak paper that was readily available: Vitava Athena Grade T Parchment, a thin, translucent, slightly textured paper. Each photograph was presented unmounted, enclosed in an elegant paper folder with its title printed on the front. The distinguished San Francisco Bay Area press of Edwin and Robert Grabhorn printed the title page, list of plates, colophon, and folders, plus a title under each image. Alas, they "imprinted the wrong title on a number of images, thereby exhausting the sets; and at the time that occurred

the paper had been discontinued,"[11] opined Ansel. Therefore the number of complete portfolios was limited to probably fewer than one hundred, but the exact figure is unknown.

Finished in the fall of 1927, each portfolio was presented in a black silk case with gold typography and gold satin lining. Years later, Ansel's friend and biographer Nancy Newhall termed the presentation "a bit gorgeous, but better gorgeous any day than grubby!"[12]

Besides the prints of *Monolith* for the portfolio, Ansel also made single prints of the image, which

A page from Ansel's record book with entries for prints numbered 221 to 240. Prints of *Monolith* are listed for numbers 222–227, 234, 238, and 240. Titles include *Face of Half Dome, Monolith—Face of Half Dome,* and *Half Dome, Face.*

he sold or gave away. Until 1930 he listed every one by hand in a ruled booklet. A typical page shows Ansel's spidery script in black ink. First he gives the number of the print, then its title, and finally the recipient. On the page reproduced here, Albert Bender's name is listed next to numbers 222 to 227. He often purchased several prints of the same image to present to friends and promote Ansel's reputation. Further down the page at number 234 is Mildred Johnson, a violinist with whom Ansel was briefly infatuated. Ansel presented number 238 to Edward Carpenter, whose poetry he greatly admired.

In the spring of 1927 he sent a print to the writer Sara Bard Field, who typed a postcard of thanks on June 22, with the opening line, "I can't tell you how thrilled I am to have the face of the Half Dome walk right up to our hill. And all through your magic."

Ansel continued to make prints of *Monolith* until

```
THE CATS
LOS GATOS, CALIF.        June 22, 1927.

Dear Ansel Adams,
          I cant tell you how thrilled I
am to have the face of the Half Dome walk right
up to our hill. And all through your magic. The
picture seems to me much more impressive than
when I first saw it. I sit looking at it for
long times,fascinated and reminded of all the
freat dramatic rocks I have ever seen. There are
percipitous straight-dropping cliffs all along
the way from Sorrento to Amalfi. You know them?
And from such a rock as this must Sappho have
taken her legendary leap to Death. So it is you
are bringing me not only the face of the Half Dome
but many memories and imaginations.

          Erskine has gone North till the fourth of
July but I know I can speak his deep appreciation,
loving, as he does, every noble manifestation of
Beauty.

          Please be sure to let me know when you get
home again. I am sure you would like knowing my
dear Katherine and it goes without saying that she
would recognize "the pilgrim soul of you" and hail
you as comrade. So be sure to keep in touch with
us, my dear boy. Your music still is vibrating
in the big room and so you have left part of your-
self behind you here forever.

          I hope you'll have a jolly vacation and I
shall often think of you.
```

Cordially Yours Friend Sara Bard Field

the end of his life. They were as small as 6½ x 8½ inches and as large as 51 x 40 inches—the size of the print that hung in Ansel's living room in Carmel. I estimate that Ansel made more than seven hundred fifty prints from the same little glass negative that he lugged back from that snowy hike in April 1927.

In 1992 I was in Ansel's workroom selecting images for a prospective book of his photographs when Virginia appeared and announced that she had found a stash of home movies from the late 1920s and 1930s. With anticipation we rented a movie projector to screen them. Miraculously, one reel included footage of the trek to the Diving Board. It showed Ansel in his favorite plus fours,[13] lugging his forty-pound pack, with a rakish fedora hat and the Keds high-top basketball shoes he favored for hiking.

The climbers struggled up steep LeConte Gully in deep snow, and when they reached the Diving Board they pulled each other up with a ludicrously thin rope. Virginia fearlessly inched out onto the sharply angled granite spur, and when she reached the tip she stood up and blithely waved. It seems appropriate that Ansel presented the very first print of *Monolith* to Virginia.

Ansel was twenty-five years old when he made *Monolith*. At age eighty he was able to recall the experience of making the negative, every detail as clear as if more than a half century had not elapsed. He photographed Half Dome hundreds of times, and there are many different interpretations that include moons, clouds, snow, flowers, leaves, trees, even deer and people. In 1978, during one of his last annual Yosemite workshops, he and his photographic assistant, John Sexton, contemplated Half Dome together and talked about the taking of *Monolith* in 1927. According to John, Ansel laughingly confided, "Maybe I should just have stopped then." [14]

Oversized *Monolith* in Ansel's living room, Carmel, 2012. Photograph by John Sexton.

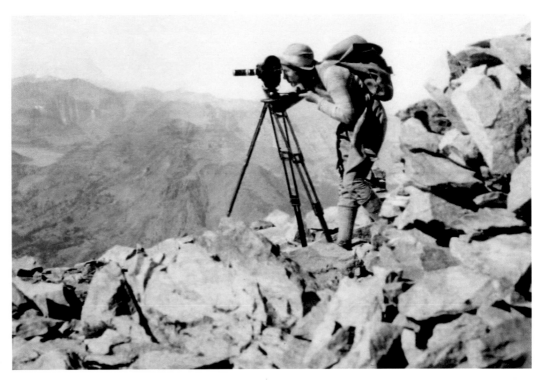

Virginia Best with a 16mm movie camera and telephoto lens on Mount Dana, High Sierra, California, c. 1927. (Collection of Michael and Jeanne Adams)

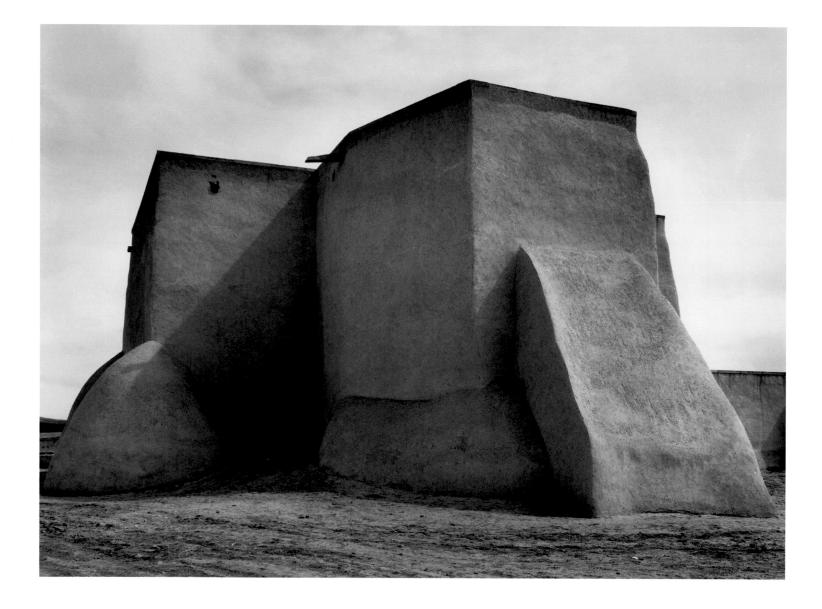

4 Saint Francis Church, Ranchos de Taos, New Mexico, c. 1929

I HAD NOT SEEN a photograph of the Ranchos de Taos church," Ansel wrote, "and had no idea of its magnificent form before I first viewed it (but did not photograph it) in 1927. The front aspects of the church are moderately impressive.... It is the rear elevation that defines this building as one of the great architectural monuments of America. It had been interpreted by numerous painters and photographers, and I could not resist the challenge."[1]

Built four miles from Taos Pueblo starting in 1772, the church in Ansel's photograph becomes "an experience in light."[2] He wrote that the structure is "not really large" yet it appears "immense." He photographed it from an angle, using orthochromatic film[3] that was sensitive only to blue and green light. This resulted in a white sky and soft shadows. Uncharacteristically, he did not apply a filter to darken the sky: "Some gentle angel whispered 'no filter' and I obeyed. A darker sky would have depreciated the feeling of light."[4]

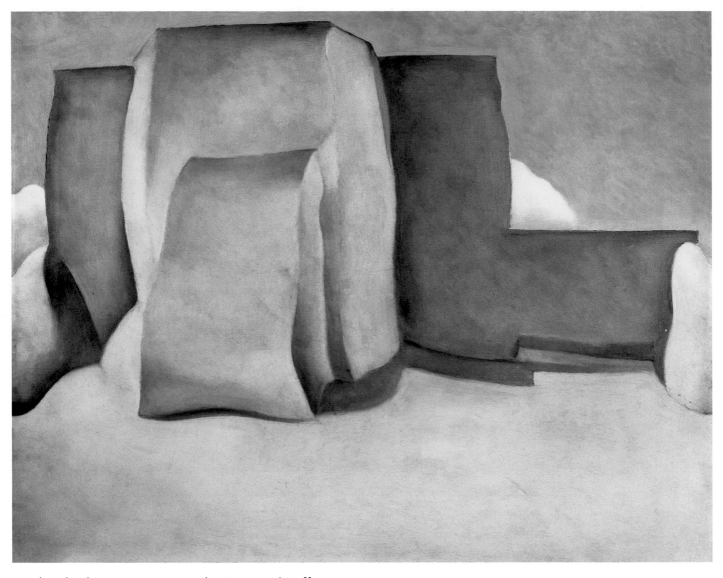

Ranchos Church No. 1, 1929. Painting by Georgia O'Keeffe.

The painter Georgia O'Keeffe made four paintings of the church, including one that looked squarely at the rear and silhouetted the cool beige building against a pale blue sky. In 1931, photographer Paul Strand recorded the church against a sky filled with lowering clouds. It is interesting that all are similar, though Ansel did not see Strand's photograph or O'Keeffe's paintings until years later.

Ansel made the photograph with his 6½ x 8½ Korona View camera using an 8½ inch lens (he

used the same combination to make *Monolith, the Face of Half Dome* in 1927; see Chapter 3). He wrote, "I seemed to know precisely the square yard of earth on which to place my tripod. There was no hesitation in this, and no change of position."[5] This recognition of where to put the camera was intuitive for Ansel. His friend and fellow photographer Edward Weston called it "the strongest way of seeing." Georgia O'Keeffe recognized this ability in Ansel and talked of how others hurried to place their tripods near his, knowing that he had found

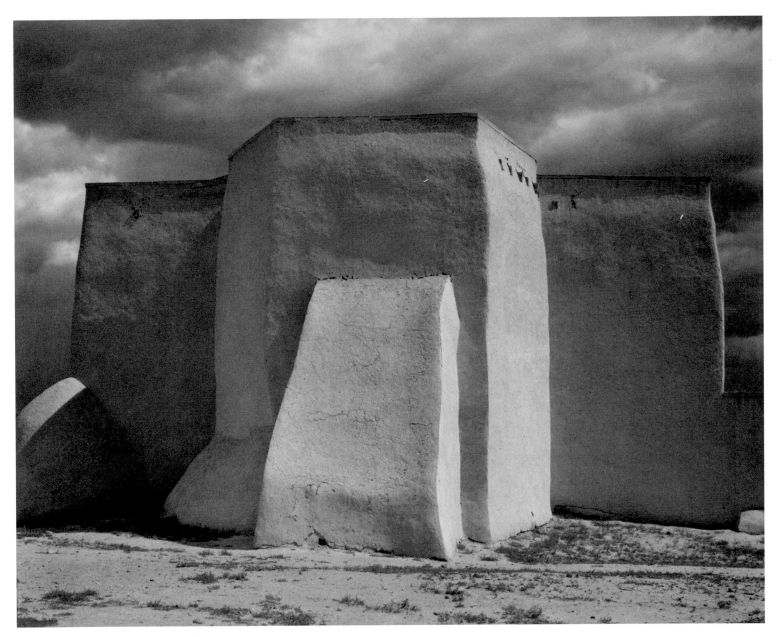

Saint Francis Church, Ranchos de Taos, New Mexico, 1931. Photograph by Paul Strand.

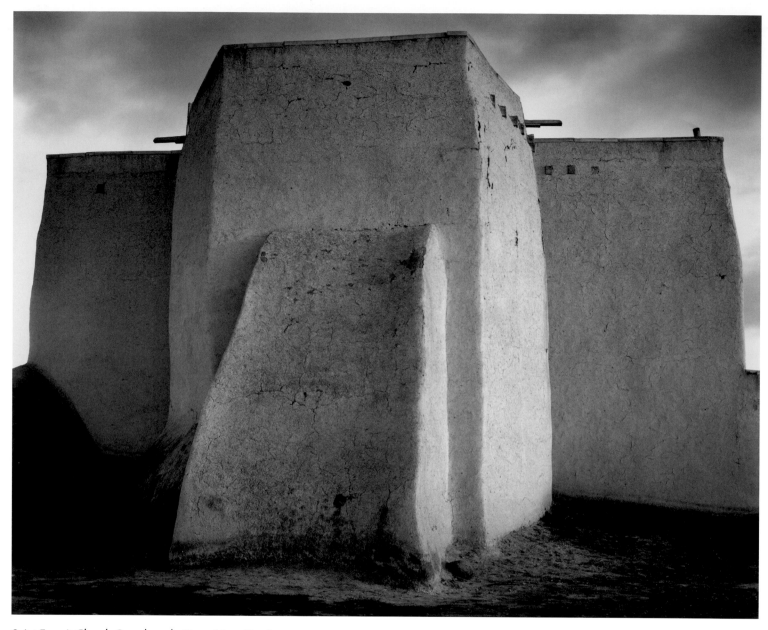

Saint Francis Church, Ranchos de Taos, New Mexico, 1941

the "sweet spot."[6] Years later Ansel made a second portrait of the church. He tightly framed the adobe structure to produce a tense, brooding presence that is altogether different from his earlier version.

Ansel fell in love with the Southwest and made repeated visits in the late 1920s. On a trip in 1928 he met the noted writer Mary Austin, and the two developed a mutual admiration. In spite of her famously formidable demeanor, Ansel described her as "a peach" with "a very warm and generous heart."[7] They hatched a plan to publish a book on the pueblo at Taos, with Ansel's photographs and text by Austin. This was a coup for Ansel since he was still relatively unknown outside San Francisco,

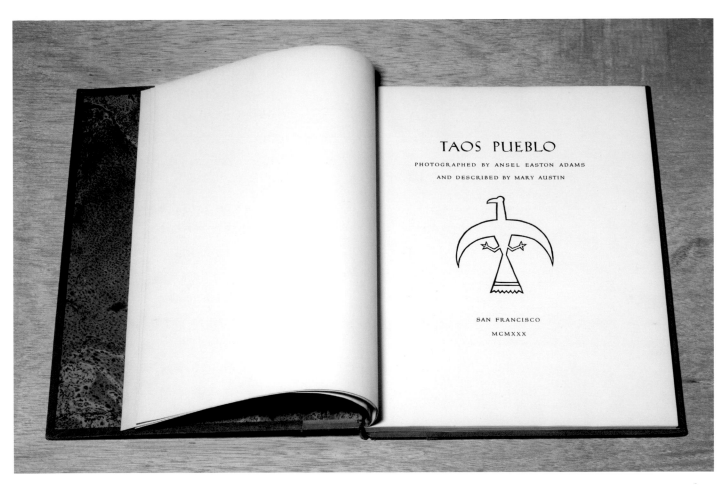

Taos Pueblo, 1930

while Austin was a published author of national repute.

It was difficult to gain access to the Pueblo, but Tony Lujan—husband of Ansel's hostess Mabel Dodge Lujan and a native of the pueblo—arranged for Ansel to photograph there for a week in 1929. Ansel described the pueblo as "a stunning thing— the great pile of adobe five stories high with the Taos peaks rising a tremendous way behind."[8] Filled with excitement, he wrote to his great friend and patron Albert Bender, who had first introduced him to the Southwest in 1927: "Look what you started when you brought me to Santa Fe!"[9]

The publication was the finest: a folio-sized book[10] with text by Mary Austin and twelve photographs by Ansel. The volume was handbound by Hazel Dreis, with a Niger leather spine, henna linen-covered boards, and hand-marbled end-papers. Valenti Angelo designed a woodcut motif of a thunderbird to punctuate the elegant design. San Francisco's foremost fine printers, Edwin and Robert Grabhorn, printed the text on Crane's all-rag paper. William Dassonville coated over one thousand sheets of the same paper with a silver-bromide emulsion on which Ansel printed the photographs in his darkroom.

The book was signed by both Ansel and Austin and numbered in an edition of one hundred

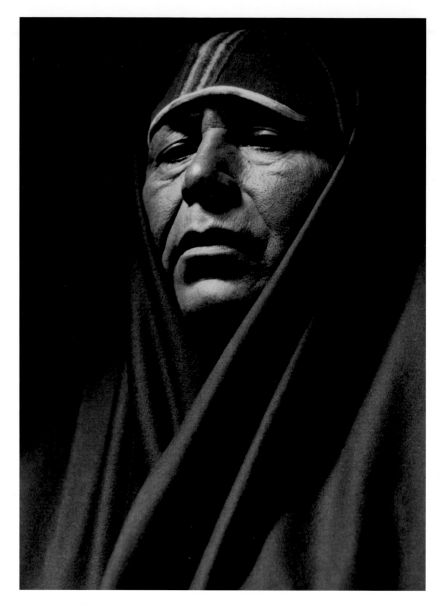

Tony Lujan of Taos Pueblo, New Mexico, c. 1929

plus eight artist's proofs. Thus Ansel needed to make more than 12 times 108, or 1,296, prints, a daunting prospect by any measure and made even more difficult by his lack of a professional darkroom—he printed in a small basement room in his home. He knew it would be a challenge: "I have a grand task to come up to it with the pictures. But I am sure I can do it."[11] He made contact prints without dodging and burning: "These prints are all direct prints and enlargements; no manipulation or retouching."[12]

Ansel wrote to Beaumont Newhall, "The Taos Book sums up all the elements of my progress in a most satisfying way."[13] Most of the negatives were made in 1929, and he observed that they represented his last work before he "changed his style from Pictorial to Direct techniques."[14] The photographs are unremarkable views of the pueblo, with two exceptions: the rear of St. Francis Church and North House, where light plays across the cubist pattern of the multistoried adobe rising against the dark silhouette of Taos Mountain.

Ansel included portraits of three Taos Indians, among them Tony Lujan.[15] There is also one image of a woman winnowing grain. Years later Virginia said she thought it looked artificial, and Ansel sheepishly admitted that he had asked the woman to pose.

Taos Pueblo appeared in early December 1930, albeit not without challenges. Mary Austin found it difficult to write her name on the colophon page: "The texture of the paper made it impossible to keep a clean line." And she further complained that there was "scarcely enough space" for her large signature with its "low hanging loops."[16] An even greater difficulty

involved the printing itself: the Grabhorn Press misaligned the text in printing because their press was not big enough to handle the large sheets, and the text had to be completely reprinted, with scarcely an extra sheet of the special paper. The biggest challenge, however, was the Great Depression that began with the stock market collapse in October 1929. The book appeared a little over a year later, hardly a favorable time to market an expensive luxury volume.

Just as he had with the portfolio of Parmelian prints published three years before (see Chapter 3), Albert Bender made the production possible by agreeing to purchase ten copies. Each copy sold for seventy-five dollars—a very high price for the time. Ansel was deeply grateful. In bed with a cold in January, he wrote: "The Taos Book represents more than an effort of fine book-making; it reflects the thoughtfulness and generosity of a dear friend. In type it is dedicated to the Indians— but in spirit it is inscribed to you."[17]

Taos Pueblo is one of the most beautiful books published in the twentieth century. It is also the first and arguably the finest book of Ansel's

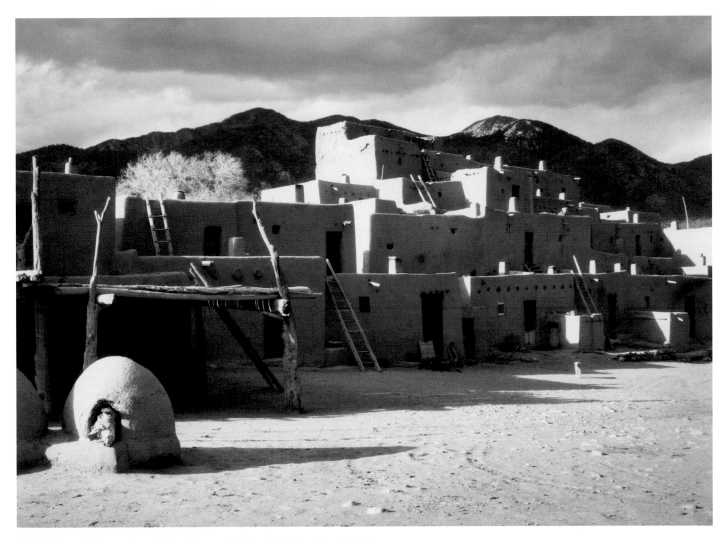

North House (Hlauuma) and Taos Mountain, Taos Pueblo, New Mexico, c. 1929

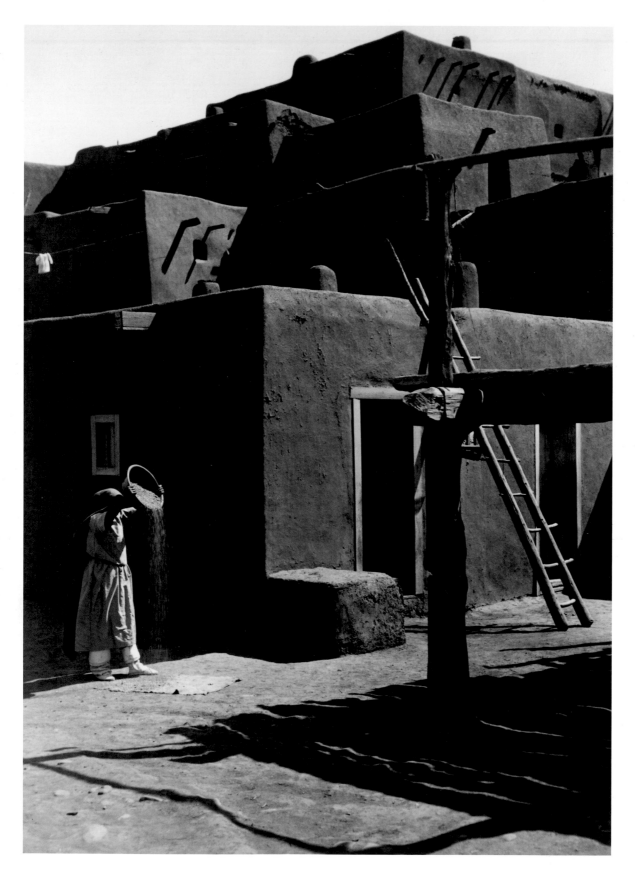

Winnowing Grain, Taos Pueblo, New Mexico, c. 1929

photographs ever produced, in part because of its inclusion of original photographs rather than photomechanical reproductions.[18] He wrote to Mary Austin, "The book exceeds all my hopes for sheer beauty."[19]

The affiliation with the finest printers and craftsmen and the juxtaposition of his photographs with text by an acknowledged author set a pattern that Ansel repeated many times. During his long career, he published more than forty books—all were characterized by the same attention to quality and detail, whether a technical manual or a coffee table book.

It sold out within two years, but the money came in slowly, and Ansel's letters to Mary Austin repeatedly reassured her that his payments would be forthcoming just as soon as checks arrived. Ansel's eight artist's copies were probably never produced, with the exception of copy number one in Roman numerals, which he sold to a collector in the early 1970s. Most copies are in public collections, but if you find one for sale, it will be priced at more than eighty-five thousand dollars. In 1977 Little, Brown and Company published a facsimile edition of 950 copies, but even that is now a rare book that sells for three thousand dollars or more.

The Southwest held enormous appeal for Ansel, and in a letter to Virginia in 1928 he spelled out his thoughts. "It is all so very beautiful and picturesque, and the air and mountains and people are so fine that I am completely 'gone' on the land."[20] The area also presented new subject matter—architecture and people—that was lacking in the

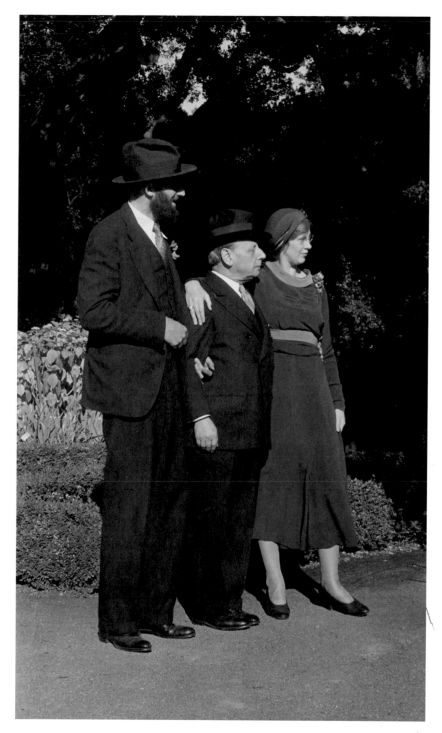

Ansel and Virginia with Albert Bender, c. 1928

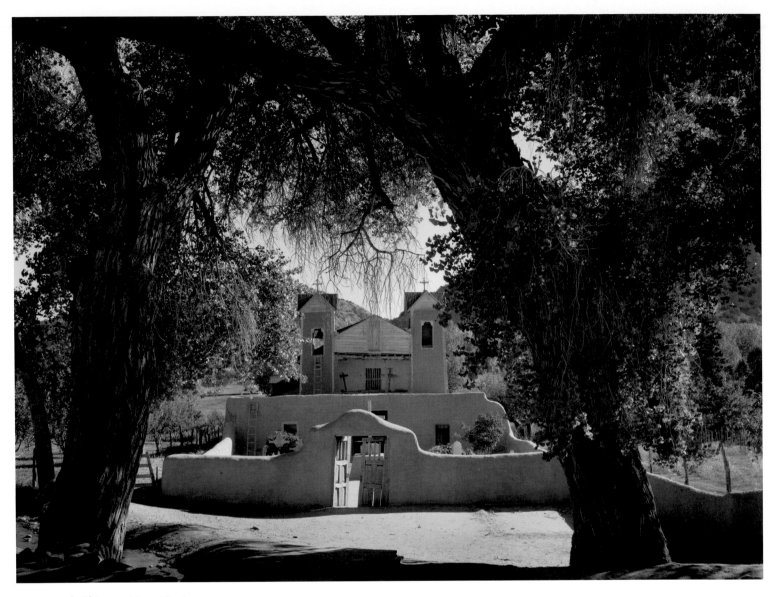

Santuario de Chimayo, New Mexico, c. 1950

Sierra: "The wealth of material is beyond belief."[21] On a drive through the small towns north of Santa Fe he reported to Virginia, "We went into churches and into homes of Mexicans and Indians and I took fifty negatives on the wave of enthusiasm."[22] He believed that serious artists had overlooked the area: "Hardly anything is more 'photographic' than these old towns and mesas and mountains," he added, 'and yet nothing has been done."[23] He

likened it to "the same opportunity that the Sierras gave the first artists that came to it."[24] Over the next fifty years Ansel returned often to the Southwest, and his body of work from the area is second in size and quality only to that of the Sierra Nevada.

As early as 1928 Ansel even considered moving to the Southwest and wrote Virginia: "I have a hunch that when you see this place you will

be even worse bitten than I am."[25] Mary Austin offered to sell them a lot near her home in Santa Fe. It would cost "three or four hundred dollars and a handsome adobe house could be built for around $2,000."[26] When they finally decided to leave San Francisco, however, they built a house not in the Southwest but in Carmel, California. It featured the Indian baskets, pottery, and textiles they had lovingly collected in the Southwest. Their son, Michael, and his wife, Jeanne, live there now.

As you enter the front door, you pass Acoma and Zuni pots carefully positioned on the floor in case of an earthquake. The mantelpiece over the massive fireplace is adorned with Indian baskets, and the living room floor is covered with bold Navajo rugs. When Mike greets you at the door, your breath is almost taken away. His uncanny resemblance to his father makes you believe that time does indeed stand still.

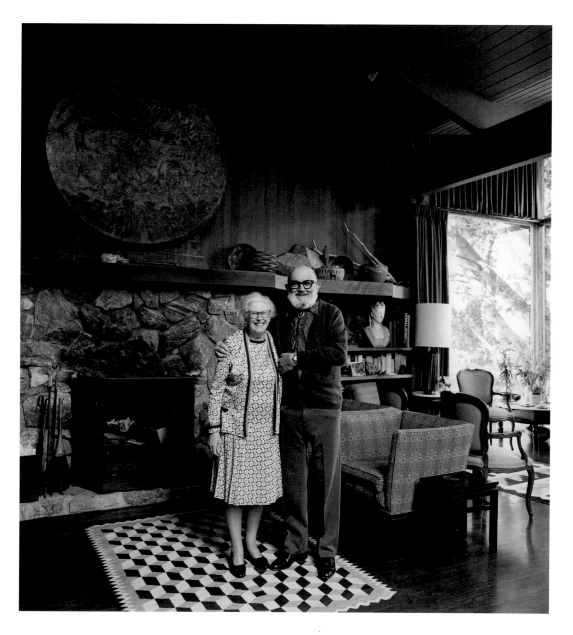

Ansel and Virginia in their living room, Carmel, California, c. 1975. Photograph by Alan Ross.

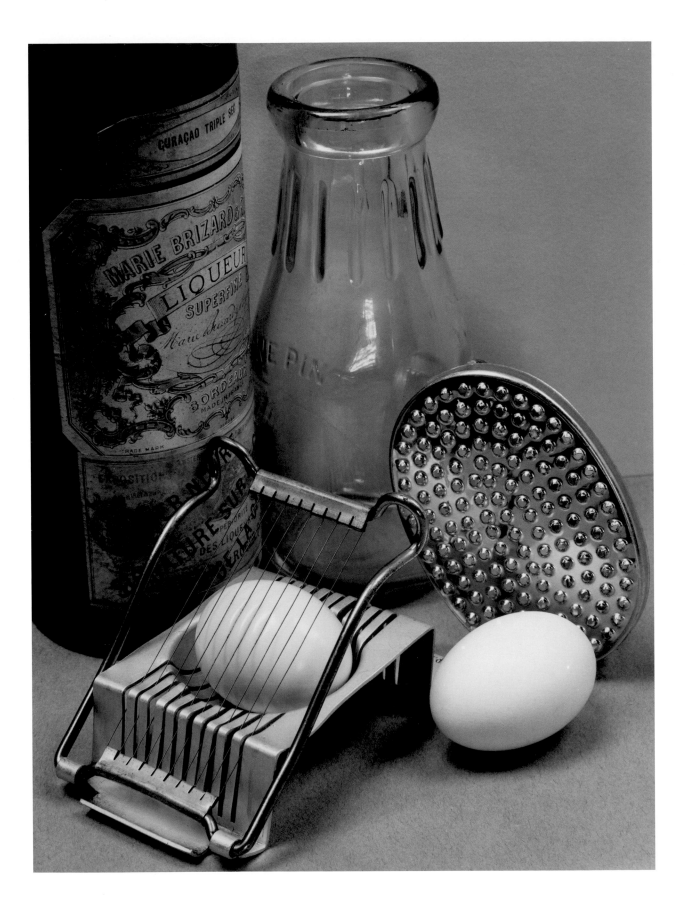

5 Still Life, San Francisco, California, 1932

I N THE SUMMER of 1974 more than one thousand finished prints—1,296 to be exact—for Ansel's *Portfolio VI* sat on his worktable, including a big stack of *Still Life, San Francisco, California*. As Ansel walked by, I blurted out that I didn't particularly like it. Unfazed, he answered, "Dear, this is a *very* important image." He patiently explained how he had first carefully arranged the various elements and then set to work to make a negative that preserved the intricate detail of the label on the Marie Brizard bottle, captured both the transparency of the glass milk bottle and its solidity, recorded the shiny reflective surface of the aluminum coffee filter, and described the subtle difference between the surfaces of the eggs, shelled and unshelled. The photograph is an example of virtuoso photographic technique.

I had just arrived to work for Ansel a week earlier. One of my assignments was to get things organized, and I started by exploring the workroom. In boxes of old photographs, I found a tiny print of a flower arrangement. Ansel probably made the negative and print around 1917, only a year after he was given his first camera. It was precious: a tiny picture (3¼ x 4¼ inches) on matte-surface cream-colored paper that was glued to a sheet of ivory paper and then mounted on a larger sheet of brown textured paper. The image featured blowsy tulips haphazardly arranged in what appears to be a hideous frog-shaped vase. It could not differ more from the still life that lay on Ansel's worktable.

The change in Ansel's photographic vision can be attributed to many influences, but one of the

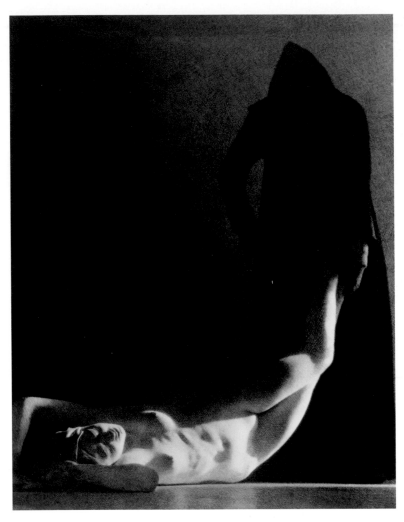

The Death of Hypatia, 1926. Photograph by William Mortensen.

most important was his profound disagreement with the photographers known as pictorialists who held sway starting in the 1860s. The pictorialists' photographs mimicked paintings. They employed histrionic lighting and complicated printing techniques, and Ansel characterized their photographs as "sticky muck."[1] In Ansel's words, their work "just seemed to be as far from photography as possible."[2]

He joined with Edward Weston, Imogen Cunningham, and a few other San Francisco Bay Area photographers in 1932 to found a loose organization called Group f/64. The name derived from the aperture on a camera lens that produces a negative with sharp focus and maximum depth of field. The group stood for "exactly the opposite of everything"[3] the pictorialists represented. They printed on glossy paper instead of matte. Instead of elaborate textured mounts, they dry mounted their prints on plain white board.

Ansel's tiny flower composition could be mistaken for a charcoal drawing or possibly a mezzotint, but his glossy still-life photograph could not be confused with any other medium. "Almost overnight, as it were," Ansel wrote, "the fussy accoutrements of the pictorialist were discarded for the simple dignity of the glossy print."[4] He was very clear: "All methods that obscure the most subtle quality of good photography—the rendering of minute textures—serve only to defeat the purity of photographic expression."[5] *Still Life* is a perfect example of the tenets of Group f/64.

The members of Group f/64 also stressed that the proper subjects for photographs were simple objects from everyday life, such as a scissors and thread that Ansel arranged in his front yard: "The scissors were laid on a dark blanket in full sun and the camera placed directly above.... The thread was gathered and dropped over the scissors quite a few times."[6]

Another example is *Rose and Driftwood*. "My mother proudly brought me a large pale pink rose from our garden, and I immediately wanted to photograph it."[7] For a support he chose a piece of driftwood found on nearby Baker's Beach—not the black velvet that a pictorialist might have selected. And he photographed with available light from skylights and a large north-facing window in his living room, rather than artificial light.

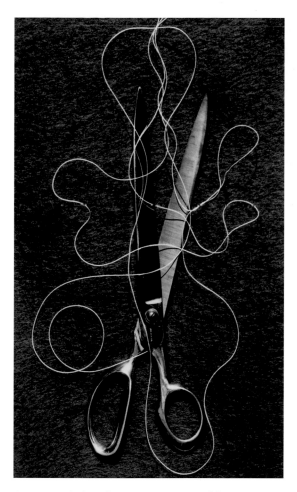

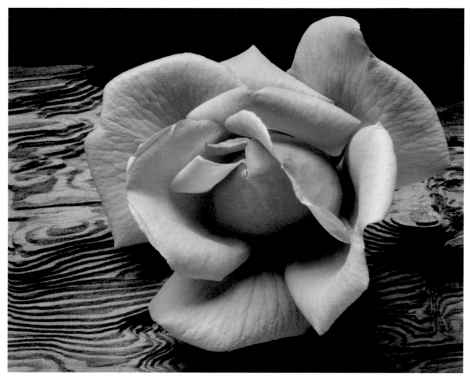

Rose and Driftwood, San Francisco, California, c. 1932

Scissors and Thread, San Francisco, California, c. 1932. Ansel occasionally mounted this image with the scissors pointing down.

Anchors, Fisherman's Wharf, San Francisco, California, 1931

Boards and Thistles, San Francisco, California, 1932

He recorded rusting anchors at Fisherman's Wharf in San Francisco and included it in an exhibition at Katharine Kuh's Chicago gallery in 1936. Kuh was surprised that the photograph sold and said that Ansel "had to be a most consummate technician in order to make a photograph of this kind work at all. It would otherwise be a big bore.... I would say he was the most accomplished technician of the twentieth century."[8]

Ansel was completely self-taught. There were no textbooks, and he learned by trial and error. In 1935 he remedied this: "I figured that someone should write on photography in a simple and direct way and try to give some conception of the straight simple photographic approach. So I tried it."[9] *Making a Photograph: An Introduction to Photography*[10] was an immediate success. Even Alfred Stieglitz admired it: "I must let you know what a great pleasure your book has given me. It's so straight and intelligent and heaven knows the world of photography isn't any too intelligent—nor straight either."[11]

Writing books about photography led to teaching. In 1940 Ansel led his first workshop. "Tom Maloney[12] asked me to conduct *U. S. Camera* forums in Yosemite that summer of 1940."[13] Twelve lucky students spent a week there with Ansel and Edward Weston, whom Ansel invited to teach as well. It was not until 1955 that Ansel began his annual workshops in Yosemite. He was a born instructor—his enthusiasm and kindness put everyone at ease. His technical explanations were sometimes opaque, but he more than made up for this with his ability to inspire. Ansel's annual Yosemite workshops continued until 1981, and he taught thousands of students over the years. Sometimes I think I have met every one, so proud are they to

Cancelled negative for
Mudhills, Arizona, 1947, an
image from *Portfolio V*

tell me of their personal association with Ansel.

In 1978 the worktable was once again crowded with stacks of photographs, including *Boards and Thistles,* in preparation for *Portfolio VII.* By then I was more guarded in my opinions and did not admit to Ansel that I failed to "get" the photograph. Shortly afterward I was walking through the San Francisco Museum of Modern Art when I spied a small 8 x 10 inch print of the image hanging in a back hall. I moved in close to inspect it. The subtle range of tones didn't shout, they whispered. I was bowled over by its quiet beauty and delicacy. Over time I grew to appreciate Ansel's f/64 images. In fact I came to love even the oddball subjects, like rusted anchors or scissors on a blanket. Perhaps my vision matured or Ansel's enthusiasm for them was irresistible, or both.

One day when I walked into Ansel's office, he greeted me with the question, "Guess what I did this morning?" He then gleefully described how he had "cancelled" all twenty negatives for the prints from his recent *Portfolios V* and *VI.*[14] He had used an old check-cancelling machine that had been gathering cobwebs in his vault. The word *cancelled* was spelled out in little round holes, usually across the middle of the image. He looked so happy that I was almost afraid to ask, "But what about prints for exhibitions or future books?"

Those were the days before damage to a photograph could easily be repaired in Adobe Photoshop. For the next thirty years we had to look through many boxes of prints to find a good reproduction print of any of the images in the portfolios, often without success. Ansel never suggested a repeat performance with the check-cancelling machine, and it disappeared without comment.

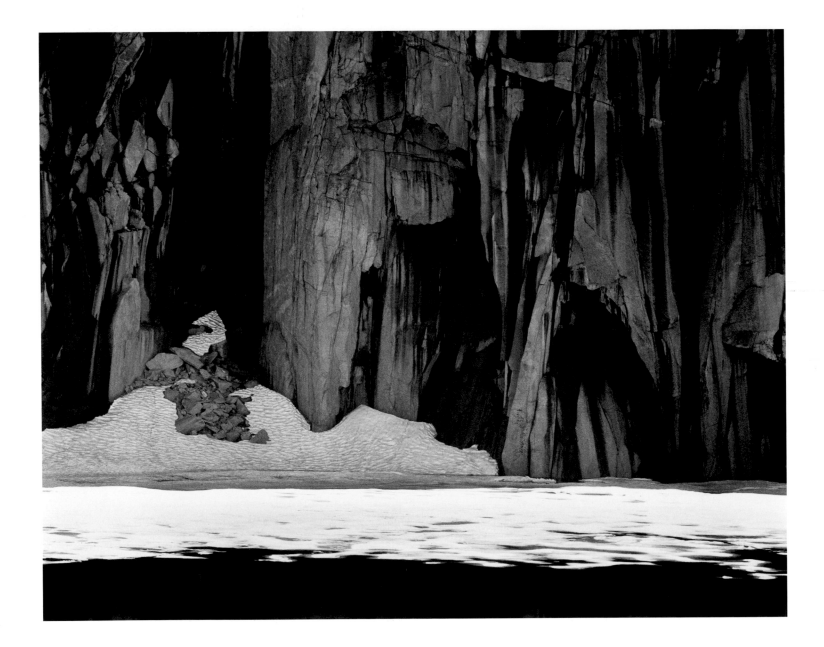

6 Frozen Lake and Cliffs, Sierra Nevada, California, 1932

"WE HIKED over Kaweah Gap," Ansel wrote, "where I was struck by the still, icy beauty of partially frozen Precipice Lake and its background, the black base of Eagle Scout Peak. I saw several images quite clearly in my mind."[1]

It was August 1932, and Ansel was on the annual Sierra Club High Trip organized to provide club members with four weeks of hiking amid the splendors of the High Sierra. Their avowed purpose was to educate the participants "to become defenders of the wilderness,"[2] but they were also congenial gatherings of friends. Up to two hundred members hiked fifteen miles every day accompanied by support staff and a string of pack mules and horses that carried supplies, including heavy cast-iron stoves. By day they hiked and climbed, and in the evening they gathered around a campfire for amateur theatrical and musical performances. The trips began in 1901 during John Muir's presidency of the Sierra Club and were a beloved tradition.

Ansel's first High Trip was in 1927. By the following year he had been named the official trip photographer, and in 1930 he became assistant manager, a position that included mapping the next day's route. The trip in 1932 visited the region of the southern Sierra that included the Kaweah

Ansel in camp, Sierra Club High Trip, Sierra Nevada, California, 1932. Note Ansel's beautiful set of false teeth. His own teeth were so bad that the dentist suggested a complete set of dentures, and Ansel agreed, although he was still in his twenties.

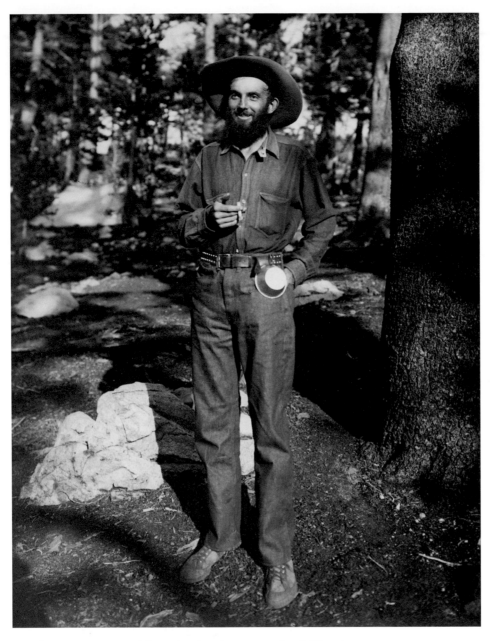

Ansel in camp, Sierra Club High Trip, Sierra Nevada, California, c. 1932. Photograph by Francis P. Farquhar.

Peaks in Sequoia National Park—an area that Ansel knew and loved. He was joined on the trip by his future wife, Virginia Best, fellow musician and photographer Cedric Wright, and Helen LeConte, with whom Ansel had hiked in the southern Sierra in 1924 and 1925 (see Chapter 2).

While Ansel photographed Precipice Lake, Virginia swam in its bitterly cold water, which was fed by snowmelt from the remnants of the glacier visible in the background. He made a total of six exposures, but the one he titled *Frozen Lake and Cliffs* is clearly the most successful. The director of the department of photography at New York's Museum of Modern Art, the late John Szarkowski, wrote, it "seems to me not only the best of these six pictures but one of the most memorable of his career. Nevertheless, the other five negatives are not negligible, and might be brought back as trophies by most excellent photographers."[3]

OPPOSITE: Variants of *Frozen Lake and Cliffs.* Ansel's preferred image is at top left.

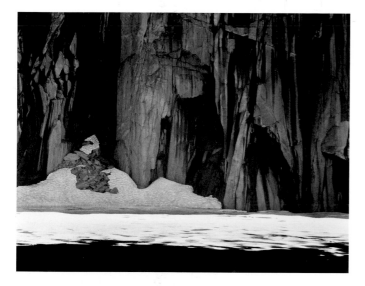

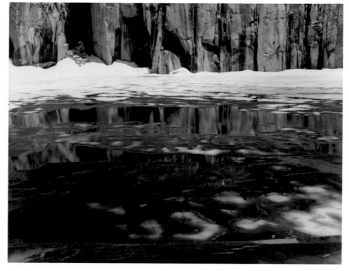

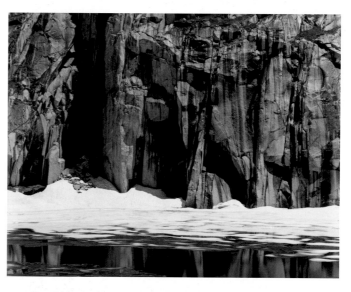

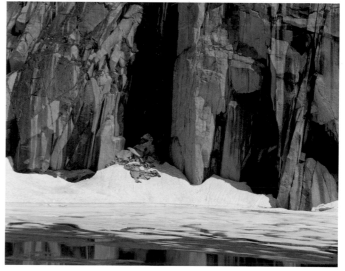

Sierra Club Pack Train Descending Elizabeth Pass, Sierra Club High Trip, California, 1932

The 1933 *Sierra Club Bulletin* features an account of the 1932 High Trip[4] that captures the high spirits and humor of what was at times a demanding experience. For instance, being roused from a warm sleeping bag at 4:30 in the morning by the ringing cry, "Everybody up! Get up! Get up!" only to find "slabs of ice upon the water-pails" would test even the most ardent camper's enthusiasm. That summer there was also a great deal of unexpected snow on the trails—in places "up to our necks or over."[5]

In order to cross Forester Pass, thirty willing volunteers spent a day shoveling what seemed like a mountain of snow to create a passable way for

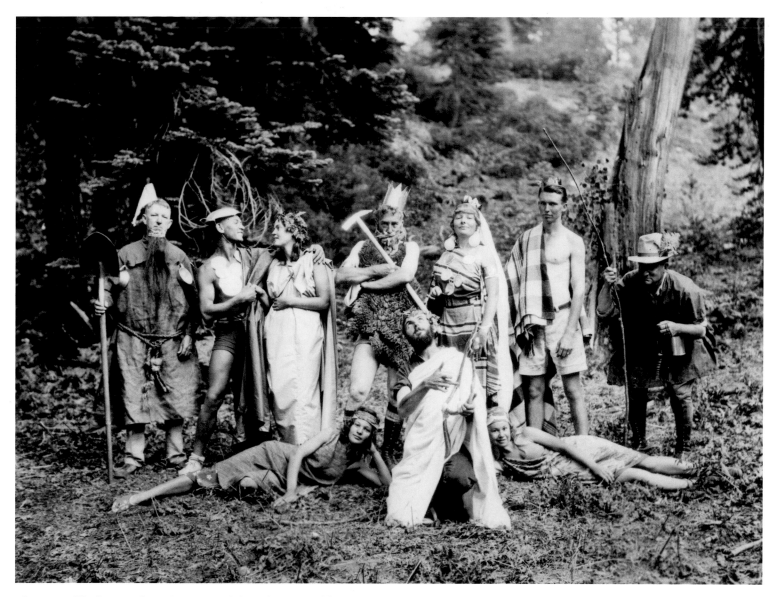

The cast of "Exhaustos" on the Sierra Club High Trip, California, 1932. Ansel is the Spirit of the Itinerary in the foreground.

campers and pack animals, a feat infinitely more tiring at an altitude of over twelve thousand feet. But there were incomparable rewards as well: "enchanting nights at Sphinx Creek, with the floodlight of the full moon penetrating the aisles of the forest, the bright stars resting on the treetops."[6]

For the nightly campfire festivities Ansel wrote mock tragedies in the Greek style. Two of them— "Exhaustos" and "The Trudgin' Women"—were presented in 1932. Costumes were created from what was at hand. In "Exhaustos," Ansel played the Spirit of the Itinerary garbed in a sheet for a toga with an ivy crown and a lyre made of "bent wood and fishing line."[7]

Ansel's hand-lettered poster for a performance of "Exhaustos" describes it as "A Lyric Tragedy Translated by Ansel E. Adams," beginning at 7:45 p.m.

The original script, in Ansel's handwriting, begins:

Prologue

Once Orpheus did twang his golden lyre
And made the very trees and rocks aspire
To move upon the hills in rhythmic motion.
But I have grasped the strings of my own Muse
And find it very difficult to choose
Between stern tragedy and foolish emotion
Now this which follows is both grave and gay
Second home to Eros and Clouds they say
And of a very definite intention.
Hellenic splendor meets Sierra dusts
And [illegible] confront mosquito thrusts

Exhaustos
A Play in One Act, thank God.
But with three scenes

King Dehydros of Exhaustos
Queen Citronella of Exhaustos
Commissaros Prince of Indigestion, son of the King
Rhykrispos of Poncha
Clymenextra, daughter of King Dehydros
Ogotellone, a fisherman
The Kings Kouncilors
Klimos
Bolonos Attendants of King Dehydros
Chorus of Weary Men
Chorus of Sunburnt Women
The Spirit of the Itinerary

Scene I In Camp at 8000 feet
Scene II The Eastern Bog
Scene III Summit of North Palisade

West Slope of Mount Whitney, Sierra Nevada, California, 1932. According to Ansel, the group hiked up the middle of the peak.

The 1932 trip also featured a "very arduous"[8] midnight climb (aided by moonlight and flashlight) to witness sunrise over the southern Sierra from the summit of Mount Whitney, at 14,505 feet above sea level the highest peak in the lower forty-eight states. Ansel was part of the hardy group, and he made two memorable photographs.

Ansel was considered a technical wizard in the darkroom, and the negative for *Frozen Lake and Cliffs* tested his skills. He described it as "quite poor in quality" because of the extreme "intensities of the subject"[9]—the "deeply shadowed recesses of the cliffs" and the "blinding sunlit snow."[10] There was an additional problem: "Unfortunately, when

Dawn, Mount Whitney, Sierra Nevada, California, 1932

Frozen Lake and Cliffs, Sierra Nevada, California, 1932. Ansel made this print in 1934 and presented it to his patron Mrs. Sigmund Stern for Christmas. (Collection of Michael Mattis and Judith Hochberg, New York)

I developed the film a month later," he wrote, "I apparently used fatigued (a nicer term than 'exhausted'!) developer,"[11] with the result that in the negative the dark areas in the cliffs lack detail.

In spite of these hurdles, Ansel made beautiful prints from the negative. He gave one as a Christmas gift in 1934 to his San Francisco patron Mrs. Sigmund Stern, who had also purchased his first portfolio and *Taos Pueblo.* If you compare it with a print made in 1975, there are obvious differences. The print made in 1975 has more contrast—the cliffs seem blacker, the light gray rocks seem paler, and the ice on the water is whiter. In addition, Ansel changed the cropping: all four sides of the image are reduced. As a musician plays the same score differently depending on the circumstances, the prints are two different interpretations from the same negative.

The back of *Frozen Lake and Cliffs* that Ansel gave to Mrs. Sigmund Stern,
inscribed, "Lake and Cliffs, Sierra Nevada—To Mrs. Sigmund Stern,
with most affectionate greetings from Ansel and Virginia Adams."
(Collection of Michael Mattis and Judith Hochberg, New York)

Ansel changed the title, too. In the *Sierra Club Bulletin* for 1933 the image is called *Half-Frozen Lake Beneath the Cliffs of Eagle Scout Peak*. Mrs. Stern's print reads *Lake and Cliffs, Sierra Nevada*. The title adopted in the 1970s was *Frozen Lake and Cliffs, Sierra Nevada, California*; John Szarkowski favored *Frozen Lake and Cliffs, Kaweah Gap*. Tonality, cropping, and title changed over time, but Ansel consistently and accurately dated the image 1932.

For the first prints Ansel made of *Frozen Lake and Cliffs* in the early 1930s, he selected photographic papers that allowed an extended range of tones from black to white. He often used musical analogies when talking about photography, and he liked to say that a photographer should be able to print every tone from white to black, just as a pianist can play all eighty-eight keys on the piano. By the 1970s Ansel complained that photographic papers no longer permitted him to print such a long gradation of tones.

In 1978 he discovered Oriental Seagull paper and found that it produced "a better print." The only drawback was that the toning process—bathing a print in a solution of selenium to remove its natural greenish cast and also add protection to insure permanence of the image—sometimes took effect so quickly on papers such as Oriental Seagull that the prints acquired a slightly brownish tone.

After the outings in 1929, 1930, and 1932, Ansel offered Sierra Club members the opportunity to purchase portfolios of the photographs he had made on each trip. Each portfolio consisted of twenty-two to twenty-five images presented in a blue or green cloth folder with a printed title page and list of plates. Ansel could not remember how many portfolios he made—maybe five or ten of each. The original price for a portfolio was thirty dollars, but today the price is over one hundred thousand dollars. The portfolio for 1932 included *Frozen Lake and Cliffs* and *Dawn, Mount Whitney*.

In 1979 I was sorting masses of correspondence for Ansel's archive when I happened upon a handwritten letter to Ansel from Cedric Wright. In it Cedric described how he saw Ansel taking a photograph of Precipice Lake on the Sierra Club High Trip in 1932 and rushed to set up his own camera next to Ansel's, sure that there must be something worth recording. It was not until several years later that he saw *Frozen Lake and Cliffs*. He lamented, "Jeez! Why didn't I see *that!*"[12]

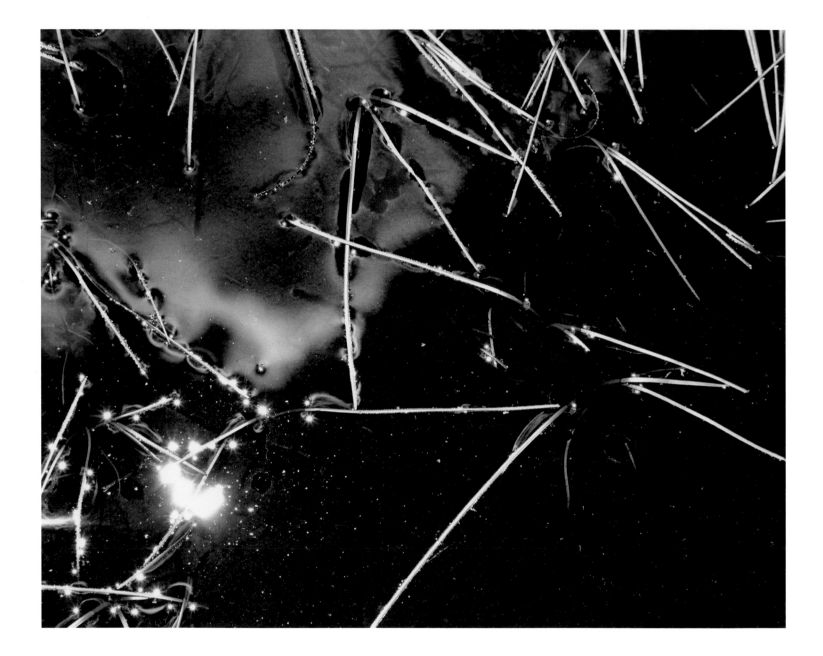

7 Grass and Water, Tuolumne Meadows, Yosemite National Park, California, c. 1935

FOR MOST PEOPLE the name Ansel Adams conjures a heroic landscape—with a mountain, a waterfall, maybe a moon—definitely something dramatic. But Ansel also made hundreds of photographs of natural details—like this study of grass in a pool in Yosemite's Tuolumne Meadows.

The meadows are more than eight thousand feet above sea level and present a gentle, open landscape dotted with streams and pools. They are ringed by what Ansel called "sculptures in stone," with romantic names such as Cathedral Peak and Unicorn Peak. Ansel knew the area well because it was the principal jumping-off point for treks into the High Sierra.

The glory of *Grass and Water* is the myriad brilliant scintillations on the water, while its subtlety rests in the pale cloud reflections and the shadows cast by the random grasses on the muddy bottom. Ansel made a variant at the same time (page 84). He pulled the camera back and recorded more of the pool and grasses. It feels almost Japanese in its abstract composition, somber tones, and quiet light.

Ansel included the smaller photograph in his exhibition at Alfred Stieglitz's New York gallery, An American Place, in November 1936. The show was tremendously important to Ansel, marking his acceptance into the pantheon of American artists whom Stieglitz championed—artists of the stature of Georgia O'Keeffe, Paul Strand, Arthur Dove, Marsden Hartley, and John Marin. "I am now definitely one of the Stieglitz Group," Ansel wrote to Virginia. "You can imagine what this means to me."[1] According to Ansel, the exhibition was unequaled. In April 1974 I was standing with Ansel at the opening of his one-man retrospective at the Metropolitan Museum of Art, and I was stunned when he confided to me that the smaller, earlier show was better.

Puzzled by his opinion, I determined to research

Grass and Pool, Tuolumne Meadows, Yosemite National Park, California, c. 1935

the American Place show. I found a faded copy of the original exhibition checklist but recognized few of the titles. Because the exhibit took place in 1936, it included none of what we know as Ansel's "greatest hits"—the iconic landscapes taken in the early 1940s.

Instead it featured an unusual group of photographs such as three close-ups of gravestones, two stiffly posed portraits of elderly women, numerous photographs of weathered wood, a stack of rusted metal anchors, a carved wooden Indian outside a news store in San Francisco, and a 35mm portrait of a ski instructor made for publicity purposes for the Yosemite Park and Curry Company. Remarkably, only seven of the forty-five images were landscapes.

At least ten photographs from the show sold, but *Grass and Water* was not among them. After Stieglitz died in 1946, O'Keeffe asked Ansel what he wanted to do with the unsold photographs that

LIST OF PHOTOGRAPHS FOR EXHIBIT AT "AN AMERICAN PLACE"

Lar
Large Mats:-

1.	Latch and Chain	$25.00
2.	Mineral King, California	20.00
3.	Half Dome, Yosemite Valley	20.00
4.	South San Francisco	25.00
5.	Factory Building	20.00
6.	Museum Storeroom	20.00
7.	Old Firehouse, San Francisco	20.00
8.	White Cross, San Rafael	25.00
9.	Windmill	20.00
10.	Pine Cone and Eucalyptus Leaves	20.00
11.	Cottonwood Trunks	20.00
12.	Grass and Burned Tree	25.00
13.	Show	25.00
14.	Church, Mariposa, California	20.00
15.	Courthouse, Mariposa, California	25.00
16.	Mexican Woman	25.00
17.	Detail, Dead Tree, Sierra Nevada	25.00
18.	Fence	20.00
19.	Fence, Halfmoon Bay, California	25.00
20.	Political Circus	20.00
21.	Americana	20.00
22.	Winter, Yosemite Valley	20.00
23.	Winter, Yosemite Valley	20.00
24.	Family Portrait	Not for sale.
25.	Hannes Schroll, Yosemite. (Advertising Photograph)	15.00
26.	Phyllis Bottome	Not for Sale.
27.	Annette Rosenshine	Not for Sale..
28.	Tombstone Ornament	25.00
29.	Early California Gravestone	25.00
30.	Architecture, Early California Cemetary	20.00
31.	Mount Whitney, California	20.00
32.	Scissors and Thread	20.00
33.	Leaves	20.00

Small Mats:

34.	Sutro Gardens	15.00
35.	Picket Fence	15.00
36.	Tree Detail, Sierra Nevada	20.00
37.	Grassaand Water	15.00
38.	Clouds, Sierra Nevada	20.00

Without Passe-Partout:

39.	Architecture, Early California Cemetary	15.00
40.	Early California Gravestone	20.00
41.	Early California Gravestone	20.00
42.	Anchors	20.00
43.	Autumn, Yosemite Valley	20.00
44.	Steel and Stone (Shipwreck Detail)	20.00
45.	Sutro Gardens, San Francisco (Lion at entracne)	20.00

Ansel's typed
checklist for his
exhibition at An
American Place,
1936

remained at the gallery. He invited various friends (including John Marin, David McAlpin, Beaumont and Nancy Newhall, and Dorothy Norman) to stop by and choose their favorites. No one selected the detail of grass and water, and finally Ansel gave it (along with eleven others) to the Museum of Modern Art in New York.

I went to MoMA in search of prints from the 1936 show and carefully looked through their substantial holdings of Ansel's photographs, which cover the entire span of his career, from the 1920s to the 1970s. Those from the show were easy to identify. They were small contact prints, not

Cigar Store Indian, Powell Street, San Francisco, California, 1933

enlargements. They were dry mounted on mat board with a smooth, lustrous finish created by a white clay (baryta) coating. On the back was a handsome label newly designed by Lawton Kennedy, one of San Francisco's premier designers.

Ansel had selected a photographic paper (Agfa Brovira glossy double weight) with which he could "obtain maximum brilliancy and clarity of image."[2] He had even changed the way he signed his prints—his name appears quite small, unlike his earlier bold signature. But the biggest giveaway was the exceptional beauty of the prints.

There were four principal reasons for their quality. First, Ansel knew that his prints must be worthy to hang on the walls of The Place, and he had spent hours in the darkroom perfecting each one. Second, over the previous five years he had honed his technique to the highest possible standard. A third factor was the change to a paper with a luxurious surface that permitted a particularly rich and nuanced range of tones. The final influence was the budding relationship with his young darkroom assistant, Patsy English.

Patsy was a beauty. She posed as a model for Ansel in commercial photographs for the Yosemite Park and Curry Company in early 1936. When she confided that she really wanted to be a photographer, not a model, Ansel "hired" her as his darkroom assistant. Only twenty-one years old, she knew nothing about photography. She was in the darkroom with Ansel almost every day during the two months in the fall of 1936 that he printed for the exhibit at An American Place.

Ansel remembered that as they contemplated a print in the darkroom, Patsy would urge him to try again and make it more luminous.[3] In a letter to her from New York in November 1936, he wrote,

Patsy English posing for a publicity photograph for the Yosemite Park and Curry Company, on the cables of Half Dome, Yosemite National Park, California, 1936. (Collection of Michael and Jeanne Adams)

"Please don't forget that without you the show might have been very different. You and your help contributed something that I cannot explain in words—except that it is exceedingly important."[4]

Very few prints of the smaller version of grass and water exist. In addition to the print shown at An American Place (now at the Museum of Modern Art), Ansel gave one to the Newhalls. Nancy described their dinner guests' reaction to the tiny photograph one evening: "Them as thought they knew something of modern art were sure it was an Albers or a Klee or name your favorite abstract painter and *what* was the medium?"[5]

In comparison, the larger image exists in many examples. In 1960 Ansel made more than two hundred for his *Portfolio III*, a selection of photographs of Yosemite. Loose prints of grass on water from broken portfolios come on the market with some regularity, but they are not popular with the public. In 2010 one was paired with an equally unpopular image of foam on water in a lot that sold at auction for only twenty thousand dollars, much less than any of the other photographs by Ansel in the sale.

Ansel also made the image into a three-panel screen measuring six feet tall for his friend and patron David McAlpin. He first experimented with making oversize prints in 1935, when the Yosemite Park and Curry Company asked him to produce murals of his photographs for the San Diego World's Fair. "I was fascinated with the challenge of making a photographic print in grand scale,"[6] he wrote.

Over the next fifteen years he made almost a dozen screens. Nearly all were of natural details. He believed that landscapes were not appropriate subjects for screens because the image needed to be divided into sections. He also made a screen of a close-up of leaves and ferns that still stands in his home.

Most people who buy a photograph by Ansel are not thinking of a small picture of sun scintillations on a grassy pool. They want one of his heroic landscapes. Consequently, Ansel's nature details are passed over by all but the most sophisticated collector (or the buyer with a limited budget). Their lack of popularity with the buying public never affected Ansel's zeal for intimate subjects or his occasional dismay at being "typecast" as a landscape photographer. Near the end of his life, when he was seventy-nine years old, he wrote me a letter with a frequently repeated complaint: "I was NOT immersed in the Landscape [in 1936]; I was a *photographer*, and covered a large field of effort. I did NOT make myself a landscape photographer—the public did. There were times when I could EXPLODE at this emphasis."[7]

There are more than forty thousand negatives in Ansel's archive, and hundreds are nature details. In his idiosyncratic catalog system they are designated C for composition. Most of his negative categories relate to geography. For instance, views of the Southwest are SW, and scenes in Hawaii are H. Yosemite National Park has three designations: Y for Yosemite, YHS for Yosemite High Sierra, and YW for Yosemite in winter. Any negative that doesn't fit into a neat category is shoehorned into the forgiving C. Hence it includes

Leaves, Mills College, Oakland, California, c. 1931

Screen of *Leaves, Mills College,* Oakland, California, c. 1931, that still stands in Ansel's living room in Carmel, California. Photograph by John Sexton.

Cemetery Statue and Oil Derricks, Long Beach, California, 1939

subjects as diverse as a cemetery statue and oil derricks in Southern California, an abandoned car in Tiburon, a burnt stump and new grass, gravestones, architecture, and on and on. Of the forty-five photographs exhibited at An American Place, twenty-seven were from the C category, including *Grass and Water.*

To Ansel's great disappointment, Stieglitz never gave him another show. David McAlpin discreetly pressed the subject with Stieglitz without success. O'Keeffe believed that Ansel never again "produced such a beautiful group of photographs."[8] Ansel felt "it's entirely my fault that I have failed to pull my stuff together to make a decent group"[9] of photographs to show Stieglitz.

However, I surmise that Stieglitz would not have been persuaded by the heroic landscapes that Ansel produced in the early 1940s. Dorothy Norman, Stieglitz's muse, recalled that what Stieglitz responded to in Ansel's photographs in the 1936 show was their "delicacy and the sense of affirmation" and the fact that they were "so clean and so tender,"[10] just like *Grass and Water.*

Meanwhile, Ansel's romance with Patsy was fraught with obstacles. He was married—and Virginia played a central role in his life. She not only

ran the house and took care of the children, she also cared for Ansel's aged parents and his maiden aunt who lived next door. She helped in other ways as well. Many of Ansel's letters to Virginia include instructions related to his work, including what photographic supplies to order, or how to renew their car insurance, even suggestions on how to juggle the payment of bills and manage their precarious finances. And he and Virginia had two young children—Michael was born in 1933, and Anne was born in 1935.

The relationship wasn't easy for Patsy either. She felt uncomfortable in the house with Virginia and the children, whose feet echoed on the stairs above the darkroom where she and Ansel worked. She also explained to me that in 1936 an affair between a twenty-one year old woman and a married man was out of the question.[11]

By early November, when Ansel left for New York to see his show at An American Place, the situation had become almost intolerable for Ansel, Virginia, and Patsy. While he was away he wrote letters to both women, often on the same day and with only slight differences. He even sent them nearly identical self-portraits from "a ten cent automatic picture machine in the R.R. Station."[12] On Patsy's copy he wrote, "I agree with you that the beard looks better off."[13] His letters to Virginia reassured her of his love and indicated that he was eager to spend time with her and the children on his return from New York. His letters to Patsy talked about her photographs and their work together in the darkroom.

When Ansel returned home, he entered the hospital, undone by the anxiety and stress of his personal situation. The ostensible reason was mononucleosis, but it was in fact a nervous breakdown. Friends including O'Keeffe, McAlpin, Stieglitz, and Weston thought Ansel should leave Virginia and devote himself to his photography. But Ansel had a tremendous fear of confrontation, and he couldn't face a divorce. All his life he sought to avoid unpleasant situations both in business and personal relationships, preferring to keep the peace at all costs. With anguish he decided to stay with Virginia—and he was proud when they celebrated

Burnt Stump and New Grass, Sierra Nevada, California, 1935

Ansel and Patsy English on the Sierra Club High Trip, California, 1936. (Courtesy of the Bancroft Library)

their fiftieth anniversary forty-two years later.

There were rumors about Ansel's dalliances with women other than Virginia, and even today I am occasionally asked if I had an affair with Ansel. I am always taken aback. The man I knew was a gentleman of the old school who might smile and even shyly flirt but with absolutely no serious intention. I believe that his high spirits and gregarious nature have been misunderstood and that even his relationship with Patsy remained chaste.

On a sunny day in July 1978 Ansel surprised me with the news that Patsy was coming for cocktails. She arrived promptly at 5:00 p.m., and from my office in the back of the house I could hear the clink of ice in glasses and the initial social niceties.

Then, with a sense of urgency in his voice, Ansel summoned me to the living room. I found him clutching to his side a small packet that he surreptitiously shoved at me like a hot potato, mumbling words to the effect, "Why don't you take these away?"

Patsy had brought the letters Ansel had written to her at the height of their romance in 1936. His nervousness stemmed from his fear that the letters might be compromising. Far from it! They were almost painfully reticent. In a letter to Patsy written on his return trip from New York, he wrote, "I received your letter today.... I, too, have had an awful time trying to hit that medium between the tedious and the censored. I have failed to do

Ansel's self-portrait taken at an automatic machine at the railroad station in Chicago, November, 1936; sent to Patsy English with the inscription, "Chicago by GAWD! Hollywood Division."

so entirely; it is better to be safe as far as accidental readers are concerned and tedious. But I trust your imagination to focus between the lines."[14] In another letter, he wrote, "My Dear Patsy, Just wait until I see you and make up in words for all the funny little stilted letters I have written you. Many hours will be filled with the saying of many things."[15] The letter was signed, "Yours, impatiently, Ansel."

Ansel returned the letters to Patsy, who eventually gave them to the Center for Creative Photography. Ansel had not kept Patsy's. Thus only one side of the correspondence is preserved. "I sure wish I had saved the letters you wrote me," he wrote Patsy in 1978. "Maybe they are here somewhere and I haven't found them, but I don't think I was very good at keeping track of papers. My loss."[16]

Grass and Water and the other photographs from the show at An American Place are a summation of Ansel's work from 1931 to 1936 in terms of subject matter, composition, and technical bravura. With few exceptions he rarely, if ever, printed the forty-five images again, nor did he include them in exhibitions or reproduce them in books. They remain a testament to the intense emotion of his relationship with Patsy and the inspiration of Alfred Stieglitz and An American Place.

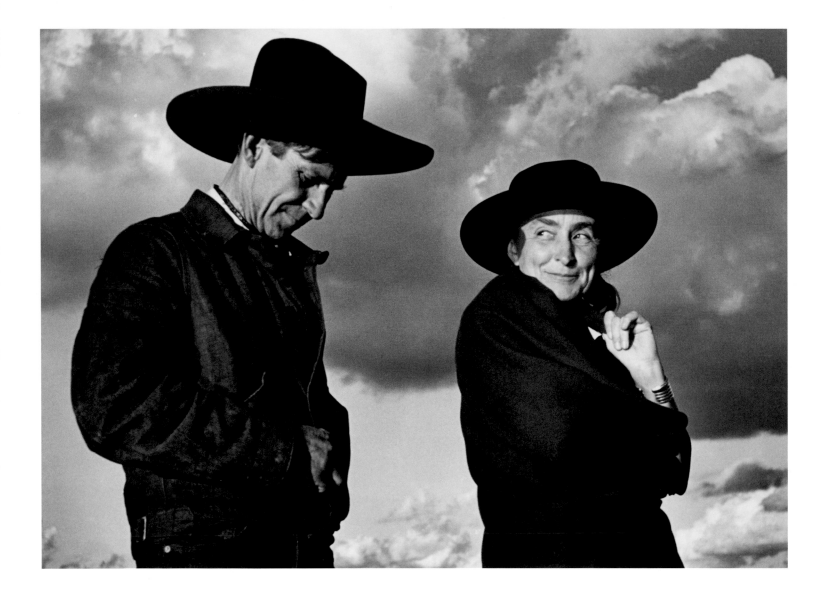

8 Georgia O'Keeffe and Orville Cox, Canyon de Chelly National Monument, Arizona, 1937

BY A MIRACULOUS sequence of circumstances and the kindness of David McAlpin," Ansel wrote in the fall of 1937, "I am in New Mexico with three cameras, a case of films, a big appetite, and a vigorous feeling of accomplishment."[1] He stayed with his friend Georgia O'Keeffe at her Ghost Ranch studio north of Santa Fe. While she painted, he roamed the area photographing.

After several days, McAlpin arrived, along with his cousin Godfrey Rockefeller and his wife, Helen. They planned to make a ten-day tour to Mesa Verde, the Dolores River Canyon in southern Colorado, and Arizona's Canyon de Chelly. O'Keeffe was part of the group and arranged for Orville Cox, senior wrangler at the Ghost Ranch, to act as guide. Ansel was elated to share several of his favorite areas of the Southwest with his friends, and he was particularly pleased that O'Keeffe was a part of the group. "I feel like a six-year-old on Christmas eve!"[2] he wrote McAlpin a few days before the trip began.

Ansel's portrait of O'Keeffe and Cox was made at the rim of Canyon de Chelly. "I was walking around with my Zeiss Contax," he wrote, "and I observed O'Keeffe and Orville Cox in breezy conversation standing on a rock slope above me. They were engaged in a bit of banter. The moment was *now....*"[3]

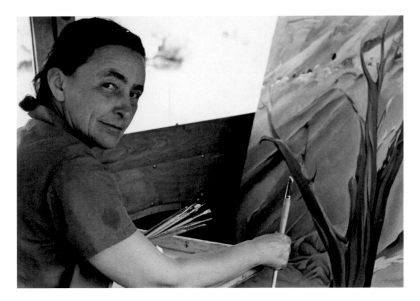

Georgia O'Keeffe painting in the back of her station wagon, near the Ghost Ranch, New Mexico, 1937

In the spring of 1935, Dr. Carl Bauer, the U.S. representative of Carl Zeiss, had presented Ansel with his first 35mm camera, a Zeiss Contax. Filled with enthusiasm for the "miraculous instrument"[4] and excited by the photographic possibilities of the small format, he spent the following summer in the Sierra in what he described as an "orgy" photographing "everything from clouds to water-bubbles, people, mules, rocks, and flowers."[5] When Ansel showed the 35mm camera to Stieglitz even he was seduced: "If I had a camera like that I would close this place up and be out on the streets of the city!"[6]

Georgia O'Keeffe and her "woodie," near the Ghost Ranch, New Mexico, 1937

Ansel with his Zeiss Contax, near Bolinas, California, 1940. Photograph by Nancy Newhall.

That winter *Camera Craft* magazine published Ansel's article on 35mm photography with the title "My First Ten Weeks with a Contax." He wrote, "The camera is for life and for people, the swift and intense moments of existence...,"[7] and his light-hearted photograph of O'Keeffe proves the point. He continued: "In general I favor a tripod-mounted view camera for static subjects that invite contemplation."[8] "This was one special moment requiring the spontaneous capability of my 35mm camera, not the cumbersome and time-consuming setting up of my view camera."[9] "My main aesthetic objective has been to find the 'rightness' of subject in relation to the apparatus; not to imitate the production of larger cameras, but to speak in the specific language of the medium employed, or, rather, in a particular dialect of the language of photography."[10]

Ansel made two exposures, both visible in the contact sheet. In the first, Cox's hat intersects with O'Keeffe's face. "I was standing precariously on a slanting ledge and did not control the horizontal tilt of the camera,"[11] he explained. For the second exposure he knelt down to avoid the overlap. O'Keeffe flirtatiously glances over her shoulder at Cox, who looks shyly down. In the 1970s Cox's daughter wrote Ansel to ask for a copy of the photograph, with the explanation that in a fit of jealousy her mother had destroyed their print!

Unlike the formal portraits that Ansel carefully composed, the photograph of O'Keeffe and Cox was taken on the spur of the moment. When O'Keeffe visited Carmel in 1981, Ansel photographed her with his Nikon F3 35mm camera. He carefully arranged the portrait in front of a display of ferns just outside the front door. Almost blind at age ninety-four, O'Keeffe stared sternly at the camera. Unfortunately the negative for the picture of

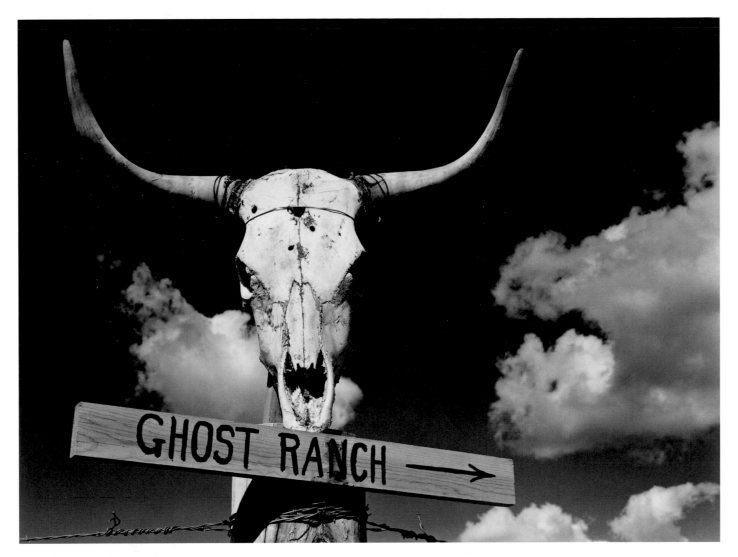

Sign, Ghost Ranch, New Mexico, 1937

O'Keeffe and Cox was badly damaged. The reel of film "slipped out of the clothes-pin on the drying wire, fell to the floor, and was stepped on! The only frame out of the thirty-six that was damaged was this one, by far the best of the roll,"[12] Ansel wrote. The resulting scratches across the center of the picture must be meticulously spotted out in a fine print, a difficult task.

Ansel first met O'Keeffe on a visit to Santa Fe in 1929, when they were guests of Mabel Dodge Lujan, an eccentric heiress who collected both art and artists at her compound. He was thrilled to rub shoulders with the guests and waxed ecstatic about his experiences in letters home. "Georgia O'Keeffe—wife of Stieglitz, and Mrs. Strand, wife of Paul Strand—N.Y. Photographer, are staying here with Lujan's. We have some great conversations,"[13] he wrote to Albert Bender. In the 1930s Ansel also spent time with O'Keeffe and Stieglitz in New York.

O'Keeffe's opinion of Ansel was complex. Stieglitz exhibited Ansel's photographs at An American Place in 1936, and he was thus accepted into the

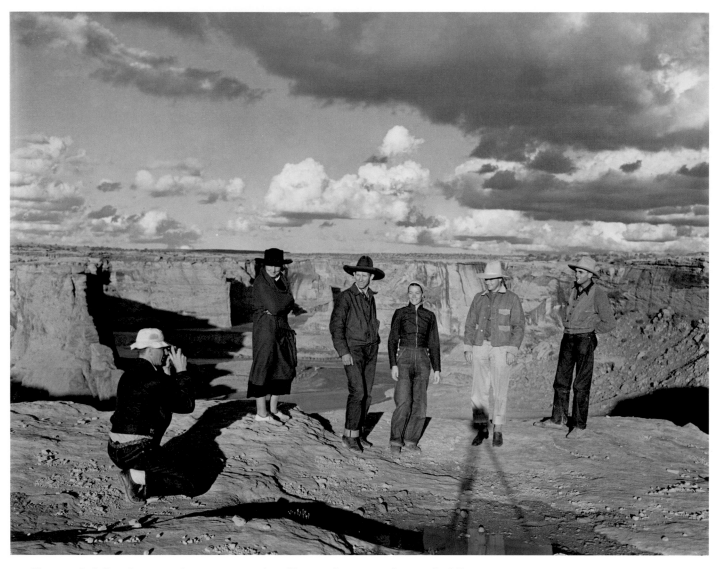

Godfrey Rockefeller photographing Georgia O'Keeffe, Orville Cox, Helen Rockefeller, David McAlpin, and Ansel at the rim of Canyon de Chelly, Arizona, 1937

Stieglitz circle. But O'Keeffe stressed to me that she and Stieglitz felt that Ansel had "sold out" for "the material side of life."[14] They thought he should cease commercial work completely and devote himself to his art. The two older artists were financially independent and had no empathy for the fact that Ansel needed to support a wife and two young children. When his marriage went through difficult times in 1936, Stieglitz and O'Keeffe thought that he should divorce Virginia.

Meanwhile, in the 1940s few galleries showed photographs, and Ansel sold only a few to collectors. In order to make a living he spent a great deal of time on commercial work for businesses like Kodak, AT&T, the American Trust Company, and *Fortune* and *Life* magazines. He traveled all over the country on assignments, yet the money earned was sporadic and insufficient to support the family.

David McAlpin, the cook, Helen and Godfrey Rockefeller, and Georgia O'Keeffe around the campfire on a pack trip in the High Sierra in the summer of 1938. The future Mount Ansel Adams is the highest peak in the distance.

Virginia's income from operating Best's Studio in Yosemite was essential, but even with two incomes life was a struggle financially.

O'Keeffe could be quite sarcastic. Her bantering with Ansel was often tinged with condescension, and she liked to poke fun at him. When they hiked to the distant peak in the Sierra Nevada that would one day become Mount Ansel Adams, she is reputed to have jested, "Oh, *now* I see why you brought us here—just to show off your mountain!"[15] (See page 31.)

Ansel, on the other hand, was in awe of O'Keeffe. Not only was she the wife of his idol, Alfred Stieglitz, but she was also a widely recognized artist. When I worked for Ansel in the 1970s, O'Keeffe came to stay in Carmel on several occasions. I found Ansel overly deferential with O'Keeffe, and I sensed a slight feeling of inferiority

Georgia O'Keeffe, Carmel, California, 1981

on his part. Even in his seventies he felt the need to gain her approval. While she was there, Ansel stuck to his usual routine—an uninterrupted morning in the darkroom followed by lunch and a nap. At dinner he was the genial host. Virginia brought out fine white table linens, with a centerpiece of bright orange nasturtiums as a counterpoint to the set of rare and seldom-used black pottery dishes made by the celebrated Maria Martinez of San Ildefonso Pueblo in New Mexico. In an effort to avoid marring the delicate finish of the plates, Virginia served soft Southwestern dishes that required only a fork.

Ansel's portrait of O'Keeffe and Cox is one of his best, and it is one of the few portraits that he included in his major retrospective at New York's Metropolitan Museum of Art in 1974. The show focused mainly on landscapes, and the critic Hilton Kramer, not one to appreciate nature, tepidly reviewed the exhibition for the *New York Times.* He registered his wholehearted approval of only one photograph: "For myself, the look on the face of Georgia O'Keeffe . . . is worth all the views of Yosemite Valley ever committed to film."[16] Millions disagree.

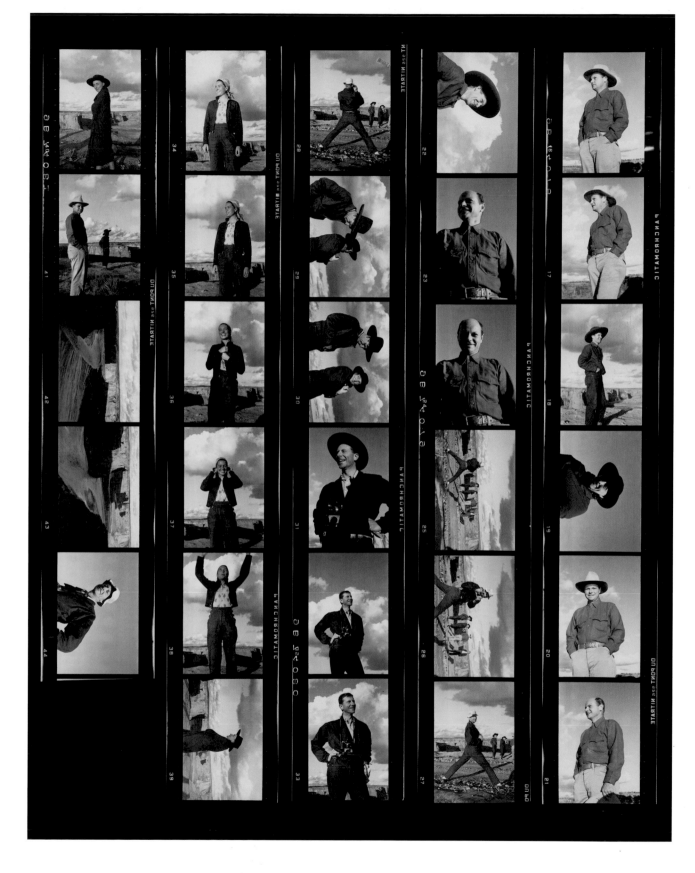

35mm proof sheet of images made at Canyon de Chelly National Monument, Arizona, 1937

9 Clearing Winter Storm, Yosemite National Park, California, c. 1937

"*CLEARING WINTER STORM* came about on an early December day," Ansel wrote. "The storm was first of heavy rain, which turned to snow and began to clear about noon. I drove to the place known as New Inspiration Point, which commands a marvelous vista of Yosemite Valley. I set up my 8 x 10 camera...and waited for the clouds to form."[1]

The spot where Ansel set up his camera, New Inspiration Point, lies on one of the major roads into Yosemite Valley. The road emerges from a tunnel at what Ansel described as "one of the most wonderful viewpoints in the whole world."[2] "Here is the most impressive and probably best known aspect of the Valley, photographed by everyone who ever took his camera with him to Yosemite. Maybe it was here that Ralph Waldo Emerson stood, in 1871, and affirmed that Yosemite was 'the one place that came up to the brag.'"[3] If this was the case, Emerson would have stood a few hundred feet up the slope, at Old Inspiration Point, the spot from which the first white man, Dr. Lafayette Bunnell, viewed the valley in 1851. Bunnell recorded that as he looked at the valley "a peculiar exalted sensation seemed to fill my whole being and I found my eyes in tears of emotion."[4]

Ansel's first view of the valley in June 1916 was also a profound experience: "That first impression of the valley—white water, azaleas, cool fir caverns, tall pines and stolid oaks, cliffs rising to undreamed-of heights, the poignant sounds and smells of the Sierra...was a culmination of experience so intense as to be almost painful. From that day in 1916 my life has been colored and modulated by the great earth-gesture of the Sierra."[5]

Successive rounds of glaciation and erosion created Yosemite Valley. Seven miles long, it is like an enormous Gothic cathedral whose gray granite walls rise straight up to a blue roof. Its perimeter is adorned with natural sculptures visible through the clearing storm in Ansel's photograph: El Capitan on the left; Sentinel Rock and the Three Graces on the right; Half Dome shrouded by clouds in the distance. In the spring the snow in the high country melts and massive amounts of water thunder from the rim to shake the valley floor. On clear nights a lunar rainbow or "moonbow" glows in the mist at the base of Yosemite Falls. No wonder Ansel was enchanted.

Ansel "had visualized for many years an image of Yosemite Valley from Inspiration Point and exposed many sheets of film in an effort to achieve that visualization."[6] His earliest photograph focused on the valley's lush greenery and El Capitan. In an image made several years later Ansel included the sidewalk and the rock retaining wall that bordered the area known as the tunnel esplanade.

Yosemite Valley from Inspiration Point, Clouds, California, c. 1925

A few years later, a clearing December snowstorm offered Ansel the perfect combination of weather and light. On the ground glass of his 8 x 10 inch camera, he "made the essential side and bottom compositional decisions" and "waited for the clouds to form within the top areas of the image."[7] It was a difficult vantage point: "One cannot move more than a hundred feet or so to the left without reaching the edge of the almost perpendicular cliffs above the Merced River. Moving the same distance to the right would interpose a screen of trees or require an impractical position on the road. Moving forward would invite disaster on a very steep slope falling to the east. Moving the camera backward would bring the esplanade and the protective rock wall into the field of view."[8]

Yosemite Valley from Inspiration Point, Yosemite National Park, California, c.1934

He attached a filter to the lens "to remove the atmospheric haze inevitable with landscape subjects several miles or more distant."[9] He considered the negative "fairly strong" with the caveat that "there is no such thing as the ideal or perfect negative." The negative records what Ansel described as a "generally gray situation," yet he "visualized the image as more dramatic."[10] Therefore he needed

to do "a certain amount of dodging and burning" in the darkroom "to achieve the tonal balance"[11] he envisioned.

During my first week working for Ansel, he was printing *Clearing Winter Storm.* One morning he invited me to join him in the darkroom. First he made sure the negative was free of dust. Then he locked it in a negative carrier and inserted it into

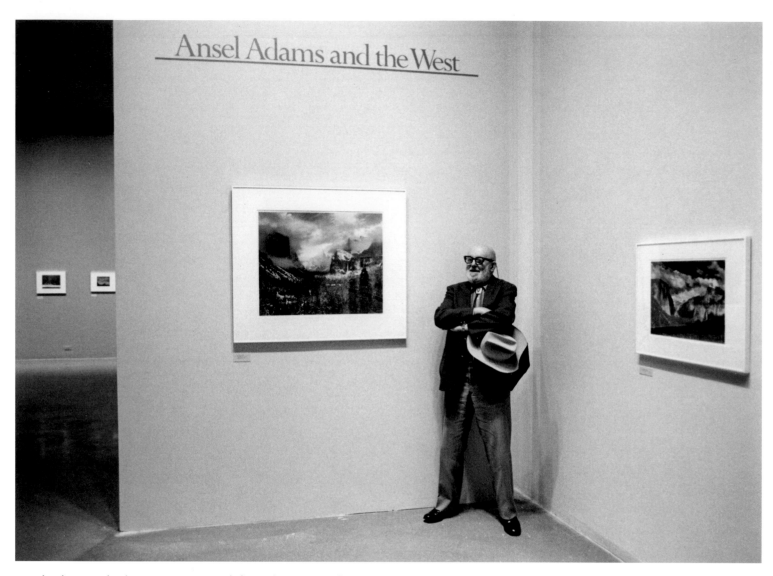

Ansel Adams with *Clearing Winter Storm* (left) and *Yosemite Valley, Summer* in the opening gallery of the exhibition "Ansel Adams and the West," the Museum of Modern Art, September 1979. Photograph by John Sexton.

his custom-built enlarger—a homemade-looking wood and metal contraption that moved on wheels along metal tracks bolted to the cement floor. Next he opened a box of 16 x 20 inch paper, inspected a sheet for defects, and fastened it with magnets to a wall with a metal coating.

With the enlarger lights on, he moved the device back and forth on the tracks while he adjusted the projected image for the desired size and for sharpness. Meanwhile, the room was dim, and you could barely see by the amber safe light.[12] A metronome beeped and water gurgled. Finally, Ansel started what his former photographic assistant John Sexton calls a ballet.

He made one initial ten-second exposure through the negative. During this exposure, Ansel gracefully moved a homemade tool consisting of a cardboard oval attached to a thin wire wand. This

Ansel's darkroom with his enlarger on the left, a piece of photographic paper attached to the movable wall at the back, and sinks for developing and washing prints on the right, Carmel, California, c. 1982. Photograph by John Sexton.

tool would cast a shadow, blocking the light from reaching the light-sensitive emulsion and thus lightening each area that was "dodged" in this manner. Then he would take pieces of mat board—either solid or with holes of various shapes and sizes—to add additional light to areas that needed to be "burned," or darkened.

Ansel smoothly moved the cardboard, exposing different areas to create an interpretation that only he could see in his mind's eye. The key was to execute the dodging and burning in such a manner that the print did not appear to have been manipulated. He was a virtuoso in the darkroom as he extracted great "performances" from his negative

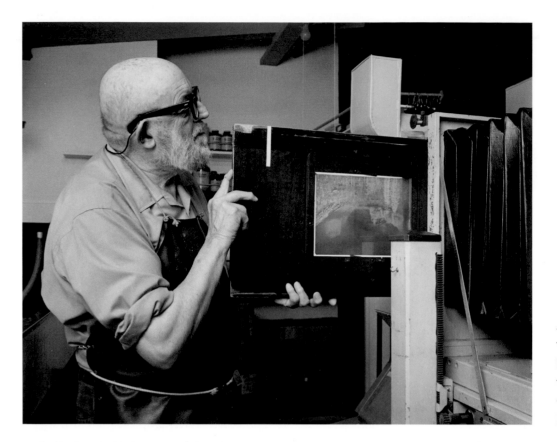

Ansel inserting the negative for *Clearing Winter Storm* into his enlarger (note that the image is upside down), Carmel, California, c. 1982. Photograph by John Sexton.

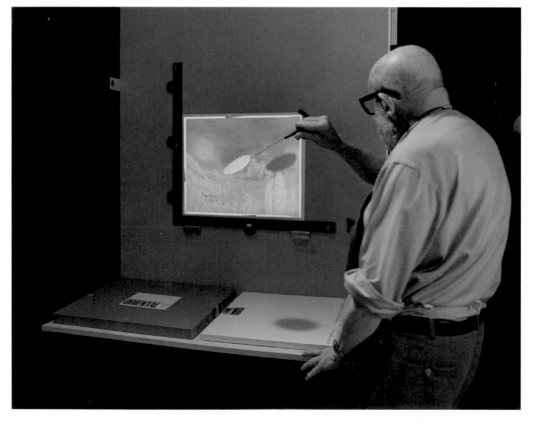

Ansel "dodges" (withholds light to) the cliffs near Bridalveil Fall to lighten the area, Carmel, California, c. 1982. Photograph by John Sexton.

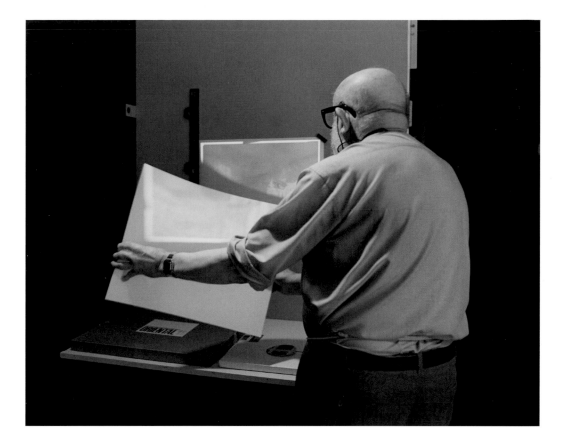

Ansel "burns" (adds light to) the top of the image to darken the sky, Carmel, California, c. 1982. Photograph by John Sexton.

"scores." His choreography was recorded in his chicken-scratch markings and numbers on a diagram, but he seldom referred to it, as if he knew the dance by heart. He repeated this process over and over until there was a stack of prints ready to develop.

Next, Ansel submerged one sheet of exposed paper in a tray of developer. As I watched, *Clearing Winter Storm* miraculously appeared. He repeated the process until every print was developed. When he finally opened the door, I happily returned to the sunshine. Ansel stayed behind. Although he was extremely gregarious, he also enjoyed time alone in his darkroom.

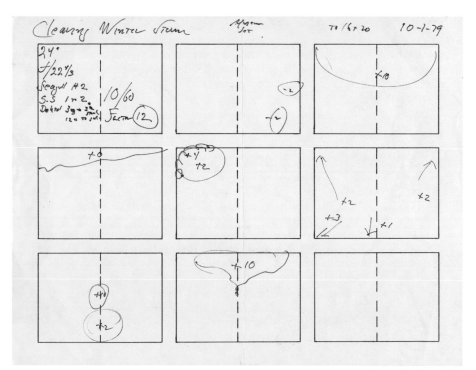

Ansel's printing notes for *Clearing Winter Storm*, dated October 1, 1979

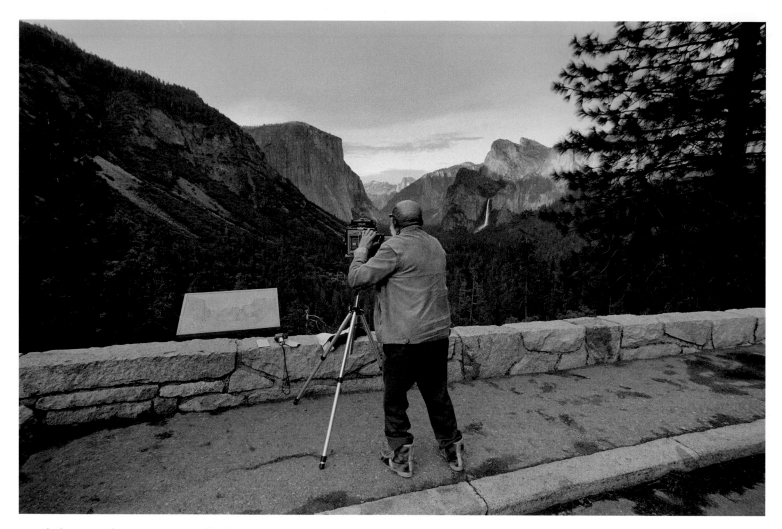

Ansel photographing Yosemite Valley from Inspiration Point, May 9, 1976. Photograph by Alan Ross. (See the image Ansel made on page 227.)

Ansel was not sure what year he stood at the Yosemite Valley overlook and made *Clearing Winter Storm*. He and Virginia moved from San Francisco to Yosemite Valley in the spring of 1937 when she inherited her father's business, Best's Studio. Living in the valley full time provided many opportunities for Ansel to drive to New Inspiration Point. He said that the negative was made on "an early December day,"[13] which could mean a date in December 1937. However, Ansel wrote, "The Yosemite storm is an old negative and went through our fire,"[14] and the fire occurred four months earlier—in July 1937.

There is further confusion: one print that was definitely made in the late 1930s bears a label that says the date of the negative is 1938. Most confusing of all, in his negative log Ansel listed a range of dates: 1935–1940.

In 1933 *Camera Craft* magazine commissioned Ansel to write a series of articles under the title "An Exposition of My Photographic Technique." In the first, "Landscape,"[15] he wrote, "Photographically speaking, landscape is possibly the most difficult subject material to work with."[16] He claimed that the subject of the photograph is of lesser import

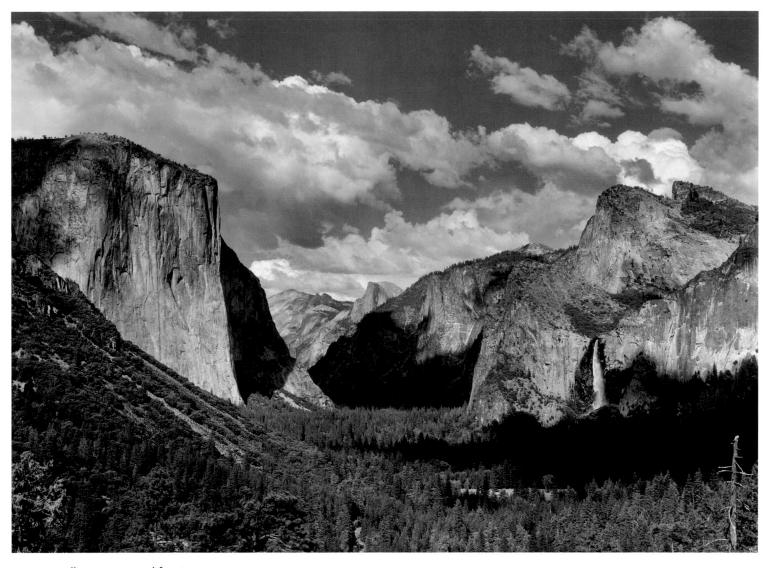

Yosemite Valley, Summer, California, c. 1935

than what the artist creates: "I do not mean that the subject is of no importance; rather, what is done with the subject as an expression of emotional and aesthetic ideas is of vastly greater importance than the mere recording of a scene or of an object."

It is extremely difficult to make a memorable work of art of the iconic view of Yosemite Valley—a view that has been photographed, painted, and sketched by thousands. Ansel's use of black-and-white photography helped set his vision apart. He heightened the drama by photographing during a snowstorm. Finally, he manipulated the print in the darkroom to give the viewer the equivalent of what he saw and felt as he stood there with his camera. The only drawback is that visitors who know Ansel's photographs of Yosemite are sometimes disappointed when they visit the park for the first time!

If you plan to visit Yosemite and photograph the

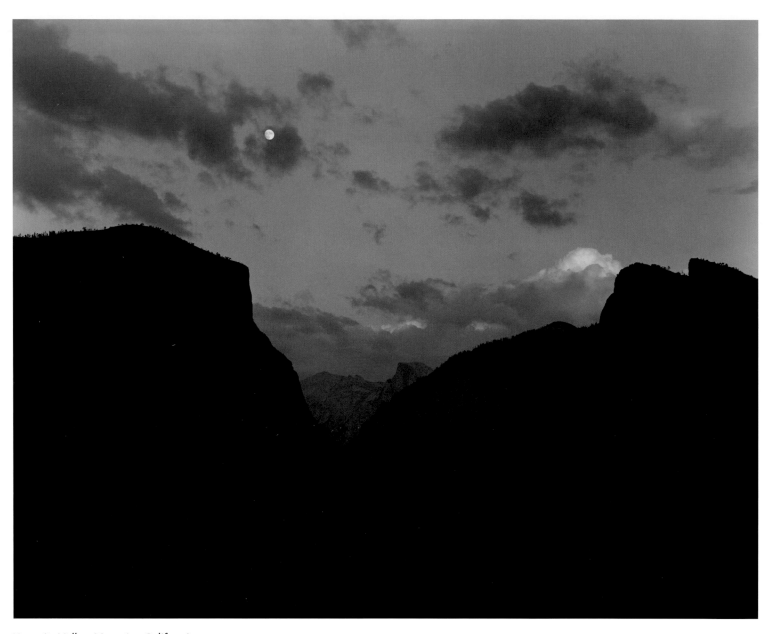

Yosemite Valley, Moonrise, California, 1944

valley from New Inspiration Point, you would do well to heed the advice of the Website yosemite hikes.com. They recommend that you choose a day with "a few fluffy clouds—or better yet a clearing storm that's left trails of fog in the valley and clouds casting patterns of light on the valley walls."[17] They predict that if you follow this advice, your picture will register "a big plus on the Ansel Adams-o-meter." I can hear Ansel laughing.

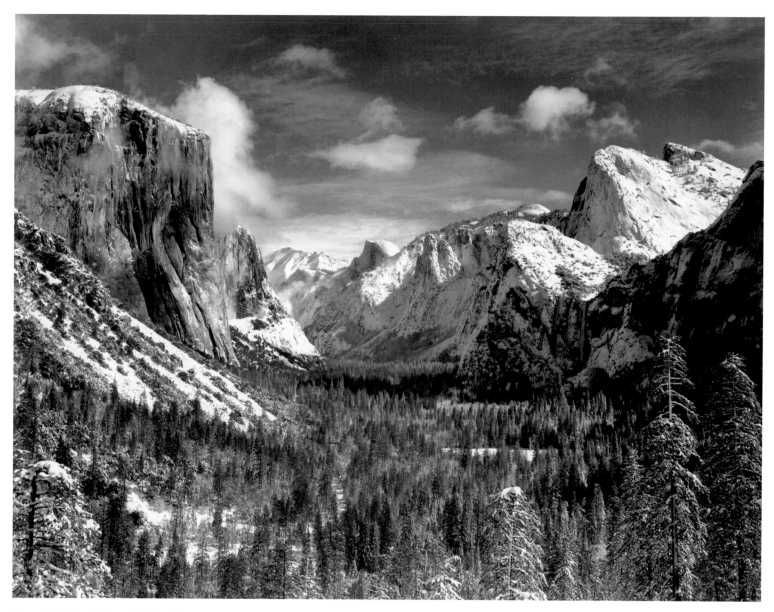

Yosemite Valley, Winter, California, c. 1940

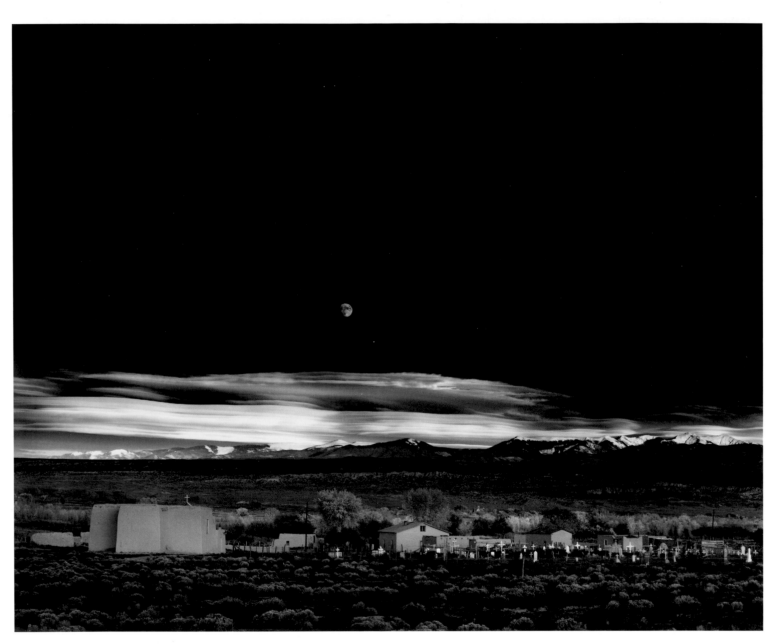

This reproduction is from a particularly beautiful print that Ansel made around 1962. (David H. Arrington Collection, Midland, Texas)

10 Moonrise, Hernandez, New Mexico, 1941

Wᴇ ᴡᴇʀᴇ sᴀɪʟɪɴɢ southward along the highway not far from Espanola when I glanced to the left and saw an extraordinary situation—an inevitable photograph! I almost ditched the car and rushed to set up my 8 x 10 camera. I was yelling to my companions to bring me things from the car as I struggled to change components on my Cooke Triple-Convertible lens. I had a clear visualization of the image I wanted...."[1]

The image was *Moonrise, Hernandez, New Mexico*. Ansel wrote, "I knew it was special when I released the shutter, but I never anticipated what its reception would be over the decades. *Moonrise, Hernandez, New Mexico* is my most well known photograph. I have received more letters about this picture than any other I have made."[2] Ansel sold more than one thousand prints of *Moonrise*—more than any other image, and he personally made every one in his darkroom. There are also literally thousands of reproductions of *Moonrise* in books, calendars, posters, magazines, newspapers, and textbooks. How can we account for the enduring appeal of this photograph? What is the magic it holds for people around the world?

On October 10, 1941, Ansel set off from Yosemite on a photographic trip to the Southwest. He traveled with his eight-year-old son, Michael, and his close friend Cedric Wright. They left with a car full of equipment and proceeded to Zion National Park, the Grand Canyon, and Canyon de Chelly.

Then they drove south toward Santa Fe in the Chama River Valley. Ansel stopped to photograph autumn trees and "struggled with several obdurate subjects, losing in battle to a stump that refused visualization."[3]

As they continued toward the town of Hernandez, Ansel looked to his left and saw the moon rising dramatically above the Truchas Peaks in the Sangre de Cristo Mountains, the "inevitable photograph." The setting sun illuminated white markers in the graveyard of the village's adobe church.

Ansel stopped the car and raced to set up his camera. But he could not find his exposure meter. "Behind me the sun was about to disappear behind the clouds, and I was desperate. I suddenly recalled

Michael Adams, Cedric Wright, and Ansel in Yosemite packing to leave for the Southwest, October 1941. Photograph by Virginia Adams.

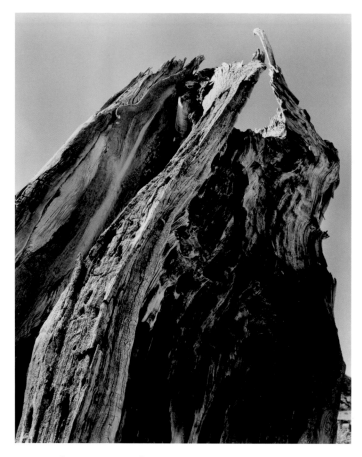

Stump, Chama River Valley, New Mexico, 1941

Stegner, that he estimated "that he had sixty seconds to stop, leap out, set up tripod and camera, guess the place on the brightness scale for which he wanted to expose (it was no guess, it was like knowing twelve times twelve), set shutter and lens, focus and expose"[6] the picture. It was a technical and artistic tour de force that proved one of Ansel's favorite sayings by Louis Pasteur: "Chance favors the prepared mind."

From Hernandez they drove on to Santa Fe (where Ansel had a roll of film developed that included some rare hatless and beardless self-portraits), Carlsbad Caverns, and Saguaro National Park. When they reached San Francisco in late November, Ansel faced the challenge of developing what he knew was an important but difficult negative. In order to handle the extreme contrast range from the dark foreground to the bright clouds and moon, he used water-bath development,[7] but even with this preventive step the negative "was quite difficult to print."[8]

When Ansel made the exposure he "visualized the sky in very deep values and almost cloudless."[9] In the darkroom he intended to darken the sky and eliminate some of the clouds. He wanted to keep some detail in the moon, which was perilously close to an unacceptable "blank white circle."[10] He also likely hoped to reveal detail in the band of white clouds above the mountains. At the same time he wanted to increase the contrast in the foreground so that the white crosses would shine. Small wonder that he described the negative as difficult.

Ansel made a print almost immediately. In it he darkened the sky and left "some random clouds in the upper sky area."[11] There is almost no detail in the moon or the white cloud bank. In the

that the luminance of the moon was 250 candles per square foot. I placed this value on Zone VII of the exposure scale; with the Wratten G (No. 15) deep yellow filter, the exposure was one second at f/32...."[4] After the first exposure I quickly reversed the 8 x 10 film holder to make a duplicate negative, for I instinctively knew I had visualized one of those very important images that seem prone to accident or physical defect, but as I pulled out the slide the sunlight left the crosses and the magical moment was gone forever."[5] In *Moonrise,* as in almost every one of his photographs, sunlight created the magic that compelled Ansel to make a photograph.

Ansel later told a friend, the writer Wallace

Self-portraits, Santa Fe, New Mexico, 1941

foreground there is little differentiation between the bushes, and the white crosses do not gleam.

Ansel worried about the bottom portion of the image. "The shaded foreground was of a very low value. Had I known how low it was I would have given at least 50 percent more exposure...and the foreground would have a slight—but rewarding—increase of density."[12] In 1948 he decided to act: he added contrast to the bottom portion of the negative by patiently dipping it in and out of a dilute solution of Kodak IN-5 intensifier.[13]

When he printed the negative again he was ecstatic: "I think the jinx is broken,"[14] he wrote Nancy Newhall just before Christmas. He sent the Newhalls a print, along with two new books and a copy of his *Portfolio I*. Afterward he wrote, "Do you like the Moonrise print? I think that for the first time I got some feeling of tonal space. Previous prints have been too bleak and cold."[15] Beaumont replied with a postcard in rhyme.

In the late 1970s Ansel's vision of *Moonrise* evolved further. He printed the sky almost solid

We prize the Moonrise
We cheer the Muir
Portfolio One is sure well done
The Negative is positive
Now all we need is ansel here
To usher in a bright New year.

Dec 31 /48

Postcard from Beaumont Newhall to Ansel, December 31, 1948[16]

black, and the rest of the scene—moon, clouds, buildings—is very somber. These late prints have been criticized as overly dark. The Newhalls had raised the issue of dark printing many years before. In February 1953 Nancy Newhall wrote to Ansel:

For the last year or two, it seems to B[eaumont] and me, your prints have been getting darker and darker—proofs of course are just proofs.... And often the fine prints—or at least the finer ones

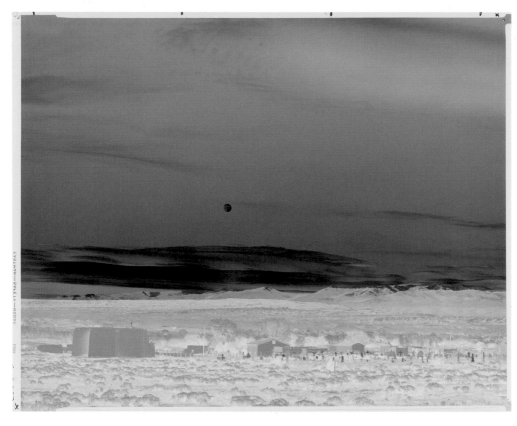

The negative for *Moonrise.* The band of black clouds will print solid white, and the light foreground will print very dark, with little contrast or definition.

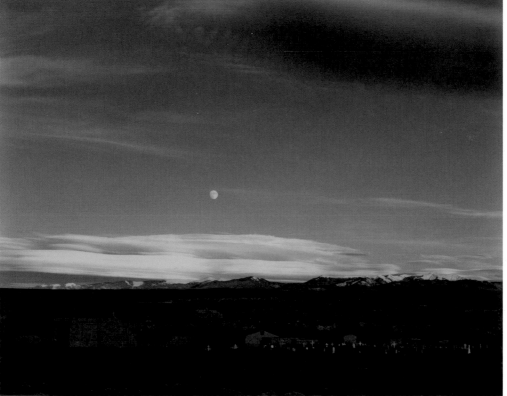

A straight print of *Moonrise* with no darkroom manipulation. Note how light the sky is, how many clouds are visible, and how dark the foreground is, with the white gravestones barely visible.

The earliest known print of *Moonrise,* made in late November or early December 1941. Note the clouds to the left and right of the moon that Ansel would later eliminate completely. (David H. Arrington Collection, Midland, Texas)

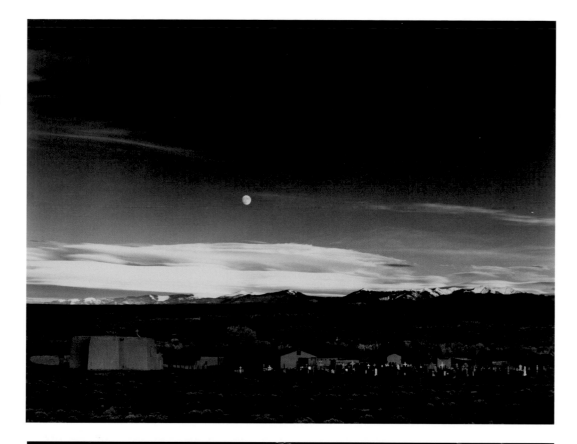

View of Hernandez, New Mexico, 2012, taken a few feet from the same spot where Ansel stood in 1941. The white line represents the edges of Ansel's composition. On his return there in 1980, Ansel said, "I would never stop and photograph that mess today."[17] Photograph by Alan Ross.

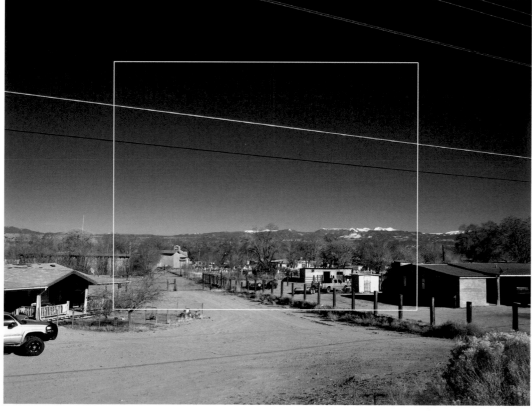

seem overdark too. This seems curious to us; you have the most miraculous sense of light of any photographer! And the earlier prints have such range. Maybe the spectacles? Or the darkroom light? Or the lousy papers? Or maybe you just feel that way and the hell with Newhalls, the old Purists! We would still thrill to an Adams though printed in the very midnight of the soul![18]

There is no record of a reply from Ansel.

Some prints Ansel made in the early 1960s tend to be dark as well, but the change in the late 1970s was more extreme. On more than one occasion I dared (with trepidation) to show Ansel two prints for comparison, one that I considered overly dark made in 1979 and one made a few years earlier. He was displeased and adamantly insisted—even raising his voice, a very rare event—that the print I preferred was "weak," that the prints he was making at the moment were superior, and that he was the artist and therefore knew best.

John Szarkowski, former director of the department of photography at the Museum of Modern Art, characterized this as a natural evolution—from "lyric to epic."[19] But the change was also attributable to Ansel's eyesight. Around 1980 he visited Dr. John McTigue, a renowned eye specialist in Washington, D.C. McTigue informed Ansel that he had cataracts in both eyes and recommended surgery—a relatively straightforward procedure. Ansel refused. But he finally understood that he actually could not see whether the sky in *Moonrise* was the desired darkness. From that time forward Ansel relied on his photographic assistant in the darkroom to ascertain when a print had reached the ideal balance of tones.

During the years I worked for Ansel, one of my Monday morning tasks was to post a list of photographs to print during the coming week. It often included his most popular images, notably *Moonrise*. Not surprisingly, he began to complain that he was tired of printing the same negatives over and over. He stated that he wanted to do two things: make new pictures and cull his thousands of negatives for undiscovered gems that he had never had time to print.

His photographic assistant suggested that Ansel simply stop accepting print orders. This was a difficult concept for Ansel to grasp. He had watched his gentle, beloved father work all his life at a job he did not enjoy in order to support the family and pay off debts from a failed family business. His mother's cold disapproval of his father's lack of success soured family life, and Ansel grew up with a constant fear of not having enough money.

With many conversations and much reassurance, Ansel's business manager, Bill Turnage, convinced Ansel that he could indeed afford to stop accepting orders for prints. In the summer of 1975 he announced that December 31 was the last day anyone—individuals, museums, or galleries—could place an order for a photograph. It was as if a weight had been lifted from his shoulders.

The only problem was the enormous number of orders for prints (over 1,000 prints, of which 320 were for *Moonrise*) that poured in before the December 31 deadline. That backlog obligated Ansel to print "the same old thing" until 1978. When the last orders were finally filled, he embarked on another monumental task: making hundreds of prints (including his most well-known images) for museum sets to be purchased by collectors and donated to museums. These two projects meant that Ansel did not effectively

The print of *Moonrise* that Ansel sent to the Newhalls after he intensified the negative's foreground, December 1948. (Karen and Kevin Kennedy Collection)

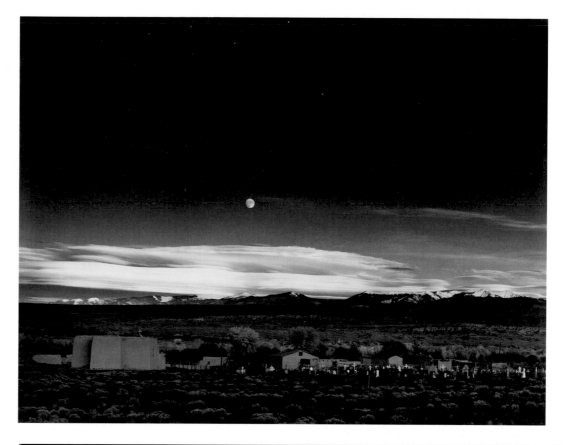

The facade of the church at Hernandez, New Mexico, 1935

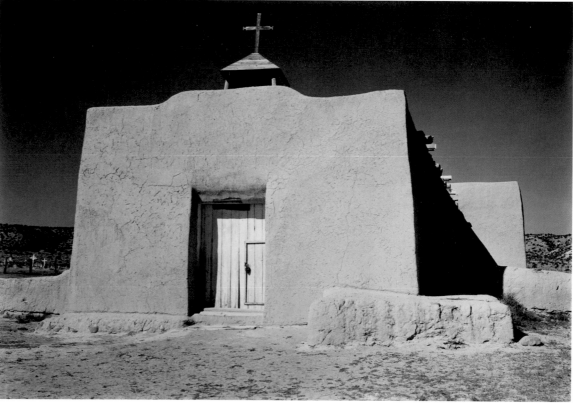

An irreverent note from
Ansel about a print
of *Moonrise* for an old
friend, August 8, 1979

Dear Andreaaska Turnovichska —

It seems that Dr. James Killian of

M.I.T (really a creative VIP) deeply

desires a MOONWIZE OVER HERNIA and it

would be expedient and pleasant for me

to present him with one. A gift, of course

Fr. Adamovici,

escape the darkroom until he was eighty years old. By then he didn't have the energy or drive to make new pictures or spend hours in the darkroom printing "unseen" images.

Ansel sold his first print of *Moonrise* for around twenty-five dollars in 1941. He sold his last in December 1975 for five hundred dollars, but subsequently prices continued to rise at an unbelievable rate. An article in *Art & Auction* in April 1981 discussed the escalation:

> Ansel Adams' *Moonrise, Hernandez, New Mexico,* the best-known image by America's best-known photographer, has become, in recent years, a sort of indicator of the state of the photograph market in general. In November 1979, for example, we reported cheerfully that "a 1978 print of Adams's *Moonrise,*" perhaps the most celebrated image in twentieth-century American photography, sold at Christie's East for $12,000—not only a record for a twentieth-century image sold at auction, but also nearly double the amount paid for a virtually identical *Moonrise* at Christie's in May.

> The implications of Adams sales in particular are important. *Moonrise* sold in 1975 for just $800, in 1972 for around $200. Such dramatic appreciation serves notice of the general strength of the market." In the following issue we wrote, with hyperbole unbounded: "Ansel Adams's *Moonrise* is showing increases that make OPEC's seem tame, the last print as of this writing sold for $15,000, a healthy 25 percent increase since last month's growing rate.[20]

In 1981 a collector paid $71,500 for a mural-sized print (35 x 55 inches). This set a new record for any photograph, and *Art & Auction* wrote that the sale "sent shockwaves through the photography community."[21] The escalation continued until a print made in December 1948 sold at auction in 2006 for $609,600. I expect Ansel would have let out a whoop of euphoria (even though he didn't earn a penny from sales on the secondary market) and disbelief.

There are more than twelve hundred prints of *Moonrise* in existence. When one is offered at

auction or in a gallery it finds a willing buyer. A certain critic for the *New York Times* would not have been among them:

No doubt much of the appeal of this picture lies in its pious sentimentality, with the last rays of sunlight gilding the cemetery's rude crosses. But even this treacly work demonstrates Adams's sophisticated use of modernist form and painstaking craft to accentuate his otherwise romantic imagery. The skies that tower above the village are in effect a giant canvas punctuated by the pale shapes of the moon and a few streaky clouds, the whole image is masterfully printed to wring every bit of emotion from it.[22]

Ansel would not have been surprised by this opinion. He believed that since New Yorkers didn't understand the American West, how could they possibly appreciate a photograph of a scene on a remote road in New Mexico?

Ansel never cared about the dates of his photographs—he thought dates were unimportant. "*Moonrise* is a prime example of my anti-date complex," he wrote. "It has been listed as 1940, 1941, 1942, and even 1944."[23] Beaumont Newhall wanted to find the exact date of *Moonrise*, so he enlisted the help of Dr. David Elmore at the High Altitude Observatory in Boulder, Colorado. "Using data from a visit to the site, analysis of the moon's position in the photograph, and lunar azimuth tables, he determined that the exposure was made at approximately 4:05 p.m. on October 31, 1941,"[24] Ansel wrote in his autobiography.

But Dennis di Cicco spent ten years, made two trips to Hernandez, and crunched the same data with the knowledge that Ansel had placed his tripod not on the current paved road but on the older and slightly lower dirt road in use in 1941. His calculations produced a new, more accurate date and time: November 1, 1941, 4:49:20 p.m. Mountain Standard Time.

Ansel was happy to talk and write about the technical aspects of any image, and he did so for *Moonrise* on many occasions. He also never tired of telling the story of taking the photograph, and anyone who knew Ansel well could relate the entire story almost verbatim. But he refused to "verbalize" (his favorite word) on any photograph: "If the image cannot stand on its own, so to speak, no patina of words will enhance it."[25] I never heard Ansel talk about why *Moonrise* resonated with so many people, and I have found only a handful of his written comments:

"It is a romantic/emotional moment in time."[26]

"The quality of light, it was late in the fall, the quality was extremely beautiful."[27]

"I felt at the time that it was an exceptional image."[28]

He was slightly more forthcoming in an interview in 1980: "People just seem to like" it. When asked why, he replied, "It's so very hard to say." He elaborated that some like the romance of the subject, others like how it's printed "very deeply," others respond to "a certain tragic mood."[29]

Occasionally, Ansel's friends addressed the subject. When the Newhalls received a print for Christmas in 1948, Nancy wrote, "The *Moonrise* print is the only photograph I have ever seen in which one seems to move; the edge and the white mount fall away and one is there under the magic sky."[30] Pulitzer Prize–winning author Wallace Stegner defined it as "a vision translated, a concept realized."[31] At Ansel's memorial service in

1984, Peter Bunnell, the McAlpin Professor of the History of Photography at Princeton University, spoke of the moon's "primal mystery, dramatically isolated in the infinity of darkness."[32] Perhaps Ansel summed it up best in an article for *U.S Camera*:

After all, a photograph is something to look at; it is supposed to convey something to the mind, to the heart, or to both at the same time. If it is a good photograph it will convey its message; if it is a bad photograph it will not. A bad photograph can convey a bald *fact*; a good photograph will give the fact another dimension—*conviction*. A supremely fine photograph will give the fact still another dimension—*universality*.[33]

Writings by Ansel Adams on *Moonrise,* in chronological order:

Moonrise was first reproduced in a double-page spread in *U. S. Camera Annual,* 1943, pages 88–89, along with Ansel's comments:

It was made after sundown, there was a twilight glow on the distant peaks and clouds. The average light values of the foreground were placed on the "U" of the Weston Master meter; apparently the values of the moon and the distant peaks did not lie higher than the "A" of the meter. The white cloud under the moon probably registered a light value about opposite the arrow of the meter. In other words, the values ranged between 1 and 8 (1 and 16 at the most). Extreme development was given this negative, as most of the values were placed within the "foot" of the curve. It is gratifying to note the amount of detail visible on the face of the moon. Had more exposure been given these highlight values would undoubtedly have been lost.

Some may consider this photograph a "tour-de-force" but I think of it as a rather normal photograph of a typical New Mexican landscape. Twilight photography is unfortunately neglected; what may be drab and uninteresting by daylight may assume a magnificent quality and mood in the half-light between sunset and dark. Data: Panatomic X sheet film, developed in Agfa 12. 8 x 10" Agfa view camera equipped with a 26" Cooke lens.

Letter from Ansel Adams to John Penfield, September 7, 1968:

The *Moonrise* was made on Isopan, 8 x 10, G filter, with the 23.5 component of my Cooke Series XV lens. It was some time in the fall and about two days before full moon. I was driving back to Santa Fe from the Chama Valley when I saw this fantastic event. I nearly put the car in the ditch, dashed out, yelling instructions to my companions to attend the tripod, get the camera, etc. The foreground was illuminated by brightly-rimmed clouds in the west (the sun just at the edge of the clouds). I fumbled to get the front component on the back of the shutter, find the gel filter, find the camera-extension piece, etc., and I could not find my exposure meter. I knew the moon was about

250 c/ft² and, placing that on Zone VII, I had the basic exposure of 1/60 at f/8; 3 for the filter gave 1/20 at f/8. I stopped to f/45 and gave 2 seconds. The light faded forever from the foreground as I reinserted the slide! I then figured the foreground brightness (luminance) and it averaged less than 5 c/ft². Water-bath development was indicated and the result is a pretty good negative, but hard to print!

From *The Negative* (Boston: Little, Brown and Company, 1981), page 127:

I came across this extraordinary scene when returning to Santa Fe from an excursion to the Chama Valley. The sun was edging a fast-moving bank of clouds in the west. I set up the 8 x 10 camera as fast as I could while visualizing the image. I had to exchange the front and back elements of my Cooke lens, attaching the 23-inch element in front, with a glass G filter (#15) behind the shutter. I focused and composed the image rapidly at full aperture, but I knew that because of the focus-shift of the single lens component, I had to advance the focus about 3.32 inch when I used f/32. These mechanical processes and the visualization were intuitively accomplished. Then, to my dismay, I could not find my exposure meter! I remembered that the luminance of the moon at that position was about 250 c/ft²; placing this luminance on Zone VII, I could calculate that 60 c/ft² would fall on Zone V. With a film of ASA 64, the exposure would be 1/60 second at f/8. Allowing a 3x exposure factor for the filter, the basic exposure was 1/20 second at f/8, or about one second at f/32, the exposure given.

I had no idea what the foreground values were, but knowing they were quite low, I indicated water-bath development. The distant clouds were at least twice as luminous as the moon itself. The foreground density of the developed negative was about a Value II, and was locally strengthened by intensification in the Kodak IN-5 formula (quite permanent and colorless …). It was of utmost importance to preserve texture in the moon itself. We all have seen the blank white circle that represents the moon in many photographs, primarily caused by gross overexposure.

From *Examples: The Making of 40 Photographs* (Boston: Little, Brown and Company, 1983), pages 41–42:

We were sailing southward along the highway not far from Espanola when I glanced to the left and saw an extraordinary situation—an inevitable photograph! I almost ditched the car and rushed to set up my 8 x 10 camera. I was yelling to my companions to bring me things from the car as I struggled to change components on my Cooke Triple-Convertible lens. I had a clear visualization of the image I wanted, but when the Wratten No. 15 (G) filter and the film holder were in place, I could not find my Weston exposure meter! The situation was desperate: the low sun was trailing the edge of clouds in the west, and shadow would soon dim the white crosses.

I was at a loss with the subject luminance values, and I confess I was thinking of bracketing several exposures, when I suddenly realized I knew the luminance of the moon—250 c/ft². Using the Exposure Formula, I placed this luminance on Zone VII; 60 c/ft² therefore fell on Zone V, and the exposure with the filter factor of 3x was about 1 second at f/32 with ASA 64 film.

I had no idea what the value of the foreground was, but I hoped it barely fell within the exposure scale. Not wanting to take chances, I indicated a water-bath development for the negative.

Realizing as I released the shutter that I had an unusual photograph which deserved a duplicate negative, I swiftly reversed the film holder, but as I pulled the darkslide the light passed from the white crosses; I was a few seconds too late! The lone negative suddenly became precious. When it was safely in my San Francisco darkroom I did a lot of thinking about the water-bath process and the danger of mottling in the sky area as a result of the print's standing in the water without agitation. I decided to use dilute D-23 and ten developer-to-water sequences, 30 seconds in the developer and 2 minutes in the water without agitation for each sequence. By using ten developer-water cycles I minimized the possibility of uneven sky.

The white crosses were on the edge of sunlight and reasonably "safe"; the shaded foreground was of very low value. Had I known how low it was I would have given at least 50 percent more exposure (a half zone). I could then have controlled the value of the moon in development, and the foreground would have a slight—but rewarding—increase of density.

The negative was quite difficult to print; several years later I decided to intensify the foreground to increase contrast. I first re-fixed and washed the negative, then treated the lower section of the image with a dilute solution of Kodak IN-5 intensifier. I immersed the area below the horizon with an in-and-out motion for about 1 minute, then rinsed in water, and repeated about twelve times until I achieved what appeared to be optimum density. Printing was a bit easier thereafter, although it remains a challenge.

There were light clouds in a few areas of the sky, and the clouds under the moon were very bright (two or three times as bright as the moon). I burn-in the foreground a little toward the bottom of the print. I then burn along the line of the mountains, keeping the card edge in constant motion. In addition, I hold the card far enough from the paper to produce a broad penumbra in its shadow; this prevents a distinct dodging or burning line, which would be very distracting. I also burn upward a bit to the moon to lower the values of the white clouds and the comparatively light horizon sky. I then burn from the top of the moon to the top of the image with several up-and-down passages.

It is difficult to make prints from this negative that I truly like; papers differ, toning sometimes gives unwanted density changes, etc. It is safe to say that no two prints are precisely the same.

From *Ansel Adams: An Autobiography* (Boston: Little, Brown and Company, 1985), pages 273–274:

Driving south along the highway, I observed a fantastic scene as we approached the village of Hernandez. In the east, the moon was rising over distant clouds and snowpeaks, and in the west, the late afternoon sun glanced over a south-flowing cloud bank and blazed a brilliant white upon the crosses in the church cemetery. I steered the station wagon into the deep shoulder along the road and jumped out, scrambling to get my equipment together, yelling at Michael

Moonrise in Ansel's living room,
San Francisco, California, c. 1950

and Cedric to "Get this! Get that, for God's sake!
We don't have much time!" With the camera
assembled and the image composed and focused,
I could not find my Weston exposure meter!
Behind me the sun was about to disappear
behind the clouds, and I was desperate. I sud-
denly recalled that the luminance of the moon
was 250 candles per square foot. I placed this
value on Zone VII of the exposure scale; with the
Wratten G (No. 15) deep yellow filter, the expo-
sure was one second at f/32. I had no accurate
reading of the shadow foreground values. After
the first exposure I quickly reversed the 8 x 10 film
holder to make a duplicate negative, but I instinc-
tively knew I had visualized one of those very
important images that seem prone to accident or
physical defect, but as I pulled out the slide the

sunlight left the crosses and the magical moment
was gone forever.

I knew it was special when I released the shut-
ter, but I never anticipated what its reception
would be over the decades. *Moonrise, Hernandez,
New Mexico* is my most well known photograph.
I have received more letters about this picture
than any other I have made, and I must repeat
that *Moonrise* is most certainly not a double
exposure.

During my first years of printing the *Moonrise*
negative, I allowed some random clouds in the
upper sky area to show, although I had visualized
the sky in very deep values and almost cloudless.
It was not until the 1970s that I achieved a print
equal to the original visualization that I still viv-
idly recall.

11 Winter Sunrise, Sierra Nevada, from Lone Pine, California, 1943

IT WAS A DECEMBER morning in 1943, and Ansel felt the chill as he and Virginia sat in their Pontiac station wagon. They were parked near the little town of Lone Pine, just off Highway 395, overlooking a pasture below the breathtaking Sierra Nevada. They sipped hot coffee from a thermos and waited for sunrise. Ansel described the scene:

> I set up my camera on my car platform[1] at what I felt was the best location, overlooking a pasture. It was very cold—perhaps near zero—and I waited, shivering for a shaft of sunlight to flow over the distant trees.[2] A horse grazing in the frosty pasture stood facing away from me with exasperating, stolid persistence. I made several exposures of moments of light and shadow, but the horse was uncooperative, resembling a distant stump. I observed the final shaft of light approaching. At the last moment the horse turned to show its profile, and I made the exposure. Within a minute the entire area was flooded with sunlight and the natural chiaroscuro was gone.[3]

That December Ansel spent more than two weeks photographing at the nearby Manzanar War Relocation Center[4] and had several opportunities to visit this same location in search of the right combination of light and landscape. On his first four visits clouds obscured the view of the mountains. But on the fifth morning, as Ansel later wrote, "I finally encountered a bright, glistening sunrise with light clouds streaming from the southeast and casting swift-moving shadows on the meadow and the dark rolling hills."[5]

Even before Ansel arrived at the turnout off the highway that morning, he visualized the final photograph: a horizontal composition of alternating black and white bands. Raking light would illuminate the foreground meadow and trees; the rolling Alabama Hills darkened by cloud shadow would

Ansel on platform atop his station wagon on the east side of the Sierra Nevada, California, c. 1949. Photograph by Cedric Wright.

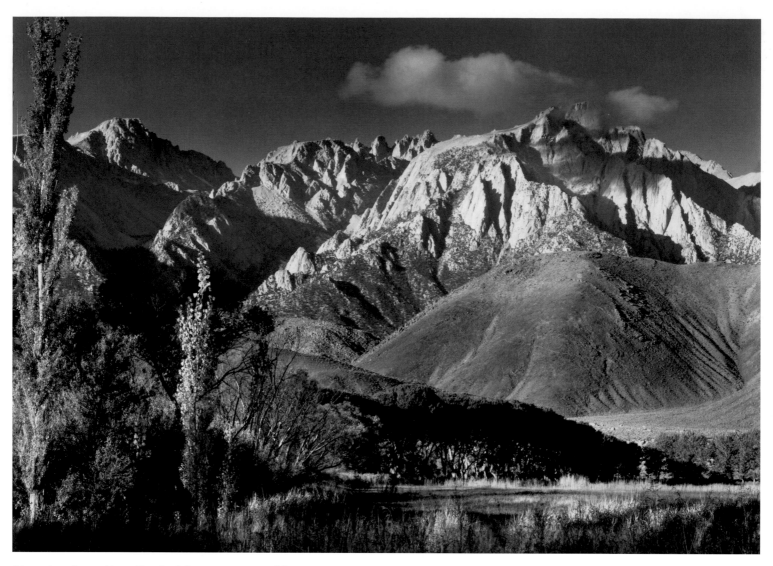

Mount Langley and Lone Pine Peak from Lone Pine, California, 1936

anchor the near distance; the snow-covered peaks of the High Sierra would stand out against the final gray band of sky, punctuated by a few clouds. Mount Whitney, the highest peak in the lower forty-eight states, is on the extreme right, fourteen miles away.

Rising early was the rule when Ansel photographed. Nancy Newhall began her biography of Ansel with the words, "If you work with Ansel Adams, you get up before dawn."[6] On that December morning Ansel and Virginia rose well before dawn in order to drive to the turnout overlooking the pasture and allow enough time to set up the camera before the sun rose. The raking dawn light is the essential ingredient in the photograph, just as it is in so many of Ansel's pictures. In fact, a few years before, Ansel had made a photograph at almost the same spot, but the composition is less successful. Ansel explained, "I made a number of efforts at different times of the day, but did not achieve the desired image, deciding it must be made at sunrise."[7]

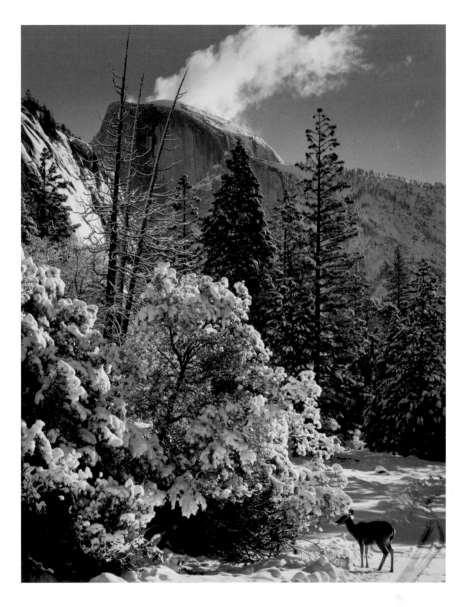

Half Dome, Trees, Deer, Winter, Yosemite Valley, California, 1948

The horse in the foreground was an unexpected bonus. It is actually among a herd, the rest barely visible in the trees on the left. Ansel rarely included animals in his photographs, although there are a few images with deer in Yosemite. On commercial assignments he included people in the landscape, such as the two models with El Capitan in the publicity photograph for the Yosemite Park and Curry Company on page 132. But he felt that animals and humans were a distraction from the natural scene.

The camera Ansel set up was the 8 x 10 inch Ansco view camera he used to make many of his most famous photographs, including *Moonrise, Hernandez, New Mexico* (Chapter 10). He used the same long lens as well, which had the effect of flattening out the scene to emphasize the alternating bands of light and dark.

On his return from a photographic trip, Ansel claimed that even before he unpacked the car he knew which were his best new negatives. He must have realized this negative was important because less than a month later he sent a proof to David

McAlpin, who responded, "The pictures arrived. They are magnificent.... The one from Lone Pine is terrific. If you ever make a fine print of it, I'd like to see if it's any better than the 'Proof Print.' The only possible thing that could be added would be a couple of Indians on the switch-back under the initials.... What do they mean by the way?"[8]

McAlpin referred to the letters that are barely visible on the far left in the Alabama Hills. The students of Lone Pine's high school annually climbed the hills to whitewash rocks that form the school's

initials: *LP*. Ansel considered this an unsightly intrusion, and in the finished prints the letters are spotted out with retouching dye. The spotting was quite difficult and time-consuming. In addition, it often showed. At some point Ansel said to his photographic assistant, Alan Ross, that he wished there were something could be done about it, and in 1976 Alan solved the problem by etching out the initials on the negative. "One evening I just did it," he wrote. "I was afraid to say anything, but the next time Ansel printed it, the deed was obvious.

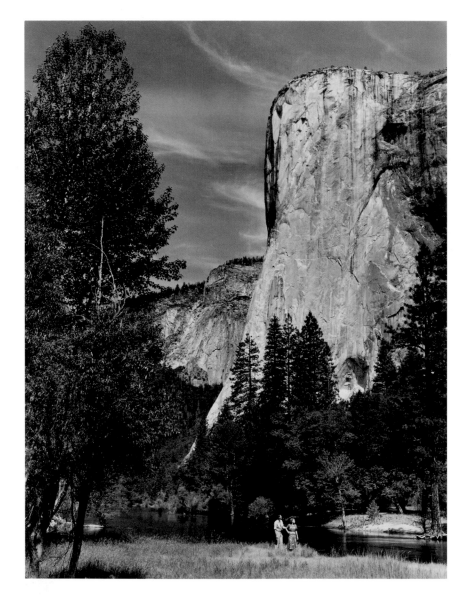

Models with El Capitan, Yosemite Valley, California, c. 1936. This is a promotional photograph for the Yosemite Park and Curry Company. (David H. Arrington Collection, Midland, Texas)

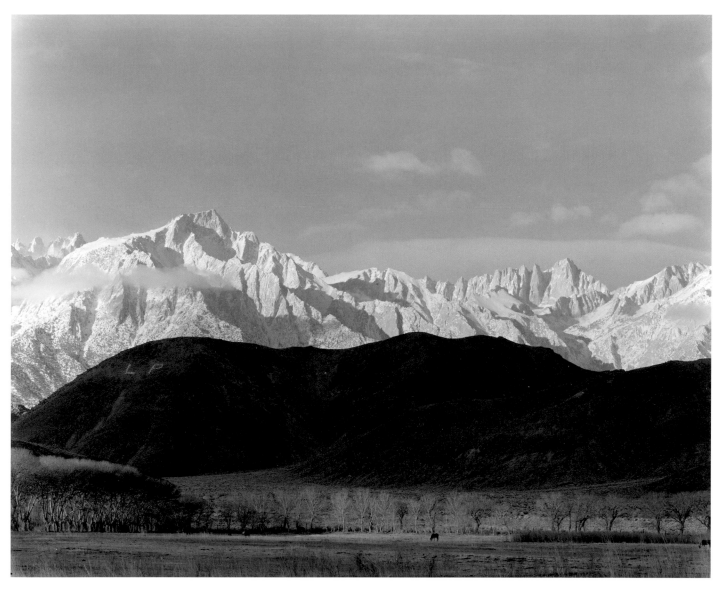

An uncropped print without manipulation in the darkroom. Note the "LP" on the hill to the left.

Fortunately all he could think to say was 'good job.'"[9]

Clicking the shutter was one step in a long process for Ansel. Fellow photographer Henri Cartier-Bresson felt that his goal was accomplished once he made the negative, and most of his photographs were printed by others. For Ansel, the process began with his initial "visualization" of the final photograph as he composed in the camera. It ended only when he made the optimal print in the darkroom—and he *always* printed his own negatives. He spoke highly of Cartier-Bresson's images while decrying the quality of his photographic prints, and I occasionally heard him lament, "If only I could print Cartier's negatives for him."[10]

To see Ansel's changes, compare the full frame "straight" print (uncropped and without darkroom manipulation) with the finished print. Ansel wanted

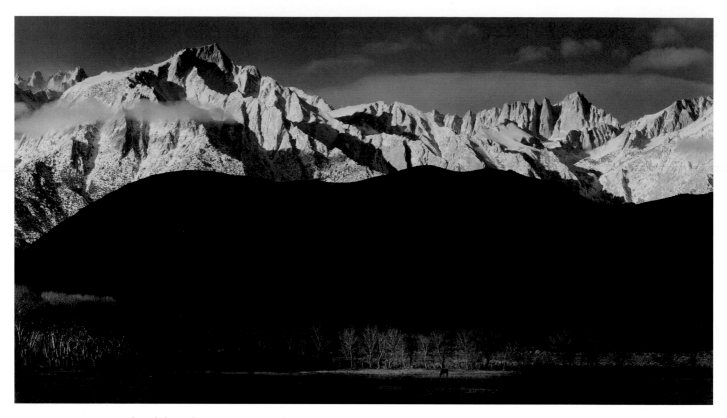

Winter Sunrise cropped with less sky, c. 1955 (David H. Arrington Collection, Midland, Texas)

the pool of light on the horse to be strong but not harsh. He wanted the snowy peaks to form a bold white band with enough shadows to provide definition. In the middle ground he wanted the Alabama Hills to be a dark line, but he was careful to keep some detail in the contours. Finally, although he used a filter to darken the sky when he exposed the negative, he intentionally darkened it even further in printing.

In general, Ansel printed images darker as he aged, and a print he made at the end of his career in the late 1970s and/or early 1980s was often quite different from a print he had made in the 1940s (for a fuller description of this evolution see Chapter 10). For instance, in late prints of *Winter Sunrise* the Alabama Hills are more solidly black; the snow on the Sierra is not as bright; the rays of light in

the foreground are weaker. This is not a mechanical decision. It is an intuitive and emotional choice on the part of the artist—the same sort of choice a painter might make.

The vast majority of the prints Ansel made of *Winter Sunrise* during his long career were printed on 16 x 20 inch paper. But his large-format negatives[11] can support greater enlargement without becoming grainy or fuzzy, and he made prints of *Winter Sunrise* that measure 40 x 60 inches and more. When I worked for Ansel, one of these so-called mural prints hung outside the door to the darkroom. These prints are rare and desirable, and one of *Winter Sunrise* sold at auction in 2010 for $482,500.

Although Ansel carefully composed an image in the camera, the final print often needed cropping. He typically eliminated details that he considered

Winter Sunrise in Ansel's workroom, Carmel, California, c. 1982. Photograph by John Sexton.

distracting. In *Winter Sunrise* he eliminated the horse on the extreme far right, the shadowed rocks about a third of the way up the left-hand margin, and more than an inch of sky off the top.

I was shocked the first time I saw him crop a print. Standing at the paper cutter in his workroom (visible to the left of the two dry mounting presses shown here), he unceremoniously and loudly whacked off slivers of the photograph, gradually rotating the paper until he had achieved the desired effect. In general, his cropping was remarkably consistent, and this image was no exception. However, in a few early prints he cropped more off the top of the sky and thus changed the dynamics of the composition.

In 1966 Ansel gave a print of *Winter Sunrise* to his good friend Wallace Stegner. Years later Stegner wrote, "I have looked at it, studied it, scores of times, and every time I do so it lifts me. It is like hearing the choral movement of Beethoven's Ninth. Once again darkness has been overtaken by light, as if an earth-promise were being kept."[12] Like so many of Ansel's photographs, *Winter Sunrise* depended on Ansel being in the right place at the right time. He summed it up: "Another cup of coffee that cold morning—and that cloud shadow would have moved off the Alabama Hills. There might still have been a beautiful image, but it would have said something else. Sometimes I think I do get to places just when God's ready to have somebody click the shutter!"[13]

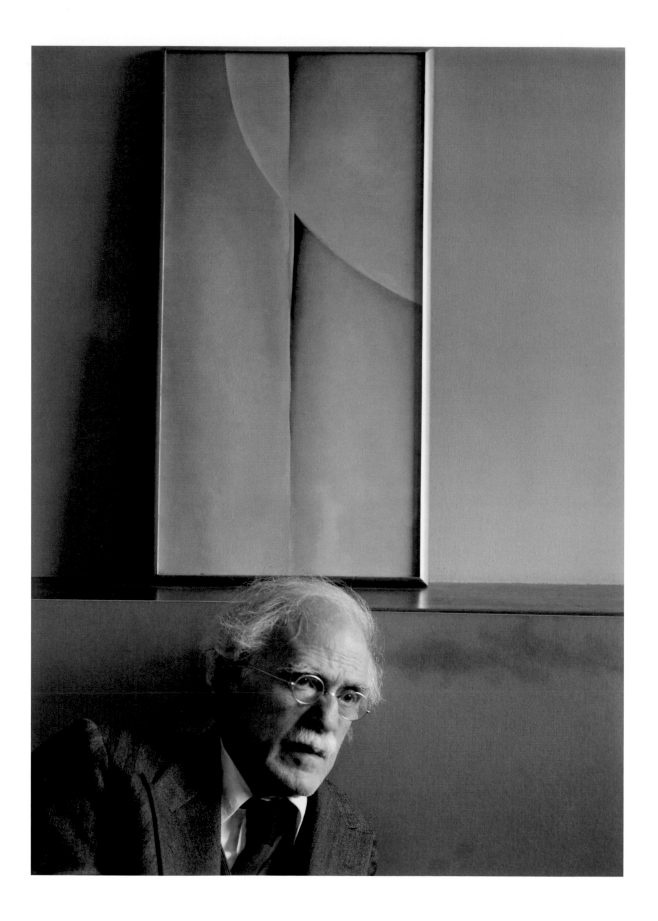

12 Alfred Stieglitz and a Painting by Georgia O'Keeffe, New York, New York, 1944

ON JUNE 4, 1944, Rome fell to the Allied forces, followed two days later by the D-day invasion of Normandy. Ansel was in New York with Nancy Newhall. She described the momentous time in a letter to her husband, Beaumont, who was serving with the U.S. Army: "The fall of Rome Sunday made us all jubilant. The news of the invasion, so long awaited, is like a jolt in the solar plexus.... The stores shut at midday, so people could go to church. There was a strange mood in the streets—a drifting crowd in working clothes, eddying about the cathedrals. A grim holiday."[1] Deeply moved, Nancy and Ansel headed to Stieglitz's gallery, An American Place. Nancy wrote Beaumont that after they cheered Stieglitz out of

his habitual gloom, "Ansel photo'd like mad. Got at least one beauty, which I saw thru the ground glass, of Stieglitz & the O'K he loves best. He took some of St. and me for you."[2]

In the small room that served as his office, Stieglitz reclined on a daybed and talked with Nancy while Ansel photographed. *Line and Curve*, the painting by O'Keeffe that was Stieglitz's favorite, was propped behind his head on a shelf, along with a torso by Gaston Lachaise and a painting by John Marin. Burlap-covered boards shielded books and paintings stored below.

Ansel photographed Stieglitz many times. A portrait he made with his 35mm Zeiss Contax was special, he wrote, because "It happens to be one

Letter from Nancy Newhall to Beaumont Newhall, June 7, 1944.
Nancy sketched the portrait of Stieglitz with the O'Keeffe painting.

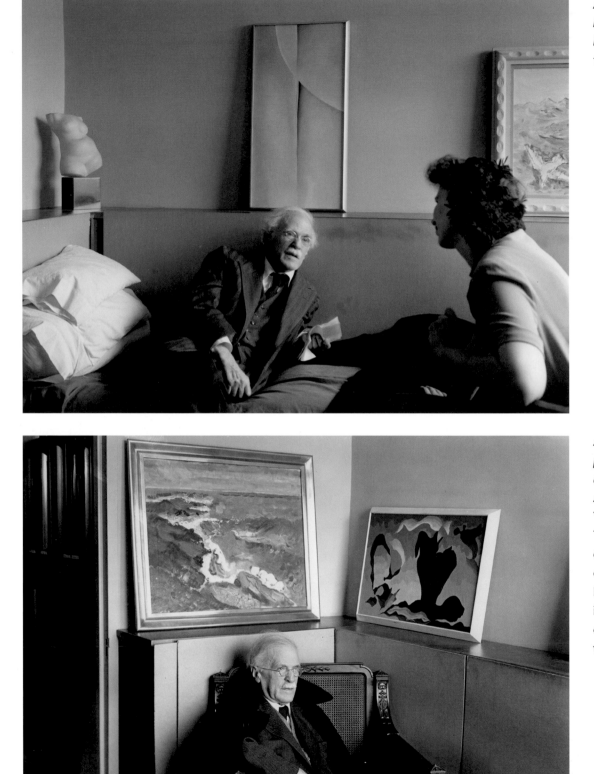

Alfred Stieglitz and Nancy Newhall at An American Place, New York City, 1944

Alfred Stieglitz, with paintings by John Marin and Arthur Dove, An American Place, New York City, c. 1939. This composition also exists as a 5 x 7 inch color transparency. Remarkably, the color is still in near-perfect condition according to John Sexton.

of the rare images of Stieg-litz smiling."[3] But the portrait with the O'Keeffe painting was his favorite.

Ansel met Stieglitz in 1933 on his first visit to New York. He recalled, "I went to New York to make my fortune. Albert Bender thought it was about time I entered a larger world, and we agreed.... I set a priority to meet Stieg-litz and get it over with as I had heard he was a tough customer to be with—he was *especially* opinionated...."[4] Bender described Stieglitz as "an intellectual talking machine, but nevertheless... the chief man in America to have raised photography to a high plane."[5] Ansel's fellow photographer Imogen Cunn-ingham advised, "Don't fail to see him."[6]

Ansel and Virginia's cross-country train trip was inter-rupted by a two-week stay in Santa Fe. They were stranded when their traveler's checks could not be redeemed because of a bank holiday decreed by President Frank-lin Roosevelt. They finally reached New York City in April. Ansel loved to tell how he walked in the rain past

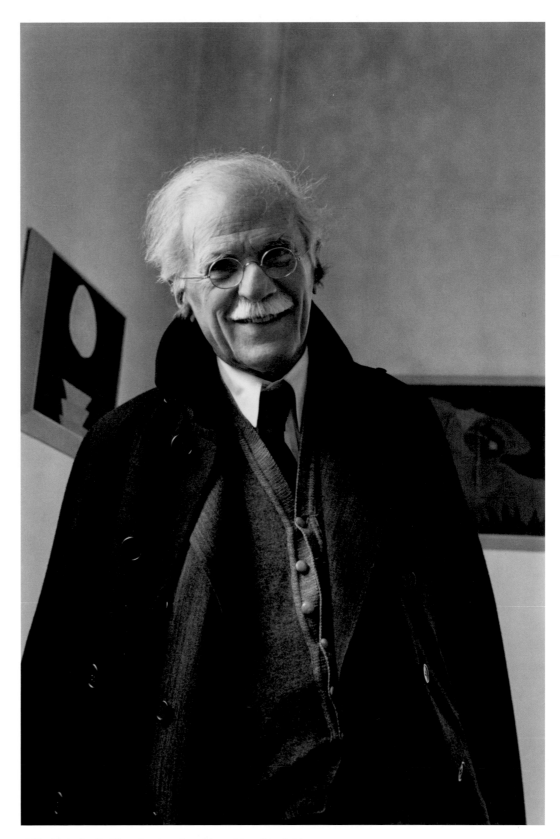

Alfred Stieglitz Smiling, An American Place, New York City, c. 1939

Sun and Clouds, unique Polaroid Type 52 print, 1969 (Collection of Susan Mikula)

time. I want to compliment you."[7]

Ansel admitted that before his trip to New York his exposure to serious art was "pretty thin."[8] He had seen paintings and sculpture at the Panama-Pacific International Exposition in 1915, but he left little comment on the experience. Although he was part of the "bohemian" musical and artistic scene in San Francisco in the 1930s, he described the city as "sort of high-and-dry isolation."[9] He had met some of Stieglitz's circle of artists on visits to the Southwest in 1929 and 1930, but meeting Stieglitz in person was a watershed moment in his life.

From that first meeting Ansel became Stieglitz's devoted friend and follower. He believed that Stieglitz was one of the greatest photographers of the twentieth century. He was inspired by and often repeated Stieglitz's mantra: "I go out into the world. I take a photograph. I give it to you as the equivalent of what I saw and felt." Among Stieglitz's seminal photographs was a series of small cloud studies entitled *Equivalents.* In 1969, Ansel used a Polaroid camera to make his own equivalent.

Ansel also greatly admired Stieglitz's role as a champion of modern artists and his fight for the recognition of photography as a fine art. Whenever Ansel was in New York, he made a beeline for Stieglitz's gallery, and they carried on an intermittent correspondence as long as Stieglitz was alive. Ansel wrote Stieglitz, "My visits with you at An American Place remain my greatest experiences in art—they opened wide and clear horizons."[10] At The Place he saw the work of some of the most important American artists of the early twentieth century, including Arthur Dove, Marsden Hartley, Georgia O'Keeffe, and Paul Strand, as well as John Marin, whose work he had already seen in the

piles of garbage to the Madison Avenue office building where Stieglitz's gallery, An American Place, was located.

When he entered with his package of photographs, a copy of *Taos Pueblo,* and a letter of introduction, Stieglitz imperiously waved him aside and ordered him to come back that afternoon. Ansel, annoyed and abashed, was persuaded by Virginia—with some difficulty—to return. Ansel recalled that Stieglitz looked through his photographs once, twice, and then pronounced, "That's about the finest photography I've seen in a long

Southwest and described as "a revelation."[11]

Ansel and Stieglitz were almost exact opposites. Stieglitz was the son of German immigrants. Ansel was a third-generation Californian. Stieglitz was difficult, opinionated, irascible, and often morose. Ansel was sweet, kind, and considerate—and the proverbial life of the party. Stieglitz felt no compunction about saying no to a collector who was deemed unworthy to buy a painting, or to a museum or gallery that wanted to borrow his photographs. Ansel, on the other hand, had a tremendous need to be liked and hated to disappoint anyone. He sent exhibitions of his work to galleries and museums all over the world. If you called ahead and made an appointment, you were welcome to join him in his Carmel home for cocktails at 5:00 p.m.

Once I overheard Ansel on the telephone: "Yes, how kind of you. Of course I would like to visit Cleveland and meet you and speak to your group." Immediately afterward he rather sheepishly asked me to call back and rescind his offer; he had been unable to say no. What united personalities as different as Stieglitz and Ansel was their belief in contemporary American art, their fight for the recognition of photography as a fine art, their mutual admiration for each other's work, and their shared nobility of spirit.

On a visit in 1939, Ansel photographed The Place. He was so elated by the results that he thought they might form "the nucleus of a book."[12] He photographed there again in 1945: the office, galleries, architectural details (windows, light fixtures, doorways), storeroom, paintings by the gallery's artists, and many pictures of Stieglitz. Ansel caught him standing in a corner of an empty gallery and recalled that he bantered, "I know just

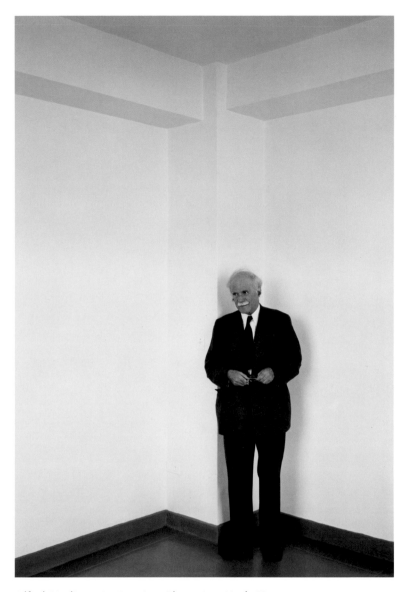

Alfred Stieglitz at An American Place, New York City, 1939

what you're getting. That baseboard is very interesting, isn't it? I hope you didn't hide a corner with my ankles."[13] Ansel sent a set of his photographs to Stieglitz, who wrote Nancy Newhall: "How beautiful they are. The tenderness—loveliness—pure feeling. I think Adams has struck a new note.... And the portrait of me with the O'Keeffe how fine. Subtle. Strong. Real Portraiture."[14]

Stieglitz died in 1946. Two years later Ansel published *Portfolio I,*[15] a collection of twelve original

Painting of a sunflower by Georgia O'Keeffe, in the storeroom, An American Place, New York City, 1945

photographs. He dedicated it to Alfred Stieglitz and explained in a letter to Nancy, "Every one of the images was selected because of some appropriate relationship in mood to some aspect of Stieglitz in relation to Adams."[16]

The portfolio features only one landscape, a view of Mount McKinley (see Chapter 16). In general, the photographs are quiet and almost ordinary in their subject matter: a vine and rock in Hawaii, ferns and flowers in the rain by a trailside in Alaska, a white church and fence, clouds above a canyon in Death Valley, a saguaro cactus at sunrise. He also included one portrait: "that very appealing picture I have of Stieglitz writing, seen through

View out the window looking north, An American Place, New York City, 1945

the doorway of the Place." "It's a swell picture; has never been well printed before, and would give a deep human touch to the set,"[17] he wrote Nancy.

The year he died Stieglitz wrote: "Adams, as I know him personally and through his works, is one of those rare spirits who has the combination of great gifts and an unquestioned integrity in whatever he does. This is not a eulogy—this is a statement of facts according to my own lights."[18] He also said, "I like Adams' work for it doesn't pretend to be anything that it isn't. It's honest photography."[19]

After his death O'Keeffe gave her painting *Line*

Ceiling light fixture, An American Place, New York City, 1944

Alfred Stieglitz at his desk, An American Place, New York City, 1939

and Curve (1927), to the National Gallery of Art in Washington, D.C. She sent Ansel a photograph by Stieglitz, *From My Window at the Shelton, North*, 1931. It was one of Ansel's proudest possessions, and in 1974 he presented it to the Princeton University Museum of Art in honor of Ansel's and Stieglitz's mutual friend David McAlpin. O'Keeffe also sent to Ansel a Double Protar lens that he had convinced Zeiss to give Stieglitz in 1936. Ansel considered it "the best in the world," which made it worthy of Stieglitz.

Ansel eloquently described his allegiance to Stieglitz in a letter to Beaumont Newhall:

> Stieglitz gave me my first fine presentation. Of all photographers, he is the one with which I am most in sympathy, and the one I respect most highly. His support of my work is the greatest compliment I could ever receive, and it has stimulated and encouraged me beyond anything else.... In a very definite sense Stieglitz *is* photography; he has anticipated almost every contemporary phase, and what we are doing today, and the reception of photography as a powerful art-form, is built upon the dynamic integrity and insistent courage of Alfred Stieglitz.[20]

From My Window at the Shelton, North, New York City, 1931. Photograph by Alfred Stieglitz. (Collection of The Princeton University Art Museum, Gift of Ansel Adams in memory of David Hunter McAlpin, Class of 1920)

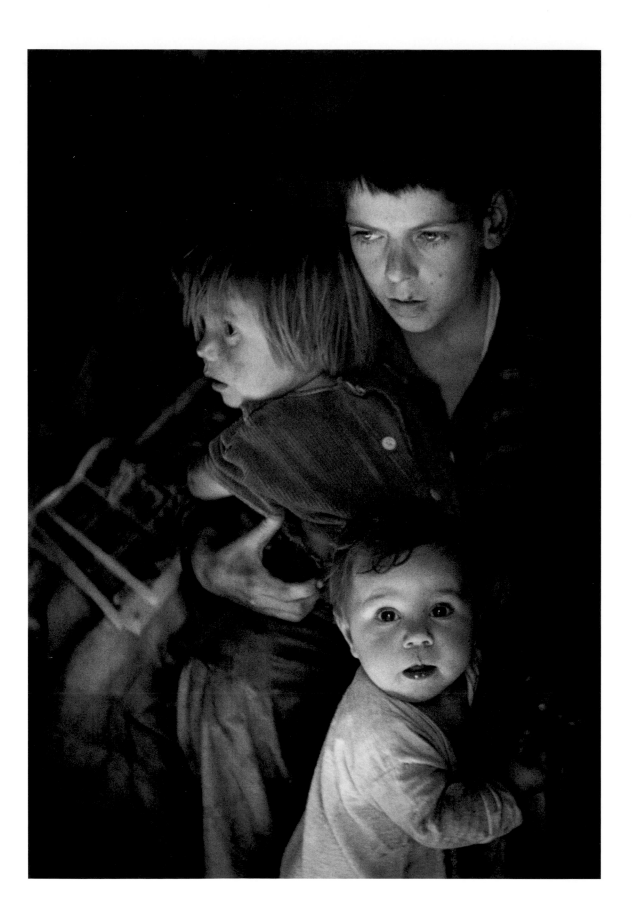

13 Trailer-Camp Children, Richmond, California, 1944

IN 1944 *Fortune* magazine commissioned Ansel and his friend Dorothea Lange to photograph the shipyards in Richmond, California, an important hub of wartime ship building for the U.S. Navy. As they walked through the shipyard they came upon a distressing scene of three children sitting in the open door of their family's shack. Lange challenged Ansel to take their picture. He felt his large 8 x 10 inch camera would be intrusive, and Dorothea loaned him her considerably smaller twin-lens Rolleiflex. A friend of Dorothea's accompanied them and wrote this description of the scene:

> Children of shipyard workers. Four grown-ups and two children live in a one room cabin (man, wife, 19, and two boarders). Came from midwest two weeks ago. The older child is clothed in a corduroy slack outfit with so many buttons missing you know for sure there is neither pants nor shirt underneath it. It is December 1944, and windy. The children are being watched by a neighbor child while the mother is away.
>
> The cabin is about the size of a one-car garage inside. It contains a bed and a sagging wine-colored couch of the type that opens into a bed; an empty jug and three suitcases under the bed; a half of a banana peel and some paper bags; a carton of piled cloths; a shipyard tin hat; a comic book; a mixture of dirty blankets and quilts; no sheets; flies; one pair of men's steel-toe shoes… small table covered with five plates, an open can of condensed milk, one broken cup, and an open cocoa can; under the table, a dirty washbasin full of water, a tea kettle, a broom and a mop; a coffee pot on the stove; an egg carton empty of eggs but full of their shells….[1]

Dorothea needed her camera back, and Ansel had time to make only one negative. He characterized it as "difficult" to print and explained, "I was fortunate to get any negative (or acceptable print) at all!"[2] The lighting was "very uneven,"[3] and he thought Dorothea's lens was probably covered with dust. In spite of these technical challenges, the image is lauded for its tender pathos and diaphanous light.

Fortune chose not to reproduce the photograph in their upbeat article about cities transformed by wartime growth. The image is an anomaly in Ansel's work. Human misery was not something he felt comfortable photographing, and he described the photograph as "quite a departure from my usual run of work."[4] Lange, on the other hand, was an experienced documentary photographer who was skilled in recording such scenes.

All his life Ansel made photographs of people,

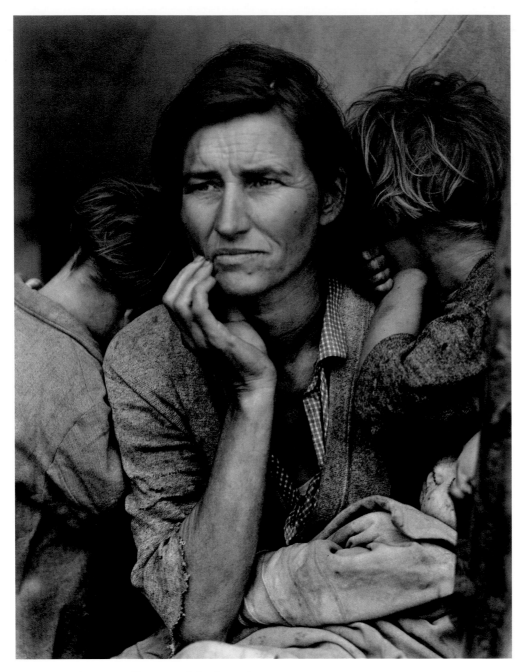

Migrant Mother, 1936. Photograph by Dorothea Lange.

but the world has not been kind to them. Margery Mann wrote of an exhibit in 1971: "I don't know who said it first. I know I didn't, and I'm sorry, but someone once said that Adams photographed rocks as if they were people, and people as if they were rocks, and the current show adds nothing to Adams' reputation as portrait photographer."[5] What Ansel had written was, "I photograph heads as I would photograph sculpture,"[6] but Mann certainly has a point.

Even his close friend Wallace Stegner, in a foreword to a book of Ansel's photographs, wrote: "Though some of the portraits do speak to us like church-bells, they are a kind of photography that others have done just as well, and there is a degree of truth in the generalization that Adams is less successful with people than with Nature."[7] Ansel was loath to accept this criticism and protested, "I wish you could see a few more of my portraits before 'Great Stone Facing' me. The 'candid' portrait (which most people think of now as 'portraiture') is, to me, representative of just a 'slice' of personality."[8]

In the early days of his photographic career Ansel needed the income from portrait

commissions, but he complained that "few individuals are content to be recorded as they actually are." After one particularly difficult portrait session in 1933, he let off steam to Alfred Stieglitz in "a manifesto in the form of a grouch":

> A man who owns 3,000,000 $s and has a Responsible Position in the Community tells me he likes my pictures and wants a portrait—tells me he wants me to avoid making his head look like a species of fruit—tells me to show only one ear—tells me to be sure and make him look at the camera—tells me, moreover, he understands ART........and I am a big enough jackass to try it, needing the cash........then he disn't [sic] like it....... then I tell him for God's sake how can I get him to look at the camera and not show his two ears when he won't turn his eyes sidewise......and he says never mind I don't know my business.....and I say Right!! I don't know that part of it......and he sails out like a clipper ship in a rip tide (and I hope he flounders on a good muddy oyster-bed) and I am left Alone kicking myself in the pants every time I remember that I tried to make that picture, which was just a collapse of moral stamina. Hell!!![9]

For portraits, Ansel believed that he "should work close to the subject."[10] He also preferred "to do large heads" against an "even-toned black screen."[11] His photograph of actress Carolyn Anspacher made in 1932 is characteristic of the many portraits he made in the early 1930s. He described Carolyn as "tall, strikingly handsome, and immensely gifted,"[12] but her portrait was almost universally disliked. "It was called 'The Great Stone Face' and was thought by some to be a picture

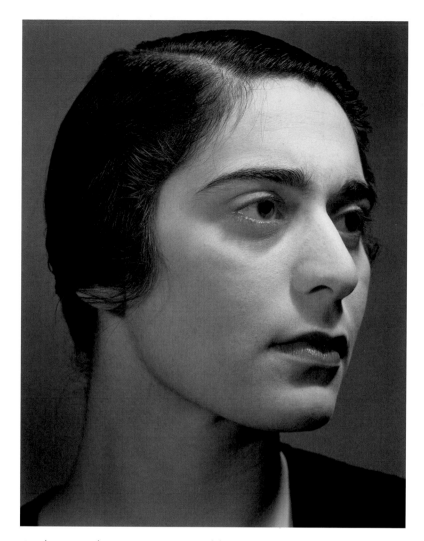

Carolyn Anspacher, San Francisco, California, 1932

of a sculptured head," Ansel wrote. "This actually pleased me, because at the time I had a strong conviction that the most effective photographic portrait is one that reveals the basic character of the subject in a state of repose."[13]

In 1936 Ansel visited Chicago for the opening of his exhibition at Katherine Kuh's gallery. He needed money, and Kuh arranged for him to photograph a few of her wealthy friends on commission. Ansel photographed them as they appeared and made no attempt to conceal wrinkles, warts, and drooping eyelids or in any way tamper with reality. "No

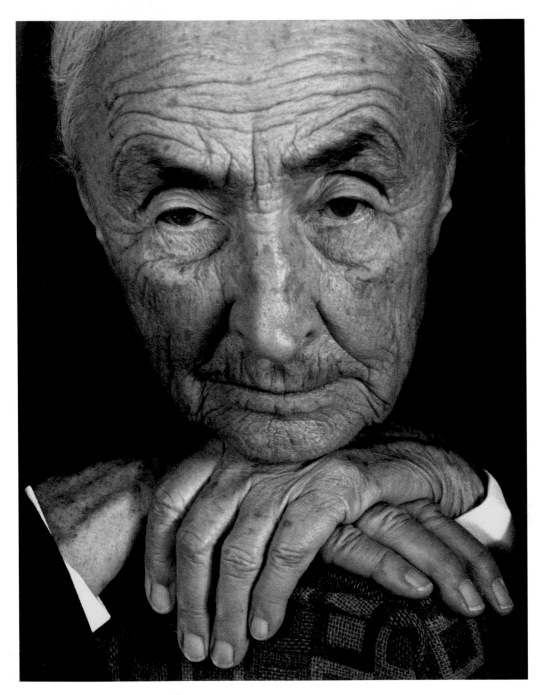

Georgia O'Keeffe, Carmel, California, 1976

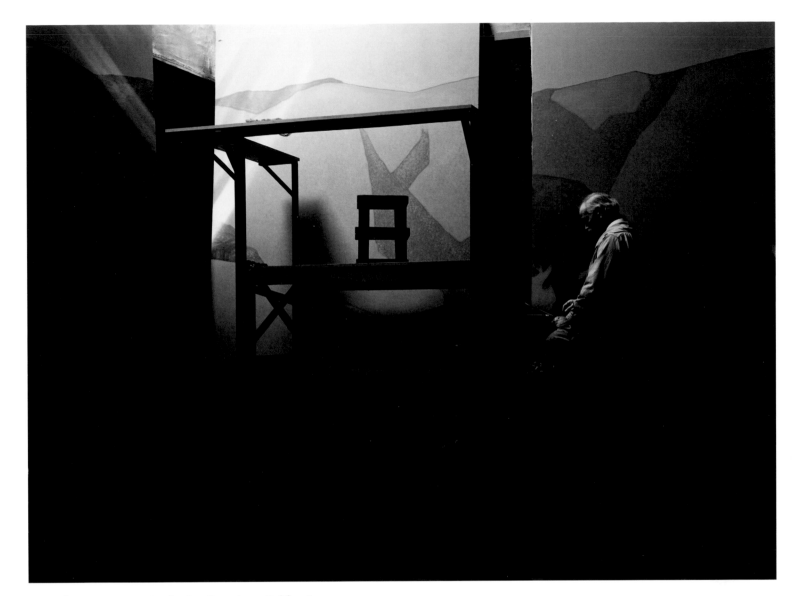

Gottardo Piazzoni in His Studio, San Francisco, California, 1932

one would accept them," Kuh recalled. "People hated them."[14] Even in his seventies he did not flatter. When he photographed his good friend Georgia O'Keeffe in 1976, he prided himself on making "no concession to her age." However, he admitted, "I understand she does not like the picture."[15] As an occasional subject for Ansel's camera, I feel the same. He made at least four portraits of me, and not one is on display in my home.

Ansel also photographed people in larger settings, particularly the outdoors. One of the best examples—of Edward Weston—is discussed in Chapter 15. Regardless of the composition, Ansel claimed that on first seeing the scene, he intuitively knew the photograph he wanted to make. In 1932 he was commissioned to photograph Gottardo Piazzoni in his studio. "When I came in he was standing on the scaffold mixing paint. I asked him

Dorothea Lange, Berkeley, California, 1965

to just keep mixing, set up very quickly and made the portrait."[16] Ansel also claimed he needed only "about a minute or two after the camera was set up"[17] to make an exposure, and he didn't try different poses. "Most of the time I knew I had it quite early."[18] He found that making portraits outdoors permitted "more creative freedom,"[19] and even indoors he favored natural light.

In an article on portraiture in *Camera Craft* magazine in 1934, Ansel discussed the inherent drawback of making a portrait with a camera. A painter or sculptor can "incorporate several moments of time in relation to movement and expression." But "the camera would crystalize the object as *it existed in that particular instant of time.*"[20] Ansel addressed this issue in 1965 by making a series of portraits of Dorothea Lange. She "had just gotten out of the hospital, and we really wanted to see her.... I had the Hasselblad set in advance and held it on a small tripod between my knees. I did about three rolls.... She had such marvelous gestures and expressions."[21]

Ansel was among the most photographed of photographers. Virtually everyone who attended

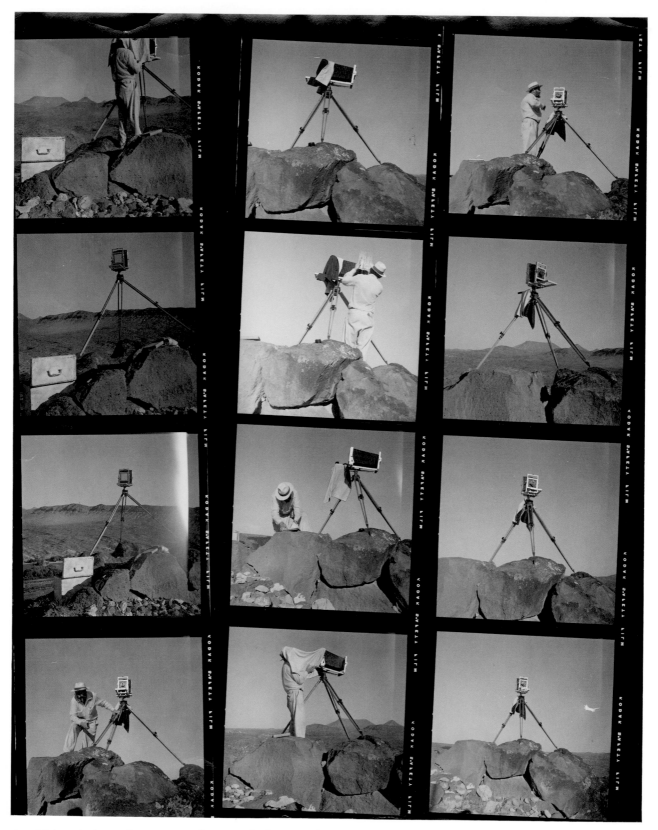

Ansel Adams in the Southwest, 1954. Photographs by Dorothea Lange.

Baseball card of Ansel in catcher's gear

his workshops or visited his home or met him at the opening of a museum exhibition or book signing took his picture. Famous photographers, including Lange, were no exception. Ansel willingly agreed to be photographed by almost anyone who asked, even if the photographer might make him appear foolish. For a set of baseball cards of famous photographers, he posed as the catcher wearing face mask and chest pads and holding (probably for the first time) a glove and a baseball.

Of Ansel's self-portraits, his favorite showed only his shadow (page 1). Sometimes he set up a composition and Virginia (or a willing onlooker) clicked the shutter. One was made around the time of his exhibition at Stieglitz's gallery in 1936. In it Ansel's beard is carefully trimmed, and he wears a crisp white shirt. He stands in front of a bookshelf in his living room with his hand on a view camera. Behind him on the wall hangs an austere photograph he made in 1927 of a dead tree at Little Five Lakes. The portrait captures the serious, introspective side that Ansel usually kept hidden behind his perennially cheerful demeanor.

In 1979 the *New York Times* commissioned Ansel to make a self-portrait. Always eager to promote Polaroid, he grabbed his 4 x 5 inch camera and tripod and asked me to accompany him downstairs to a back guest room (Ansel's house was

Self-portrait, San Francisco, California, c. 1936

Self-portrait, Carmel, California, 1979

Ansel on the cover of *Time* magazine, September 3, 1979. Photograph by David Hume Kennerly.

"upside down" on a hillside—the living quarters where you entered were upstairs and the bedrooms were downstairs). He set up the camera in front of a Victorian mirror. As I stood behind him and peered over his shoulder, I was struck by the bend in his nose. I knew perfectly well that his nose was crooked, and I had often heard the story of how it was broken by an aftershock in the earthquake of 1906. But I saw him every day and no longer noticed anything out of the ordinary.

According to family lore, the doctor said they would straighten his nose when he matured. He always joked that as he never matured, his nose was never straightened.

The *New York Times* did not publish Ansel's self-portrait in the mirror. But a year later, on the occasion of the opening of his one-man exhibit at New York's Museum of Modern Art, Ansel's portrait by his friend David Hume Kennerly graced the cover of *Time* magazine.

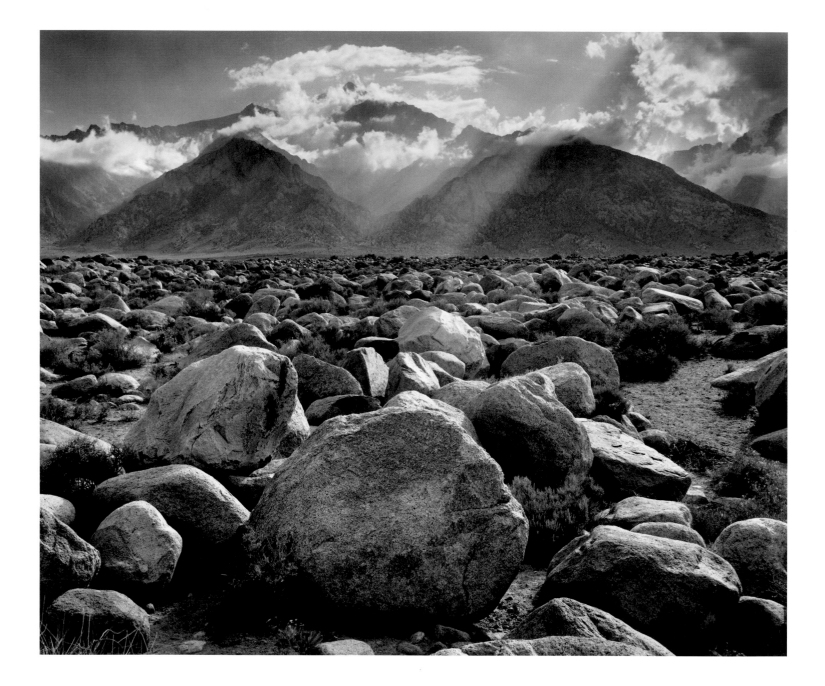

14 Mount Williamson, Sierra Nevada, from Manzanar, California, 1944

TEN MILES in an air-line from Manzanar, the summit of Mount Williamson rises against the sky to 14,384 feet, magnificent and shimmering under the clear sun."[1] In the fall of 1943 and early 1944, Ansel spent several weeks nearby at Manzanar War Relocation Center photographing the Japanese American internees, with whom he deeply sympathized. "The grand view of the Sierra from Manzanar visually excited me,"[2] Ansel wrote.

One day he drove to the "vast field of boulders" that leads to the mountain's base. On his tripod he set up the same camera and lens with which he had made *Winter Sunrise* a few months earlier (Chapter 11). He had attempted to photograph Mount Williamson on several previous occasions without success. This time it worked because "there was a glorious storm going on in the mountains."[3] If Ansel had photographed on a bright, clear day, the gray of the rocks in the foreground would have melded with the peaks and sky. Instead, the storm's dramatic clouds created "very intense" shadows on the rocks that made them stand out from the distant peaks.

Like so many of Ansel's negatives, this one is "terribly hard to print."[4] He wrote, "This is a subject that invites too-strenuous printing. I have made many prints that are too heavy because in trying for maximum richness, I simply over-printed them. I have also made prints that are too light, as a thoughtless rebound from the heavy images."[5] In addition, "The negative was loaded in a small, stuffy room at Manzanar during the war and there is a damp fingermark in the sky which does not show in the small print but comes through like the finger-print of Gawd in big enlargements."[6]

Edward Steichen, the curator of photographs

Mount Williamson in the exhibition "The Family of Man," at the Museum of Modern Art, New York City, 1954

at New York's Museum of Modern Art, asked to borrow the negative for *Mount Williamson* to make a mural-sized print for the exhibition "The Family of Man" in 1954. Ansel refused to part with his original negative and only reluctantly agreed to send a copy to be printed in New York. When he saw the mural installed at the museum, he was incensed: "They made a terrible copy, and then when they cut the prints they trimmed off so [much that] the sections didn't match. There was an inch lost

between each one. And here was this thing on display!"[7]

Ansel considered the work that he did at the Manzanar War Relocation Center starting in 1943 "the most important job I have done this year."[8] His friend Ralph Merritt, the director of the camp, suggested that Ansel "interpret the camp and its people, their daily life, and their relationship to their community and their environment."[9] It was just what Ansel had been looking for, and he felt

U. S. Army convoys in Yosemite Valley, 1943

that the project was "about as constructive a thing as anyone could do—and strictly American."[10]

Ansel's good friends were already engaged in the war effort: David McAlpin was in the Navy; Beaumont Newhall read aerial photographs for the Army; Edward Weston was an air-raid spotter for the Ground Observer Corps. Ansel had completed a few worthy projects. In Yosemite he photographed Army convoys and led convalescent Navy men on photographic outings. He printed "top secret negatives of Japanese military installations in the Aleutians."[11] But he was dissatisfied. He wrote McAlpin: "I want to be of some creative use, to do something which will help to get this war over with. I do not need to wear a uniform, hold a title, strut, or wield authority."[12]

Starting in October 1943 Ansel spent several weeks at Manzanar. The camp was almost two years old. Tar-paper shacks stood in military alignment in the dusty plain, and strong winds whistled

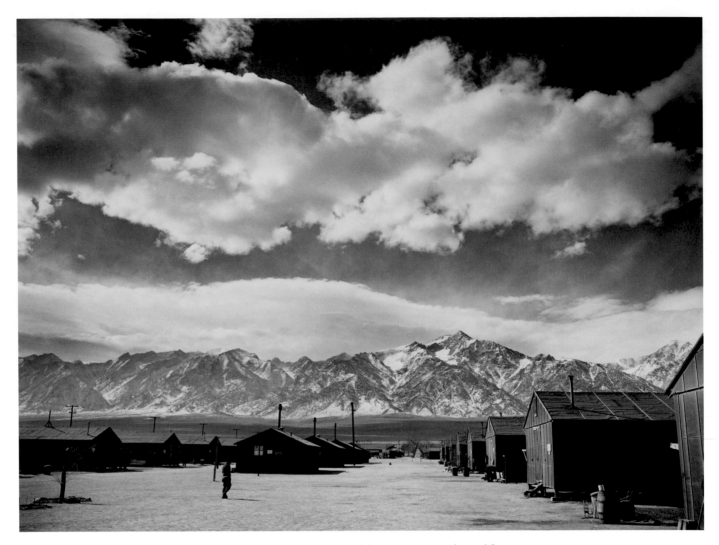

View of Manzanar War Relocation Center looking west toward the Sierra Nevada, California, c. 1943

down out of the Sierra. But the Japanese-American internees had brought about a remarkable transformation. They planted and irrigated the barren soil. They published a newspaper, held classes in music and art, and staffed and ran a clinic. They built a Japanese garden with stones from the Sierra for sculpture.

Most touching were the shrines created by families whose children were serving in the armed forces. Ansel's photographs reflected what he saw: "Everyone seemed constructively occupied, alert, and cheerful."[13]

Photographer Dorothea Lange had preceded Ansel at Manzanar. She was there in early 1942 when the camp was newly set up, and she documented the arrival of the first bewildered Japanese-Americans in their desolate surroundings. By the time Ansel arrived in the fall of 1943, Ralph Merritt's humane leadership and the natural resilience and hard work of the internees had effected a tremendous change.

Ansel thought the change was, in part, due to the positive effect of the surrounding landscape. "I believe that the acrid splendor of the

desert, ringed with towering mountains, has strengthened the spirit of the people of Manzanar,"[14] he wrote in *Born Free and Equal,* the book that reproduced his photographs of the camp. "One feels the power of the huge wall of the Sierra Nevada, rising on the west for hundreds of miles, a fantastic granite range supporting the loftiest summits of the continental United States."[15] He often cited the positive effect on him of a childhood spent in the wild sand dunes near his home west of San Francisco. "Had I been raised in bleak and bitter urban surroundings I am certain my life would have been vastly different."[16]

Ansel's photographs of Manzanar, with their upbeat treatment of the internees, received considerable disapproval from the press and the photographic community. Lange spearheaded the criticism. She felt that Ansel's "approach had been 'shameful' and politically naïve."[17] Ansel was puzzled and disappointed. "The photo-journalists raked me up and down over the coals.... 'Why do you have these people smiling? That's all fake! They were oppressed prisoners.'"[18]

John Szarkowski wrote in 2001 that the "criticism seems to me to miss the point. Adams's idea was to show that the Issei and Nisei, in spite of the injustices that they had suffered, had maintained their cohesion, dignity, and their will. This seems to me a wholly admirable ambition—perhaps even preferable to that of those who were willing to photograph the people of the camps merely as victims."[19]

Ansel was proud of his work at Manzanar and wrote, "Pardon my conceit, but it is a

Young couple at the door of their home in Manzanar relocation camp, California, 1943

Feeding chickens, Manzanar relocation camp, California, 1943

good documentary job."[20] He was also "profoundly affected"[21] by the experience. He wrote, "We must be certain that, as the rights and dignity of the individual are the most sacred elements of society, we will not allow passion, vengeance, hatred, and racial antagonism to cloud the principle of universal justice and mercy."[22]

After the war, the camp at Manzanar was closed. Buildings were dispersed and only remnants of a few foundations remained. However, the National Park Service is now working to restore the camp as the Manzanar National Historic Site. There is a visitor's center, one of the tar-paper barracks has been rebuilt, the Japanese garden has been partially restored, and a reproduction of one of the original guard towers stands close by the highway. Mount Williamson remains unchanged nearby. Alan Ross, Ansel's former assistant, recently returned to photograph it. The mountain was just as impressive, even without the storm, and Alan could identify every one of the rocks in the foreground of Ansel's photograph.

Ansel died on April 22, 1984, and the *New York Times* reported it on the front page two days later. With the article, they reproduced Ansel's photograph of Mount Williamson.

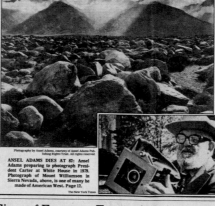

Front page of the *New York Times* announcing Ansel's death, April 24, 1984

15 Edward Weston, Carmel Highlands, California, 1945

EDWARD WESTON lived several hours south of San Francisco, in Carmel, and Ansel often drove down the coast to visit him and his wife, Charis. On one visit Ansel recalled, "I told Charis I was looking for a place to make a really good photograph of Edward. She said there was a big eucalyptus tree nearby that he liked. In fact, the tree is still there."[1] Earlier that year Edward had photographed the tree's "exciting roots."[2] When Ansel moved to Carmel many years later, he built a home not far from the site.

Ansel wrote, "At first I was not satisfied with the location and I began to explore nearby. Edward sat down at the base of the tree to await my decision." Ansel walked off toward a picket fence, but he "suddenly saw the inevitable image.... The relatively small figure at the base of the huge tree, the convoluted roots, and the beautiful quiet light" of a foggy day. "I pleaded, 'Edward please just keep sitting there.' I was very excited and fumbled my meter, dropped my focusing cloth and inadvertently kicked the tripod leg. Edward was amused and relaxed."[3]

Ansel and Edward met in 1928 at a dinner at the home of Albert Bender. Bender insisted that Ansel and Edward show their photographs that evening, and then he convinced Ansel to play the piano. Edward liked the music but was unimpressed with the photographs: "The thought that in this young musician, with such a future before him, we'd have one of the greatest photographers we've ever had, never so much as crossed my mind."[4] Ansel's opinion of Edward and his work was similarly lackluster. He described Edward as "slight of figure, thoughtful, and reserved" and considered the photographs he shared "hard and mannered."[5]

Over the next few years their opinions of each other's photographs underwent a 180-degree change. In 1931 Ansel glowingly reviewed Edward's one-man show at the M. H. de Young Memorial Museum for the San Francisco-based journal *The Fortnightly*. Ansel observed, "Weston is a genius

Eucalyptus Tree and Roots,
Carmel Highlands,
California, 1945. Photograph
by Edward Weston.

Leeks, 1927. Photograph by
Edward Weston. Virginia
Adams purchased a beautiful
print of this image from
Weston; it hung at the foot
of the stairs outside her
bedroom in Carmel, California.

in his perception of simple, essential form."[6] He also admired Edward's "use of simple, almost frugal, materials" and the way he photographed natural subjects, like the leeks in one photograph, a print of which hung in the hallway outside Virginia Adams' bedroom for almost forty years.

Edward was sixteen years older than Ansel. Nevertheless their relationship expanded to a deep and lasting personal friendship, one of the most important of Ansel's life. In the summer of 1937, Edward and Charis joined Ansel in Yosemite for a pack trip into the High Sierra. Early in their trip they paused above Tenaya Lake, where Edward made a series of beautiful photographs of juniper trees and Ansel photographed Edward photographing.

Juniper, Lake Tenaya, Yosemite National Park, California, 1937. Photograph by Edward Weston.

Edward Weston
photographing
above Tenaya
Lake, Yosemite
National Park,
California, 1937

Farther into the wilderness of the Minaret area, they both photographed Charis. Ansel recalled: "I wanted to get a picture of her in that sweater. She put her hands in her pockets and looked at me, and there it was."[7] Edward captured her in a rocky recess wearing high-laced boots. All of them were swathed in scarves, headgear, and long sleeves to minimize exposure to the ferocious High Sierra mosquitoes.

Both Ansel and Edward loved to laugh and joke, and Edward's humorous glance in Ansel's portrait gives only the barest indication of the hilarious and even ribald times they spent together, often fueled by copious amounts of distilled spirits.

Charis and Edward visited Yosemite again in

Charis Weston, Yosemite National Park, California, 1937.

Edward Weston clowning, with mosquito and sun protection, Yosemite National Park, California, 1937

Charis Weston, Yosemite National Park, California, 1937. Photograph by Edward Weston.

Ansel Adams, Carmel, California, 1943. Photographs by Edward Weston.

1938. Edward "brought 150 of his new prints," wrote Ansel, "and I was overcome. He is as good a photographer as he is a person, and I felt like one of the Seven dwarfs. But I am still conceited enough to believe I can put the stuff out, too!"[8]

In April 1943 it was Edward's turn to photograph Ansel, who arrived in Carmel exhausted from a stint at the Art Center School of Los Angeles, where he had been teaching photo-lab workers as part of the war effort. He and Edward "talked, ate, put away a few 'call tool' ones, had a grand time."[9] The next morning Edward photographed Ansel clean-shaven.

"OY OY OY !!!" Ansel wrote when he opened the package that contained two of the portraits. "I think I should grow a beard! But you can't help that; Gawd hath made mountains but he did a louzy job on my nose.... I like them tremendously;

it's the first time anyone ever got a true mood through my face. The only thing is that the mood that was there was one of fatigue, disgust with the Art Center experience, and a couple of sore eyes from all the formaldehyde I was dosed with at the L.A. Morgue the night before."[10]

Besides trading prints and portraits, Ansel and Edward regularly exchanged technical information about photography. Or rather, Edward asked Ansel's advice, and Ansel happily explained in detail anything and everything of a technical nature—from lenses to cameras to chemicals. On September 28, 1945, Edward wrote for advice:

I have no E K [Eastman Kodak] Catalogue—So maybe you could tell me if K2 gelatin comes in sheets large enough to use for printing through? I don't want to change from Chloride Paper

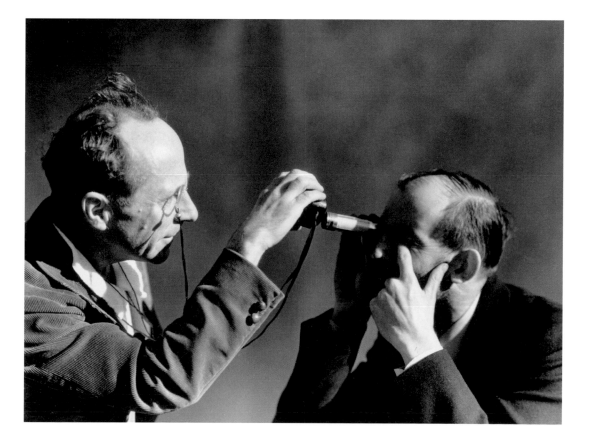

Edward Weston and Ansel Adams clowning with a light meter. Photograph by Brett Weston, c. 1935.

while winding up the work on shows.... What is Weston rating on XXX?...I don't feel *too* guilty asking questions since you have "stenog."[11]

Ansel replied:

The speed of Tri-X Pan is Weston 160, daylight and Weston 125, tungsten. With your development, proportionate change in speed will apply. In regard to the Wratten filter you ask about, the largest listed size is a 5 inch square which lists for $2.48; the same in square B glass would be $9.42. I am writing to ask if a sheet of K2 in 8x10 would be available, in gelatin form, of course. The only thing I can see against using a large sheet of gelatin would be that dust and abrasions would accumulate. My suggestion would be that you get the new Eastman Kodak darkroom lamp, a cone-shaped device which hangs down vertically, holding a 5½" diameter safelight. This costs $3, including one Wratten safelight.

My recommendation would be either the Series 6B or Series 00; then if you used a 200 Watt lamp you would have a powerful amber printing light which should work well on Chloride.

Always happy to answer questions if I can do so.[12]

Edward took Ansel's advice:

Thanks for info—I have ordered light as suggested—don't know what "6B" light is, but told Scudder to send me the lightest in color. Don't forget to order me the scale! No hurry—Ever—E[13]

Regardless of Edward's lack of technical expertise, Ansel idolized the man and the photographer:

"Edward worked with a monk-like simplicity. His camera and lens were adequate, his darkroom as simple—or simpler—than any darkroom can possibly be."[14] Edward's prints had "an almost ascetic quality" for Ansel, "as if they had been sent down from a clean heaven as the work of angel craftsmen."[15] He summed up his admiration for Edward: "I believe you to be one of the greatest artists of our time—certainly the top man in photography. I mean that in every way. I am proud to know you, to know you are my friend."[16]

Ansel was dismayed when Edward and Charis split in 1945. The following year Edward was diagnosed with Parkinson's disease. "Am much concerned with Edward," Ansel wrote to Beaumont and Nancy Newhall. "Obviously not at all himself. Strange tragic mood which he does his best to overcome when people are around."[17] By 1950 Edward's Parkinson's was so advanced that he could no longer print his negatives. Money had always been in short supply, but now it became even more elusive. Ansel and the Newhalls tried to fill the gap—offering advice on the illness, writing letters and postcards to keep up Edward's spirits, visiting as often as possible, and trying to find ways to help financially.

Ansel and Virginia convinced Edward that a book of his photographs of Point Lobos would bring him much-needed income. They proposed to publish it simultaneously with a volume of Ansel's photographs of Yosemite. Ansel wrote Nancy, "Edward seems vastly interested; has always wanted a book on Point Lobos.... Think we can do these books and make a really tidy sum for EW and AA. EW needs it worse than AA."[18]

The two large spiral-bound collections of photographs were beautifully printed on thick glossy

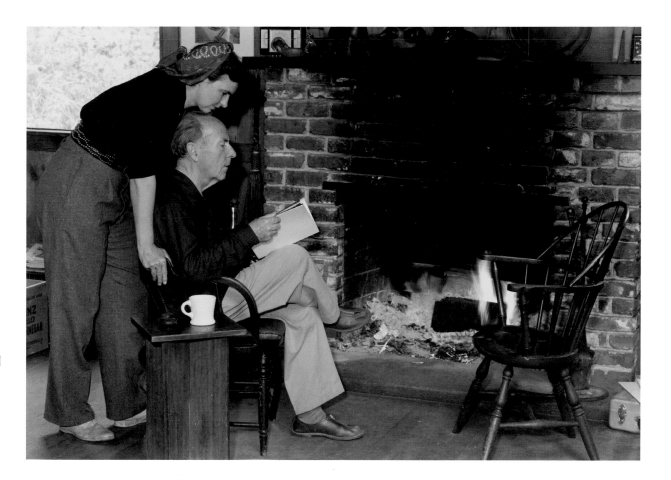

Nancy Newhall and Edward Weston in his home at Wildcat Hill, Carmel Highlands, California, c. 1950

Postcard from Ansel, Edward, and his assistant Dody Warren to Beaumont and Nancy Newhall, January 20, 1950. Ansel, Beaumont, and Nancy visited Edward often to cheer him as he battled Parkinson's disease.

ANSEL ADAMS *131 24th Avenue, San Francisco 21*
at Edward's en route to Yosemite, morning of January 20-1950

Just a line from us old boys by the Sea! Twice last week I was called America's
 vetran photographer. Makes me feel I am in line for a pension. And a repulsive
gent in L.A. said " Weston is undoubtedly one of the brights$ young men in photog."
I said "WHAT Weston" He saud "Eddie, of course - what other Weston is there". I said
"FOUR of them!" He said "I didn't know that; which one invented the Weston meter"?

Collective affection is herewith transmitted from

DODY

EDWARD

AND ME

My Camera in Yosemite Valley by Ansel and *My Camera on Point Lobos* by Edward Weston

paper, with technical information and a modicum of text. They originally sold for $10 each, but they are long out of print, and copies in good condition routinely bring several hundred dollars. Alas, at the time Edward's book did not sell, and Ansel lamented to Nancy, "It is a great shock to me to realize how small the responsive audience really is.... The picture is a grim one."[19] Ansel dedicated his book on Yosemite "To Edward Weston—Great among photographers and friends."[20]

Ansel also tried to help by obtaining commercial assignments for Edward, who inexplicably—to Ansel—balked at the task. In 1946 Edward made a few color photographs for Eastman Kodak, a commission arranged by Ansel, but Edward felt that

commercial work was not for him. He wrote Ansel, "For a price I'll give you a lesson on how to live without working."[21]

Edward lived simply. First he photographed vegetables and fruits, then he ate them; Ansel— though far from comfortable financially—was known to dine on a good, thick steak and the best bourbon. Edward's darkroom was a wooden shack with a bare bulb and so many holes in the walls that he could print only before sunrise or after sunset. Ansel's darkroom was a palace in comparison, and he said that Edward "used to refer jokingly to my darkroom as my 'factory' or 'production line.'"[22] When Ansel left on a trip his car was loaded with hundreds of pounds of cameras,

lenses, even a spare axle; Edward stuck to a few tried and true cameras and lenses.

In a conversation with good friend Edwin H. Land, the inventor of Polaroid instant photography and founder of the Polaroid Corporation, Ansel recalled, "Edward has said to me many times that I am too involved in external problems such as conservation, museums, teaching and photography in general, and that I should make my life simpler and concentrate on my creative work. Whenever I visit him and see his work, I am led to believe he might be right." Land countered: "I disagree. Weston lives in a shrine; you live in the world."[23]

Ansel complained about and chafed at the constant round of commercial assignments and the myriad distractions that drew him away from making creative photographs. He wrote to Edward, "Were I free of all responsibilities I would live in the mountains—I would rather chop wood for a living than do most of the trips I have to do in commercial photography."[24] But in the last analysis he recognized that "my destiny seems to get me right in the vortex of events and developments,"[25] and he seemed happiest with a schedule that would have overwhelmed most people.

Edward suffered from Parkinson's for more than ten years. He died peacefully in his chair on New Year's Day in 1958. After his death, Ansel wrote in an article for *Aperture* magazine: "The image of the little gray man, bent with his cruel affliction, yet nobly dominating everything about him with supreme patience and perceptions, will stay with me always."[26] In his *Autobiography* Ansel wrote of Edward, "He was one of my dearest friends, a man of genius and compassion."[27] Ansel dedicated his *Portfolio VI* to Edward's memory, writing that Edward "encouraged me in so many ways to observe the beauty of the world and challenged me to express and interpret it through the medium of photography."[28]

Ansel and Edward shared a deep admiration for each other's photographic legacy. Edward wrote of Ansel: "One of the greatest photographers we've ever had. Landscape, to my mind is the most difficult form of photographic expression, but Ansel has made some of the mightiest landscapes yet."[29] Ansel wrote of Edward: "Weston securely holds the position of one of the greatest, if not the greatest living photographer."[30]

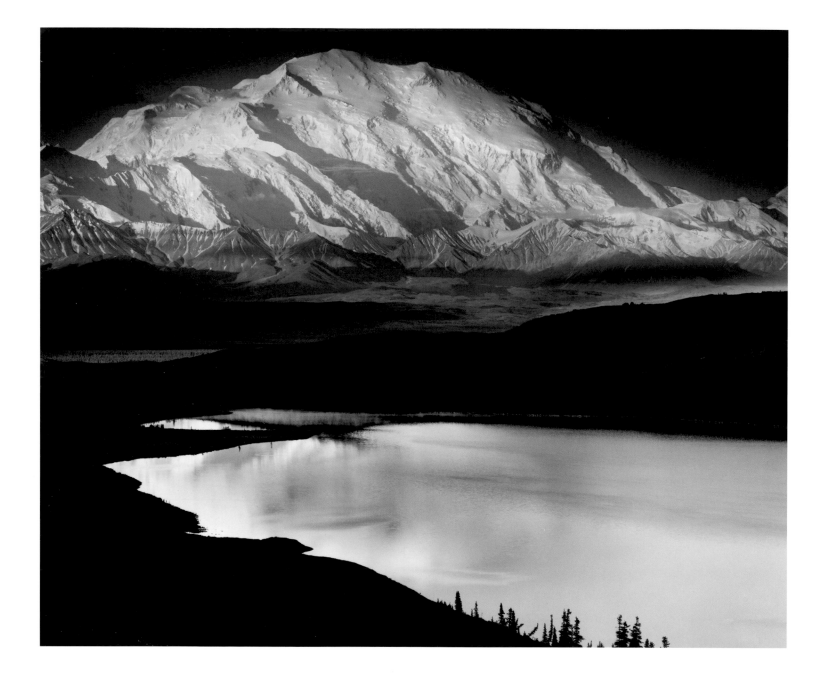

16 Mount McKinley and Wonder Lake, Denali National Park, Alaska, 1947

I WAS STUNNED by the vision of Mount McKinley, which rises eighteen thousand feet above its immediate base to its summit of twenty thousand six hundred feet. It is a vast, magnificent mountain presenting complex challenges to the photographer."[1]

In 1947 Ansel spent the month of June in Alaska. His trip was made possible by a Guggenheim Fellowship (the first of two) to photograph the national parks and monuments, a project begun in 1941 but left unfinished because of World War II. His fourteen-year-old son, Michael, accompanied him. They traveled by boat, plane, and rail to reach Denali National Park with the express purpose of photographing Mount McKinley. Ansel wasted no time: "Upon arrival, I photographed it, wreathed in clouds and with a glorious full moon setting behind its snowy peak."[2]

They went to bed in the park ranger's cabin, and around half past one in the morning Ansel photographed the mountain again. "As the sun rose, the clouds lifted and the mountain glowed an incredible shade of pink. Laid out in front of Mount McKinley, Wonder Lake was pearlescent against

the dark embracing arms of the shoreline. I made what I visualized as an inevitable image."[3] Ansel photographed from a site more than thirty miles away from the mountain. His long lens flattened the view and made the peak and lake appear equal in size and in close proximity to each other. In reality, Wonder Lake is much smaller than Mount McKinley and many miles distant.

Ansel aboard the SS *Washington* en route from Seattle, Washington, to Juneau, Alaska, June 1947. Photograph by Michael Adams. (Collection of Michael and Jeanne Adams)

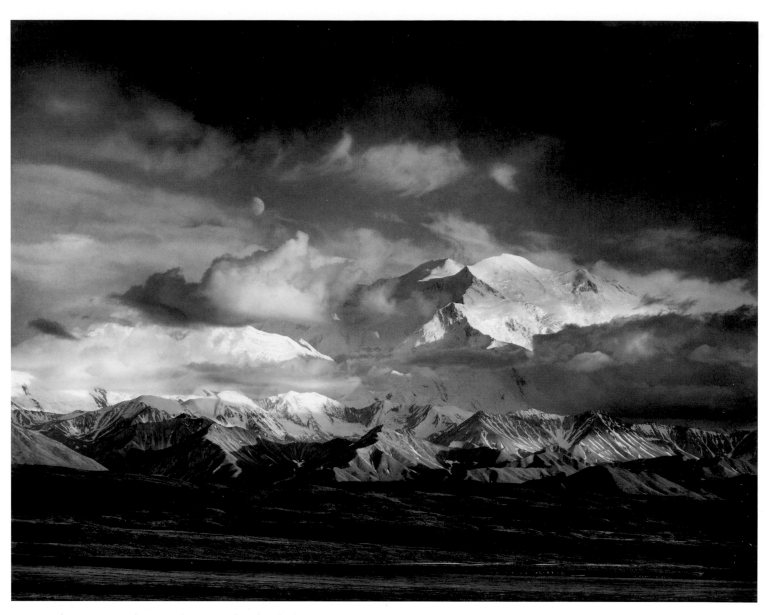

Moon and Mount McKinley, Denali National Park, Alaska, 1947

The weather during Ansel's visit to Alaska was dismal. He experienced drizzle, downpours, and clouds and was lucky to see Mount McKinley even briefly. Besides uncooperative weather, Ansel was also plagued with swarms of hungry mosquitoes. The small, slightly fuzzy area on the far left side of Wonder Lake is such a swarm. Because of their size and number, swatting was ineffective, and Ansel used to demonstrate how he swept his hands over his head and arms in one continual motion. The weather forced him to concentrate on subjects close at hand, such as details of flowers and leaves.

The following year, in 1948, Ansel published *Portfolio I.*[4] He included two photographs from his recent Alaska trip: *Trailside, Alaska* and *Mount McKinley and Wonder Lake.* The prints he made for the portfolio are subtle, quiet, and small (8 x 10 inches). Mount McKinley appears very white, and the lake

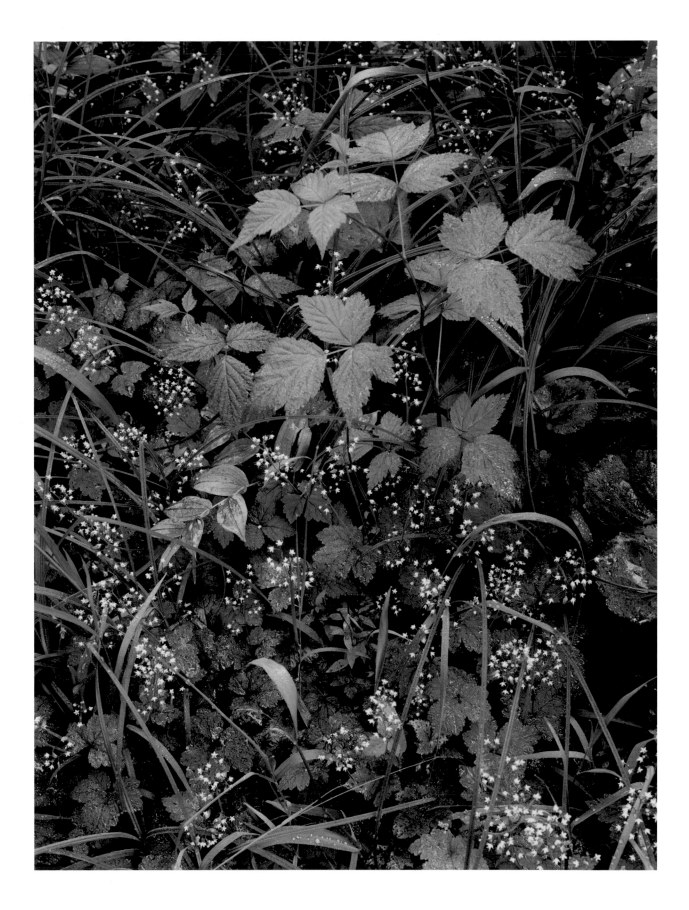

Trailside, near
Juneau, Alaska,
1947

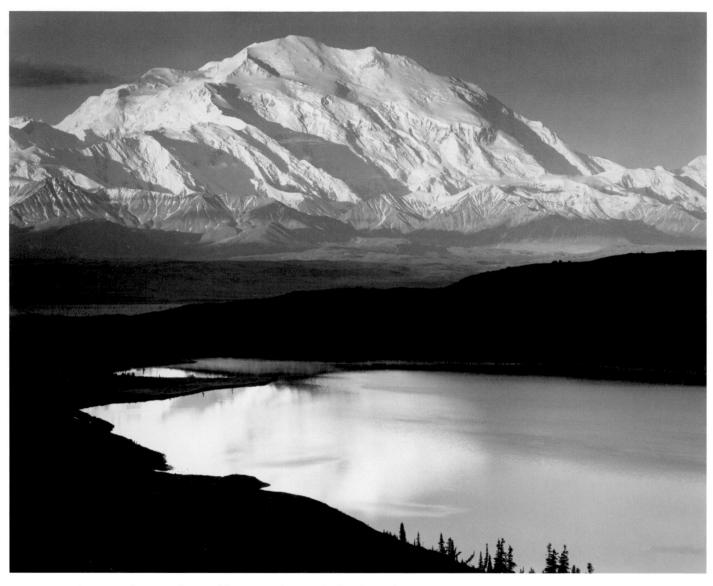

Mount McKinley printed in 1948 for *Portfolio I*. Note how pale the sky and mountain appear.

glows in the "dark embracing arms" of the land.

In the late 1970s Ansel's interpretation of *Mount McKinley and Wonder Lake* changed. "The first prints I made were quite soft and do not adequately express the impressive qualities of the subject,"[5] Ansel wrote. Alan Ross, his photographic assistant at the time, remembered, "He decided he liked the sky dark and moody." In his zeal, "Ansel bumped up the voltage of the light bulbs in his enlarger so much that they overheated and broke the sheet

of heat-absorbing glass! I still have the shards."[6] Besides darkening the overall tonalities, Ansel also printed the image on 16 x 20 inch paper. The larger size emphasized the mountain's heroic scale.

Ansel returned to Alaska in 1948 and 1949. He overcame his trepidation about flying and spent hours aloft viewing "a panorama that I guess is unequaled anywhere, not excepting the Himalayas."[7] He sent several postcards to Beaumont and Nancy Newhall describing his flying experiences.

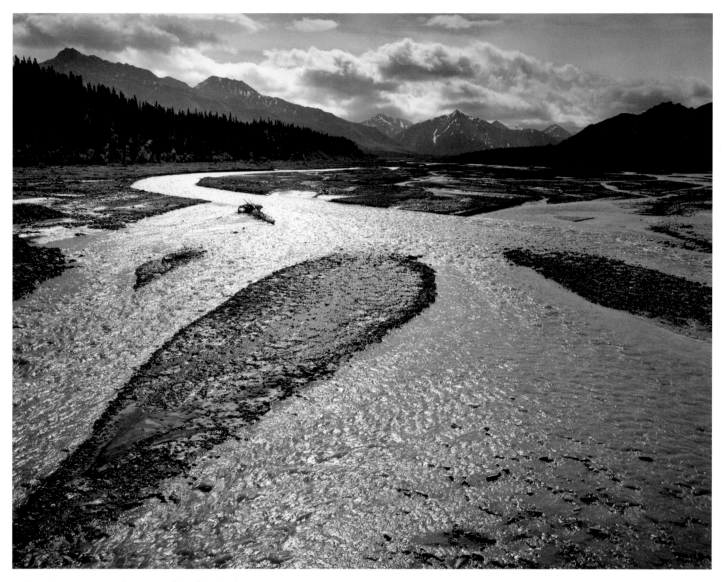

Teklanika River, Denali National Park, Alaska, 1947

Ansel said that the vast size of Alaska was "VERY hard to photograph," but he believed that he "got some swell things."[8] Sadly, there are relatively few negatives of Alaska in his archive. In part this was due to water damage. As he transferred from a seaplane in Glacier Bay during his 1947 visit, "The case holding my film of the entire Alaska trip fell into the shallow water of the landing dock,"[9] he recalled. A few were too badly damaged to print. But bad weather was the principal reason.

In 1948 and 1949 it was again uncooperative— "only four clear days in the whole month of July."[10] Bedeviled by "rain, fog, mist, rain, drip, drip, drip,"[11] as he phrased it, he photographed grass, leaves, and rocks instead of mountain vistas. In addition, it was a challenge to capture the vast scale of the landscape, so different from the Sierra Nevada, which seemed small and intimate in comparison.

Still, Alaska turned out to be "the most beautiful, spectacular, rich sight in all my experience,"

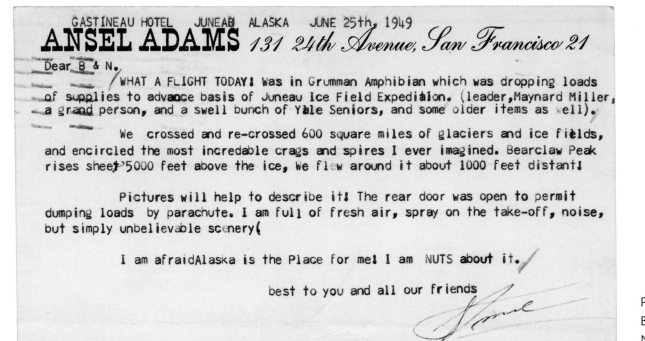

GASTINEAU HOTEL JUNEAU ALASKA JUNE 25th, 1949

ANSEL ADAMS *131 24th Avenue, San Francisco 21*

Dear B & N.

/WHAT A FLIGHT TODAY! Was in Grumman Amphibian which was dropping loads of supplies to advance basis of Juneau Ice Field Expedition. (leader,Maynard Miller, a grand person, and a swell bunch of Yale Seniors, and some older items as well).

We crossed and re-crossed 600 square miles of glaciers and ice fields, and encircled the most incredable crags and spires I ever imagined. Bearclaw Peak rises sheer 5000 feet above the ice, We flew around it about 1000 feet distant!

Pictures will help to describe it! The rear door was open to permit dumping loads by parachute. I am full of fresh air, spray on the take-off, noise, but simply unbelievable scenery(

I am afraidAlaska is the Place for me! I am NUTS about it. /

best to you and all our friends

Postcard from Ansel to Beaumont and Nancy Newhall, from Juneau, Alaska, June 25, 1949

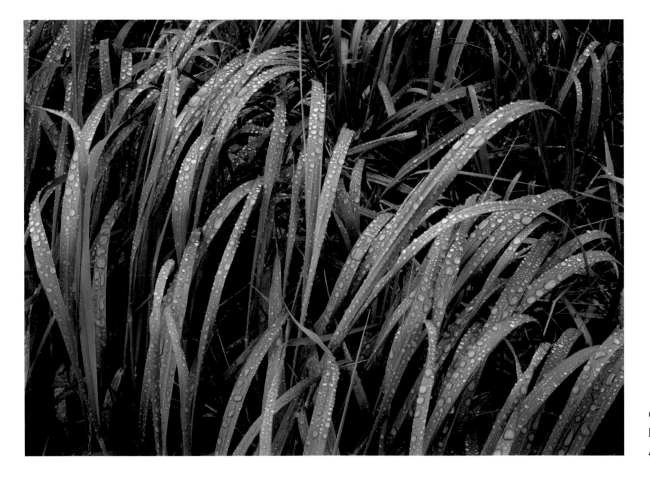

Grass in Rain, Glacier Bay National Park, Alaska, 1948

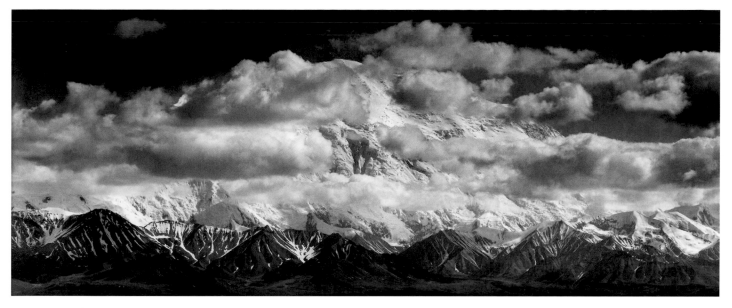

Mount McKinley Range, Clouds, Denali National Park, Alaska, 1948. The negative of this image was badly damaged by water.

Ansel wrote. "I am definitely coming back to do a book just on Alaska."[12] The book never happened, but Alaska turned out to be "the wilderness perfection"[13] that Ansel sought:

> As I spent the quiet days in the wild regions of Alaska, I clarified my own concepts of re-creation versus recreation. I saw more clearly the value of true wilderness and the dangers of diluting its finest areas with the imposed accessories of civilization. In Alaska I felt the full force of vast space and wildness. In contrast, the wild areas of our other national parks in the Lower Forty-eight are relatively confined and threatened with increasing accessibility and overstressed facilities.... I realized the magnitude of the problem and resolved to dedicate as much of my time and energy to it as I could.[14]

Ansel spent more than fifty years working to save America's wild places—through the Sierra

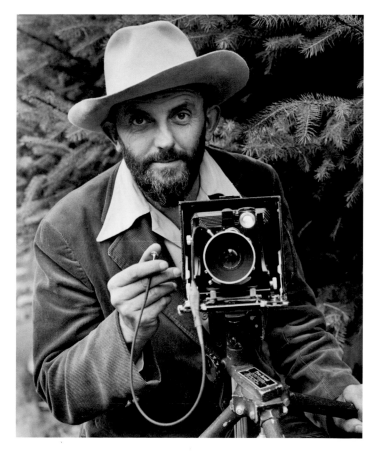

Ansel with a Zeiss Juwel Camera, Juneau, Alaska, 1947. Photograph by J. Malcolm Greany.

Forest, Beartrack Cove, Glacier Bay National Park, Alaska, 1948

Club, The Wilderness Society, state and local politicians, the National Park Service, Congress, secretaries of the interior, even presidents. He strove to send at least one message a day—and sometimes several—on behalf of the environment. It might be a letter, phone call, telegram, or book. His photographs played an equally important role. However, he was always careful to make the point that he could not make a photograph "to order" for an environmental purpose; a photograph had to spring from his heart and spirit. He often repeated the mantra that his photographs were "assignments from within" not "without."

President Jimmy Carter was a strong advocate for the environment. In 1979 he broke with tradition by inviting Ansel to make the official presidential portrait.[15] Ansel spent a week in Washington and photographed President Carter, Rosalynn Carter, and Vice President Walter Mondale.

Ansel's assistant, John Sexton, recalled, "I have vivid memories of Ansel talking to both President Carter and Vice President Mondale about the importance of preserving and protecting Alaska during the photographic sessions."[16] Their topic

Ansel photographing President and Mrs. Carter at the White House, Washington, D.C., 1979

of conservation was the Alaska National Interest Lands Conservation Act that would protect 79.53 million acres as public lands, one-third as wilderness. The legislation had been in the works since 1974 but was opposed by Alaska residents and Republicans. With the possibility of Ronald Reagan taking office in 1981, time was running out.

Ansel's influence was crucial in strengthening the president's resolve to see the bill through. He sent the president and his wife his photograph *Mount McKinley and Wonder Lake,* and he wrote Carter, "The preservation of Alaska is *symbolic* of hope" for mankind's future. "You, as our President, have the great—and quite possibly—the *only* chance to clarify this enormous problem."[17] The legislation passed and was signed into law on December 2, 1980. It expanded the protection of millions of acres of pristine wilderness, including what Ansel described as "the crown jewel of the north"— Denali National Park.

17 Sand Dunes, Sunrise, Death Valley National Park, California, 1948

I WAS CAMPED in my car near Stovepipe Wells, usually sleeping on top of my car on the camera platform, which measured about 5 x 9 feet. Arising long before dawn, I made some coffee and reheated some beans, then gathered my equipment and started on the rather arduous walk through the dunes to capture the legendary dune sunrise."[1]

Ansel watched the "searing sun" rise over the Funeral Mountains on what he knew would be a hot day. "Fortunately," he wrote, "I had just arrived at a location where an exciting composition was unfolding. The red-golden light struck the dunes, and their crests became slightly diffuse with sand gently blowing in the early wind."[2] He elaborated: "Just then, almost magically, I saw an image become substance: the light of sunrise traced a perfect line down a dune that alternately glowed with the light and receded in shadow."[3] He set to work.

Years later, Alan Ross, Ansel's former photographic assistant, plotted Ansel's path (page 190) as he made a series of five photographs of the dune. By "examining the shadow in the lower portion of the image," Ross wrote, "it was pretty straightforward to deduce the exact sequence."[4] Ansel photographed the vertical dune first in color[5] and then in black and white.

He next switched to the horizontal format, "pointed the camera down and tilted the camera clockwise a bit to avoid the dune field in the distance." For his third photograph he "moved the camera slightly forward and a foot or two to the right," which "allowed him to position the large dune peak more centrally" in the image. This became his preferred composition. Next "he moved the camera quite a bit forward along the dune crest, and pointed it down once again." Finally, he pointed the camera "severely down, tilting it wildly to the left" and moved the tripod very slightly to "straighten out the geometry."

Ansel photographed Death Valley in 1947, 1948, and 1949, on trips made possible by Guggenheim Fellowships. When he received notice of his first award, he immediately wrote his friend Edward Weston,[6] a prior recipient of a fellowship: "I got some exciting news. It's confidential until April 15th, but I wanted you to know among the very first. I got the Guggenheim Fellowship! Yep! At last! Generous project—interpretation of the Natural Scene—National Parks and Monuments! Two years—perhaps three. It's the turning point in Adams Creative work, I am sure."[7] Weston quickly replied, "I rejoice with you. This must be a, or the, turning point in your life & Work. And you are ripe for it."[8] Alfred Stieglitz also sent congratulations:

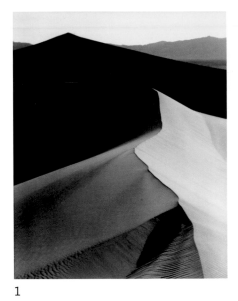

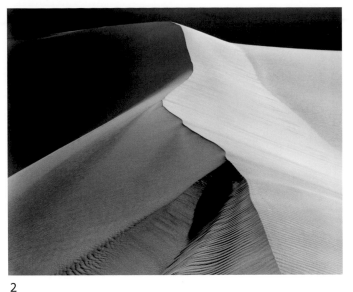

1

2

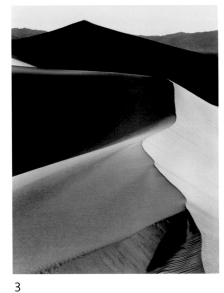

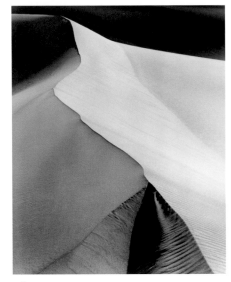

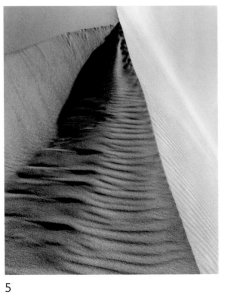

3

4

5

"I'm delighted. If anyone ever earned the Guggenheim you did."[9]

In early 1947 Ansel set out on his first Guggenheim trip. "I have burned many bridges behind me," he wrote to Beaumont and Nancy Newhall. "Commercial obligations fulfilled, most work done, start Saturday on my first Guggenheim trip. What a feeling! . . . I will go to Death Valley for at least a week."[10] From Death Valley he wrote a long letter to his friend and fellow photographer Minor White: "I had not realized how far I had drifted from the 'creative condition.' But I have exposed eight dozen films and think I have some of the best stuff I have ever done. Peach, it's marvelous! Death Valley is SOMETHING! No use talking about it—it's just a tremendous nest of photographic opportunity."[11] However, Ansel admitted, "Death Valley is very difficult to photograph: a few obvious opportunities

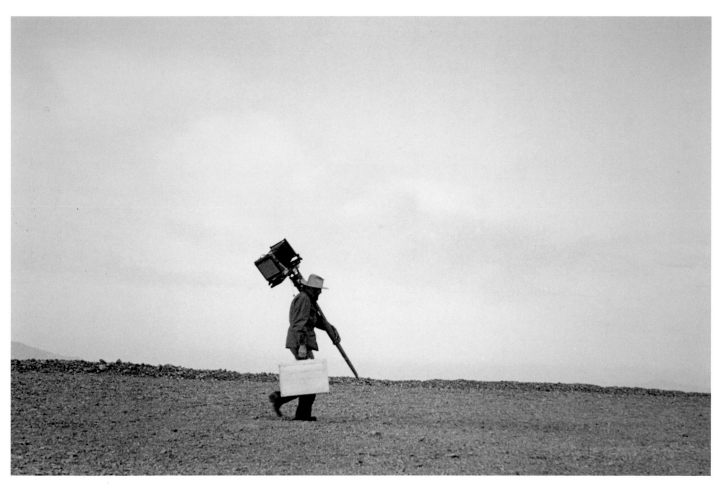

Ansel Adams in the Southwest, 1947, by Beaumont Newhall

and a vast number of recalcitrant situations that try the photographer's patience and craft."[12]

In 1952 Ansel returned to photograph Death Valley for an article for *Arizona Highways.*[13] Nancy Newhall, who wrote the accompanying article, traveled with him. She wrote to her husband:

We rise before dawn, arrive at some extraordinary spot in early light, break out some fruit juice, A sets up cameras. I set up stove and cookset and eggs, dawn comes, A works like fury, and when it's full morning, we have breakfast. We go in only for dinner or sleep.... I try to help A., but of course it is he who does the helping. He allows me to think I help by carrying the SEI meter or a case or an extra film pack, but actually he looks after me.[14]

A year later they expanded the article for *Arizona Highways* and published it as a paperbound book.[15] A perusal of the photographs in both publications proves Ansel's point that it is indeed difficult to photograph Death Valley. In spite of his enthusiasm, relatively few images are memorable.

For Ansel, the years from 1947 to 1950 were a period of tremendous accomplishments. His Guggenheim Fellowships allowed him to spend months traveling to national parks and monuments he had

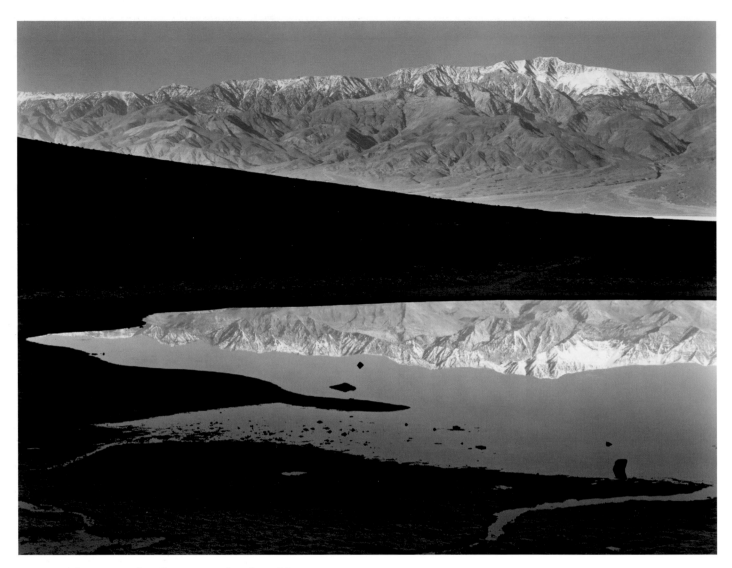

Sunrise, Badwater, Death Valley National Park, California, 1948

never previously visited. The number of memorable photographs he created was prodigious—all the more remarkable because his visit to each park lasted, in most cases, for only a few days.

In 1948 he produced *Portfolio I* consisting of twelve photographs, of which seven were taken earlier that year. The portfolio was an exhausting project that involved making more than a thousand prints. It was so successful that he immediately planned *Portfolio II: The National Parks and Monuments* for 1950. He published the first three books of his monumental five-volume series of textbooks on photography, the Basic Photo Series.[16] He also published *Yosemite and the Sierra Nevada*[17] (with text by John Muir) and *The Land of Little Rain*[18] (with text by Mary Austin). In addition, two large-format photographic books were published: *My Camera in Yosemite Valley*[19] with Ansel's photographs, plus a book of Edward Weston's photographs, *My Camera on Point Lobos,*[20] both closely supervised by Ansel. All in all it was a period of titanic labor.

In 1950 Ansel's mother, Olive Bray Adams,

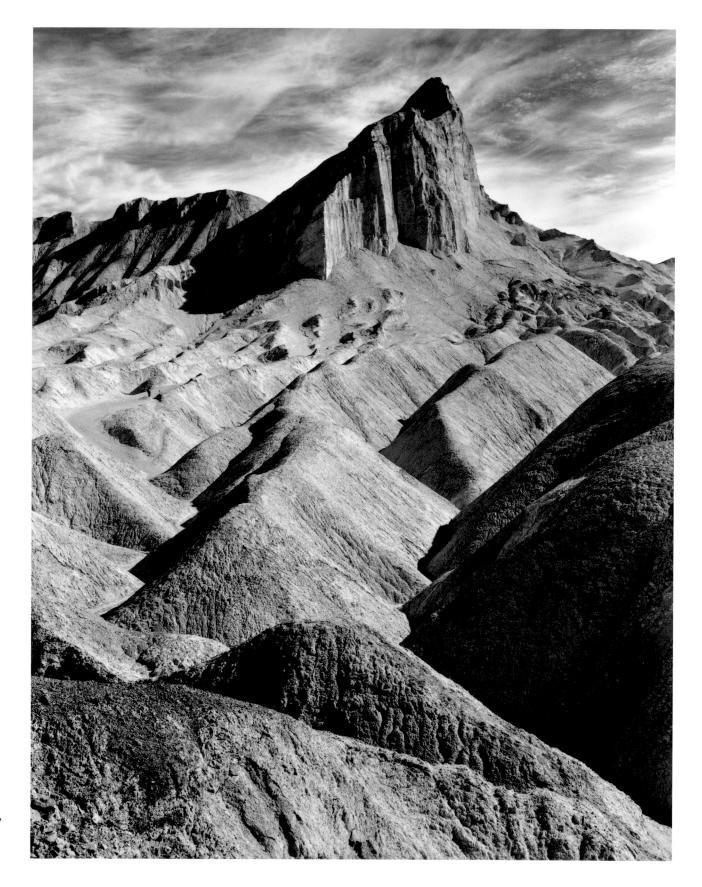

Manly Beacon,
Death Valley
National Park,
California,
c. 1948

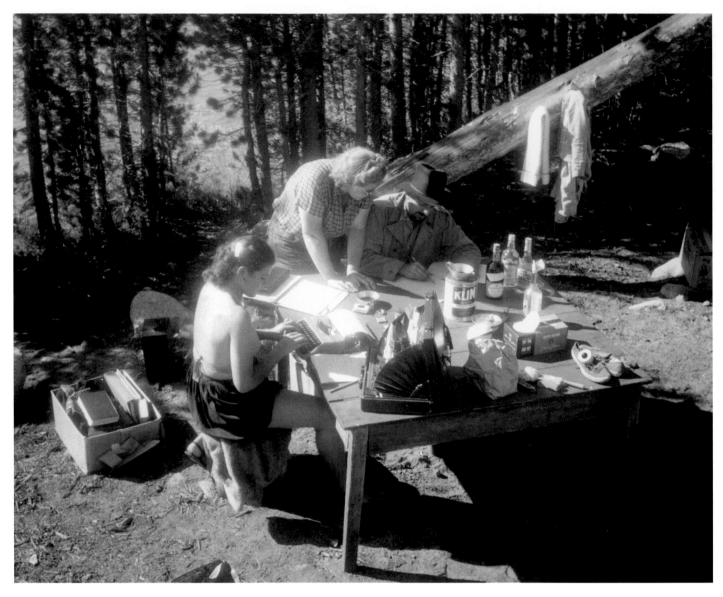

Ansel's office at Parsons Lodge in Tuolumne Meadows, Yosemite National Park, California, c. 1945

died—followed the next year by his beloved father, Charles Hitchcock Adams. The combination of the loss of his parents and the intellectual and physical toll of an almost superhuman program in the previous years resulted in a period of depression and self-questioning. He was worried that perhaps his best work was behind him: "Artists have a period of rise, then a period of 'leveling off,' then, perhaps, a period of descent.... I told Brett[21] [Weston]

that such had happened to me, that I had passed the leveling-off stage and was on the other side of the 'sine curve.'"[22]

He also feared that he had lost the desire to photograph, as he wrote the Newhalls: "I feel less and less interested in the *making* of pictures.... I admit, I am *bored* with making pictures! Should I see a psychiatrist or just follow my inclinations?? This will probably disconcert you, but I have had

Ansel with his parents, Charles Adams and Olive Bray Adams, 1908

Hands weaving a magnetic core, IBM, Poughkeepsie, New York, 1956. This photograph was made on assignment for IBM.

no real burning desire to make a picture for a long time!"[23] In addition Ansel was concerned about the public's understanding of his work: "It is also a shock to realize how many of my prints and books sell because of subject and not because of expressive potentials."[24]

Meanwhile, the need for commercial work to support his family never abated. Kodak was his most consistent and remunerative client, but working for Kodak was not creative: "It's just bread and butter—and HOW much that is needed now!"[25] But he had strong reservations: "I am prostituting my very eternal soul in doing the various commercial jobs I am doing."[26] He equated taking money for commercial work to support his family to feeding "dogmeat to the wolf"[27] that he pictured at his door.

The constant treadmill of trip after trip to produce photographs of diminished creative merit wore him down. He did not know where to turn, and he dreamed of a commission or stipend from some wealthy patron (such as David McAlpin) or company (such as Kodak) that would make it possible for him to devote himself to creative work. At the same time he claimed, "I have shot the Primeval Scene until there is nothing but some Eval left to shoot. In other words, I find myself repeating myself and not doing a very good job of it!"[28]

Ansel was never one to wallow in self-pity, and by 1955 his spirits had revived. He resumed his customary whirlwind of activity and had so many projects to track that he created a special form with initials to circle for copies for Virginia Adams, Nancy Newhall, his photographic assistant Don

```
MEMO:          PROJECT NO.    QUESTIONS !  DATE  1-8-58

TO      AA   (VA)  (NN)  (DW)  (MC)   OTHER:
FROM   (AA)   VA    NN    DW    MC    OTHER:
COPY TO:  AA   VA    NN    DW    MC    OTHER:
```

```
I am confronted with a rather complex year of work. The various
projects are listed below. I need help in planning these projects
so that I can accomplish them without putting myself in the nut-
house. It is a matter of careful scheduling, and fitting in loose
hours. Suggestions will be appreciated. It will be necessary to
have adequate materials on hand, and to keep careful accounting.
The various projects are:

POLAROID    -over-riding project.

1.       HAWAIIAN PROJECT.                 Proofs made this wk.
                                           Trunk shipped 1-13
                                           Make check list

2.       THIS IS THE AMERICAN EARTH BOOK.  Meet with Brower
                                           this week,

3.       PRINT PROJECT (PORTFOLIO THREE)        ditto

4.       NEWHALL-BRAZILLER BOOK

5.       BOOK SIX

6.       TELEPHONE JOB                     Finish before 19th

7.       LOUISE BODY PROJECT               Call this week

8.       YOSEMITE WORKSHOP                 Ads.and Ancmts.

9.       I.B.M. PROJECT                    Not certain

10       MISCELLANEOUS.            Prints,lectures,etc.

I think we should assign project numbers to these (in logical order)

and refer thereto at all times,accounting, etc.

((see separate sheet for Polaroid projects))
```

Memorandum form that Ansel used to track his projects in the 1950s

Worth, his administrative assistant Marian Carnahan, and his own files.

The memo for January 8, 1958, listed commercial assignments (Telephone Job, I.B.M. Project) plus Ansel's own projects (*Portfolio III* and his environmental magnum opus, *This Is the American Earth*). Two years earlier he wrote with enthusiasm about printing his unseen negatives and making new photographs: "I have a firm resolve that I WILL print in 1956. Simply have to get to creative work—or BUST!"[29] He wrote Beaumont Newhall, "You shall get a NEW photograph! I am getting very tired of my old stuff. Time for a change!... Need to re-establish myself as a creative photographer."[30]

Alas, creative photography largely eluded Ansel after 1965. He continued to say that when his myriad projects were finished, he would go out and make new photographs, but it did not happen. He liked printing in the darkroom, loved typing on his IBM Selectric, thrived on projects, people, and trips. There was always a new book or exhibition with accompanying adulation. Once, Ansel and I were looking through a group of his early photographs of Yosemite. I

"Masters of American Photography" stamps issued by the U.S. Postal Service in 2001, including Ansel's photograph, *Sand Dunes, Sunrise,* in the lower left corner.

asked him if he missed those days striding the High Sierra with his camera. He explained that when he looked at a photograph, he was catapulted back in time to the moment he clicked the shutter. He added, "I don't need to do that again."

In 2001 the U.S. Postal Service issued a sheet of twenty stamps that reproduced photographs by "Masters of American Photography." The masters included Ansel and his friends Imogen Cunningham, Dorothea Lange, Alfred Stieglitz, Paul Strand, and Edward Weston. Ansel's stamp reproduced *Sand Dunes, Sunrise, Death Valley.*

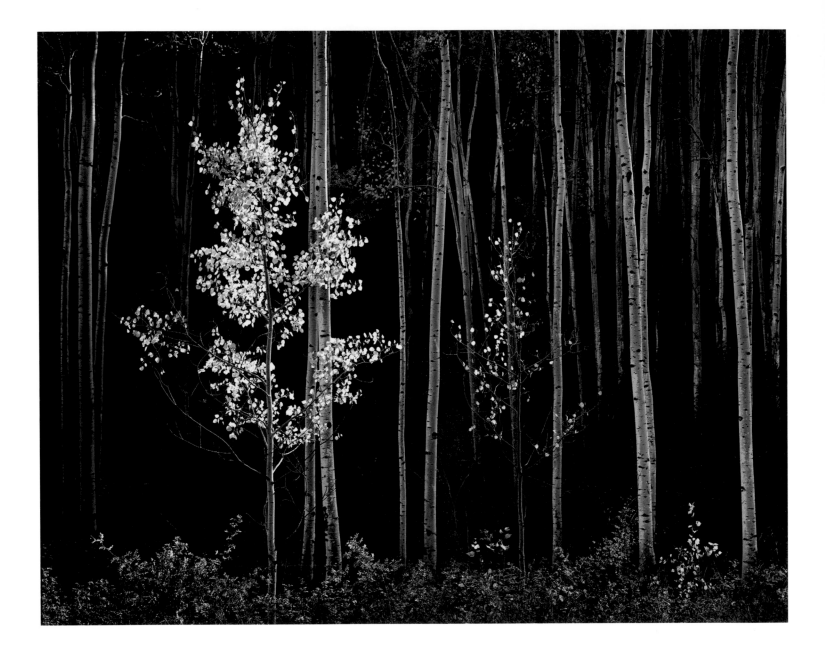

18 Aspens, Northern New Mexico, 1958

ANSEL WAS DRIVING "on the beautiful high-way near the crest of the Sangre de Cristo mountains"[1] when he "came across a stand of young aspen trees in mellow gold." He intuitively knew "there were wonderful images to be made in the area."[2] It was about three in the afternoon, and the light was "cool and quiet," reflected from distant thunderclouds. A color photograph of the green, yellow, and russet foliage would have been soft and subtle, but Ansel envisioned a black-and-white image that was "a considerable departure from reality."[3]

"I made the horizontal picture first," Ansel wrote, "then moved to the left and made the verti-cal image [page 200] at about the same subject distance."[4] The aspens in the vertical composition are visible at the extreme left of the horizontal image. He described the photographs as "different in image and mood, though the groupings of trees were within feet of each other."[5]

More than twenty years earlier, Ansel had made equally memorable but very different photographs of aspens on a trip to the Southwest in the fall of 1937.[6] Before he left on that trip, he wrote to Stieglitz, "I think I am getting some very good things—quite different, I believe. I like to think of my present stuff as more subtle, more lifting-up-the-lid, if you know what I mean.... Perhaps I am on the edge of making a really good photograph. I

hope so."[7] In the Dolores River Canyon in southern Colorado, he happened upon groves of leafless aspens and made several exposures.

On his return home in 1937, he made quiet, inti-mate 6 x 8 inch prints from two of the negatives. He sent one to David McAlpin and the other to Nancy and Beaumont Newhall, who hung it in their New York apartment. Nancy described it as "a pas-sage from Bach, in the pre-dawn light."[8] McAlpin

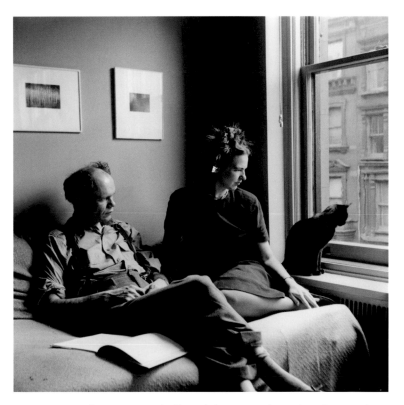

Beaumont and Nancy Newhall (and their cat Ulysses) at the window of their New York City apartment, c. 1939. The photograph above Beaumont's head is *Aspens, Dawn, Autumn,* Dolores River Canyon.

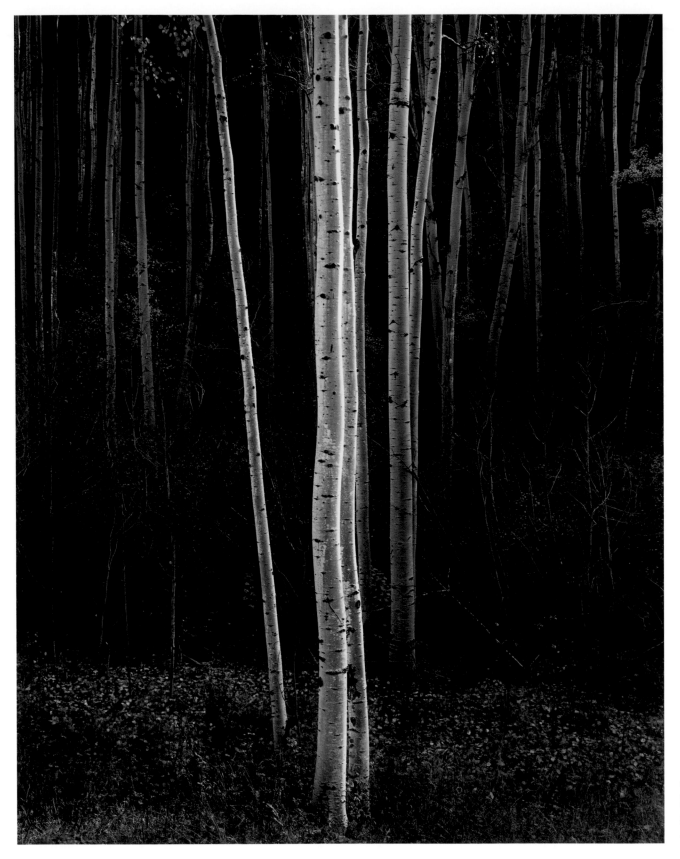

Aspens,
Northern
New Mexico,
1958

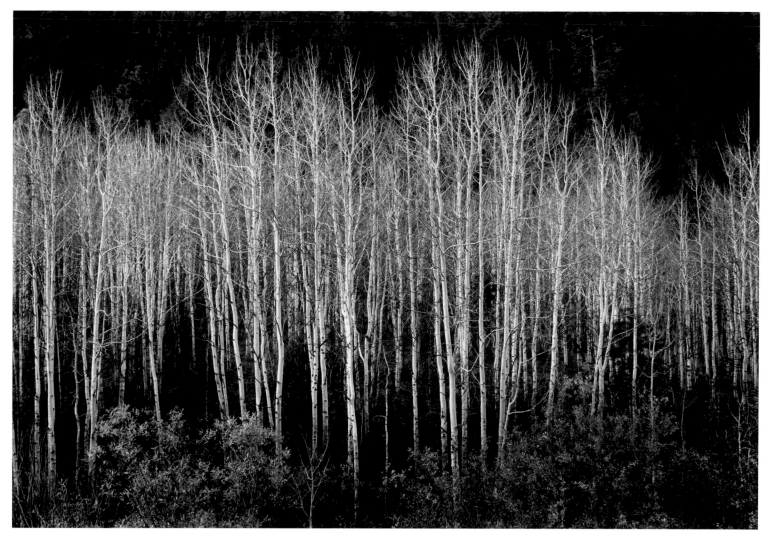

Aspens, Dawn, Autumn, Dolores River Canyon, Colorado, 1937

eventually donated his print to New York's Museum of Modern Art. John Szarkowski, the museum's director of the department of photography, also resorted to musical analogy in calling it "a fugue of aspens."[9]

When Ansel printed the negatives of the horizontal and vertical aspens made in 1958, the results were markedly different from the small prints he made in 1937. He used large paper—16 x 20 inches—and boosted the contrast to make them dramatic. The aspen leaves seem to flutter in full sunlight, and Ansel was proud that "even worm holes are clearly defined in the bright areas."[10] He was careful to maintain detail in the dark areas between the tree trunks, but the overall effect of the prints was more black than white. John Sexton,

Ansel's photographic assistant, observed that the negative for the horizontal aspens is "an almost textbook perfect negative and is relatively easy to print."[11] However, he described the negative for the vertical aspens in words not appropriate to reproduce here.

Ansel relied on his famous Zone System of exposure when he made the aspen negatives. Codified with Fred Archer in 1939–1941, the Zone System allows a photographer to calculate exposure and development to control the negative densities and corresponding values for the final photographic print. The tones from black to white were divided into ten zones. Ansel described his process in making the negative and a print of the horizontal aspens:

> I placed the deepest shadow on Zone II and indicated Normal-plus-two development time. I selected pyro as the appropriate developer for this subject, because I knew it would give high acutance to the glittering autumn leaves. I knew I must use a higher-than-normal paper contrast for printing, since the highest values of the leaves fell on about Zones VI–VI½. As I recall, the exposure, with the No. 15 filter (factor of 3), was one second at f/32 on Kodak Panatomic-X film at ASA 32. With no wind this relatively long exposure was possible; had the aspen leaves been quaking I would have had a severe problem.[12]

This seems like a foreign language for someone not versed in photography (and even some photographers find it impenetrable). The essential point is that Ansel first visualized the finished image he wished to create. Then, using the Zone System and his incredible technical knowledge, he calculated how to expose a negative that would allow him to produce that print in the darkroom.

Ansel was a passionate advocate for his Zone System. He taught the system in his annual workshops in Yosemite. He wrote about it in his books on photographic technique. Even today, seventy years later, it is still taught in advanced photography courses and has been adopted for digital photography. "Ansel Adams Zone System" pulls up around one hundred forty-five thousand entries on Google.

In 1962 Ansel made a stunning mural-sized print of the horizontal aspens. It measured 40 x 60

The Ten Commandments, 1977. Photograph by Ka Morais.

inches, and he presented it to his friend Bradford Washburn, a mountaineer and photographer. It was Ansel's new darkroom that made it possible for him to "super-size" his prints. A year earlier he and Virginia had moved from San Francisco to a house in Carmel that was designed by their friend and architect, Ted Spencer. It featured spectacular views of the Pacific, a huge living room/gallery with a cathedral ceiling, and, most importantly, a darkroom built to Ansel's specifications. At last he was able to more easily produce mural-sized prints, and he proceeded to make over one hundred of them between 1962 and the early 1970s. They remain highly prized, and a 40 x 60 inch print of the horizontal aspens sold at auction in 2010 for over four hundred ninety thousand dollars.

The photograph of horizontal aspens was closely associated with the Sierra Club. It was reproduced on the cover of their groundbreaking publication *This Is the American Earth*,[13] a collaboration between Ansel and Nancy Newhall. The book was the first of the large "Exhibit Format" publications that brought national recognition to the Club and its cause. It memorialized the exhibition, also called "This Is the American Earth," that opened at the LeConte Memorial Lodge in Yosemite Valley in 1956. The United States Information Agency subsequently circulated the show internationally, and it was seen by hundreds of thousands of people. The companion book is often recognized as the photographic equivalent of Rachel Carson's *Silent Spring*, and many feel that both volumes had an important role in launching the environmental movement.

It is impossible to overstate the importance of the Sierra Club in Ansel's life. From the age of nineteen it was "home" to him. The Club gave him his first job, at the LeConte Memorial Lodge in Yosemite Valley. His photographs were first reproduced in their bulletin, and some of his greatest images were made on the Club's High Trips. Club members became his intimate, lifelong friends. "My involvement with the Sierra Club was a basic introduction to the concepts of wilderness and conservation,"[14] he wrote, which led to his work as a renowned environmentalist. He served on the Club's board of directors for over thirty years. He participated in its battles, lent his photographs as

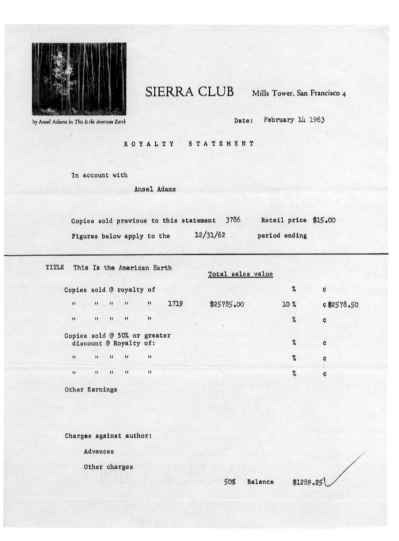

Ansel's royalty statement from the Sierra Club typed on the stationery the club printed in 1960 to coincide with the publication of *This Is the American Earth*. The stationery imprinted with Ansel's *Aspens* remained in use for many years.

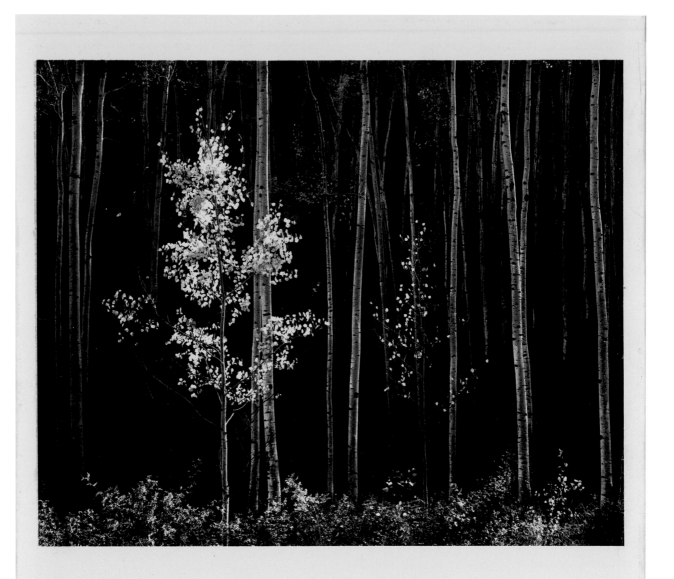

THIS IS THE AMERICAN EARTH

ANSEL ADAMS & NANCY NEWHALL

persuasion, and was a passionate advocate for their mission. The Sierra Club was truly at the core of his life.

This Is the American Earth featured many of Ansel's best-known images, and it also included photographs by Edward Weston, Eliot Porter, Henri Cartier-Bresson, and others. The long, poetic text by Nancy Newhall began: "This, as citizens, we all inherit. This is ours, to love and live upon, and use wisely down all the generations of the future." It ended with Ansel's picture of horizontal aspens and the words: "Tenderly now let all men turn to the earth."

ANSEL ADAMS

NANCY NEWHALL

ANSEL ADAMS: *Half Dome, Winter, Yosemite Valley*

THIS IS THE AMERICAN EARTH

SIERRA CLUB · SAN FRANCISCO

This Is the American Earth, with photographs by Ansel and others and text by Nancy Newhall

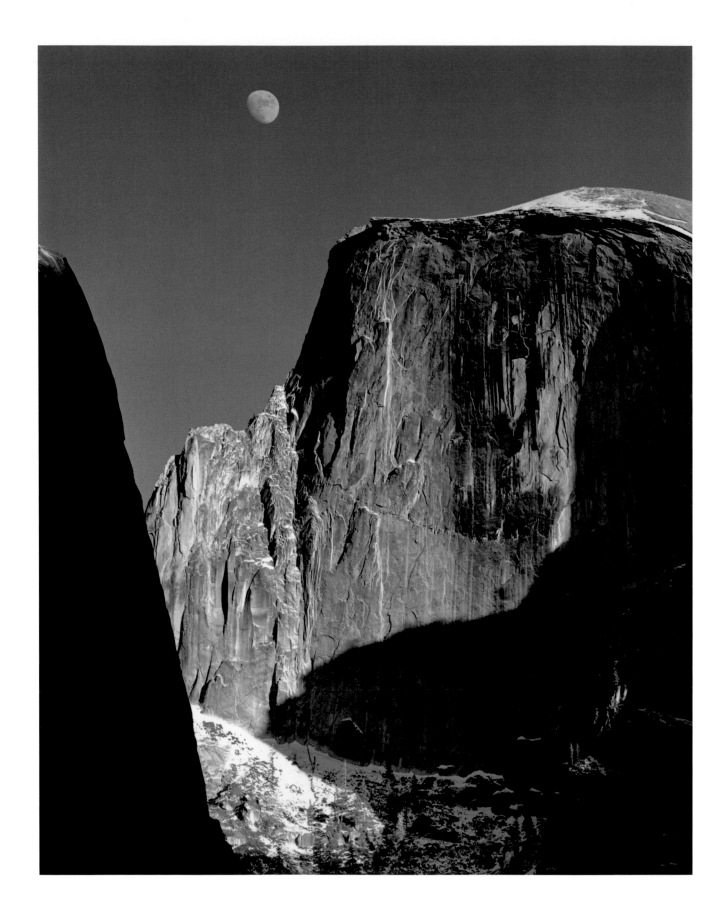

19 Moon and Half Dome, Yosemite National Park, California, 1960

I HAPPENED to be driving toward the Ahwahnee Hotel in Yosemite Valley one winter afternoon about 3:30 and saw the moon rising to the left of Half Dome. The sky was clear and the late afternoon shadows were advancing on the 2000-foot cliff of the Dome."[1]

Ansel stopped the car, walked "several hundred feet to the point that best revealed the scene clear of nearby trees,"[2] and set up his camera and tripod. "I waited until the moon rose to a favorable position, for a balanced composition. I made several exposures, at intervals of about one minute."[3] It was uncharacteristic for Ansel to make "several exposures." He believed that a competent photographer need make only one negative plus a backup for safety.[4] He felt that bracketing of exposures[5] was "nothing but indecision."[6]

Ansel used a Hasselblad camera to make *Moon and Half Dome*. His first Hasselblad was a gift from its inventor, Victor Hasselblad, in 1950. Ansel subsequently collaborated with Hasselblad to refine and improve the camera. He thought it a marvel of brilliant design and the ultimate in quality construction. The lenses were made by Carl Zeiss, and none were better. The camera produces a square negative. Until that time Ansel had used cameras that produce rectangular negatives in various sizes

and proportions: 3¼ x 4¼, 4 x 5, 5 x 7, 6½ x 8½, and 8 x 10 inches. He even employed a banquet camera that produces a wide horizontal negative that measures 7 x 17 inches.

The square format was a new experience. Shortly after he received the camera, he wrote

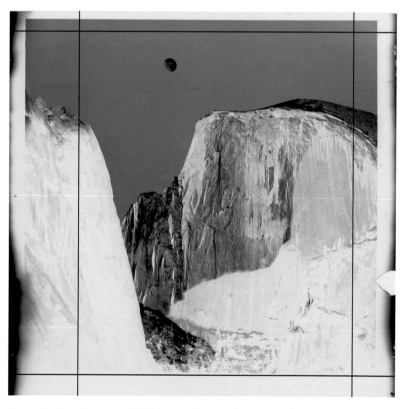

Negative for *Moon and Half Dome* showing how Ansel cropped the image from square to vertical.

the Newhalls, "New seeing with Hasselblad!"[7] For some images Ansel retained the square format with only minimal cropping. But for *Moon and Half Dome* he knew he would crop the image even before he clicked the shutter: "I visualized the image in vertical format, the cropping closely determined from the start."[8]

People often ask how many prints exist from Ansel's negatives. For *Moon and Half Dome*, the answer is thousands, but of that number only around two hundred were printed by Ansel himself. The others were made by his assistants to be sold at The Ansel Adams Gallery as high-quality keepsakes of a visit to Yosemite.

The Ansel Adams Gallery is the successor to Best's Studio, which Virginia Best Adams inherited on the death of her father in 1936. The following year Ansel and Virginia moved full time to Yosemite with their children, Michael, age three, and Anne, age two. Virginia ran the studio, and Ansel photographed, but Ansel—always full of ideas and energy—also threw himself into the management

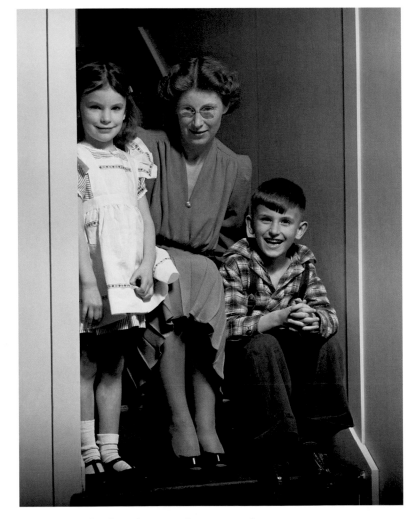

Virginia, Michael, and Anne Adams in Best's Studio in Yosemite, California, c. 1941

Dunes, Oceano, California, 1963. Ansel cropped the edges very slightly, leaving the image almost square. Note the crop marks at the corners of the image.

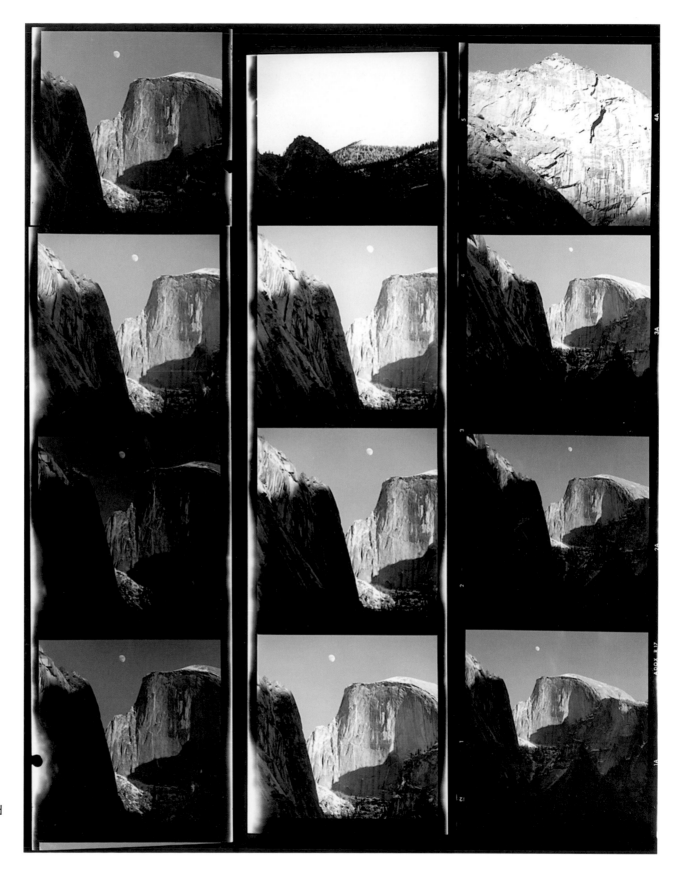

Proof sheet for *Moon and Half Dome,* showing Ansel's preferred negative in the top left corner

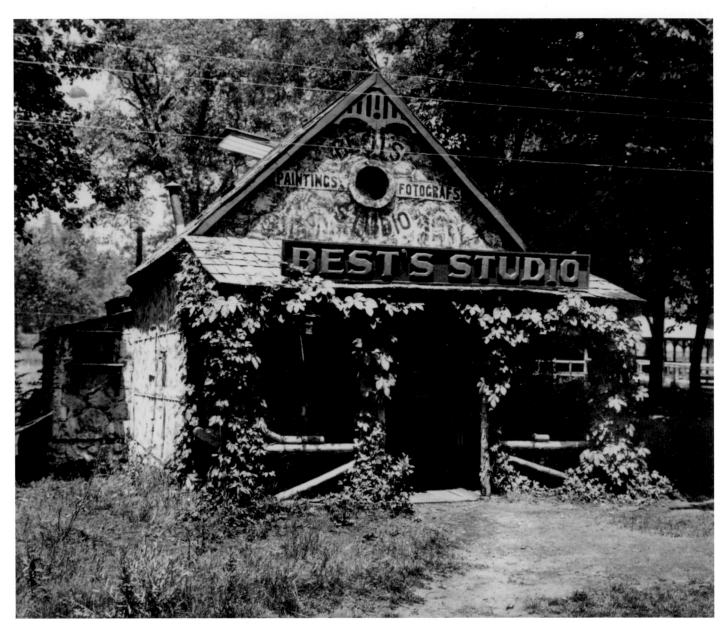

Best's Studio in Yosemite Valley, California, c. 1910 (Collection of Michael and Jeanne Adams)

of the small business. "The first thing we did," he wrote, "was to stock it with quality books, photographic supplies, and the finest American Indian crafts we could find."[9]

He was dismayed by the lack of high-quality mementos of the national park experience available for sale to visitors: "Here in Yosemite we have many forms of souvenirs that have no justification for sale in National Parks. Factories churn out pennants, pillow cases, purses, book markers, paper knives, paper weights, dolls, even hip flasks—all inscribed with the words 'Yosemite National Park.'"[10]

This was a subject that Ansel cared about deeply. In the late 1920s he humorously complained to his friend Cedric Wright about the

"Goddamn Curios" for sale in Yosemite shops. In a serious vein, in 1938 he sent a "Statement on the Types of Curios Appropriate to the National Parks"[11] to the director of the National Park Service. It recommended the production of "good quality curio material in volume production," including the use of natural forms such as rocks, leaves, and wood. He set an example at Best's Studio by selling prints, made from his negatives, for $3.50—"a nominal sum"[12] that was, he hoped, affordable by all park visitors. His assistant, Ron Partridge,[13] made the first prints in 1937. Partridge recalled that he printed and mounted hundreds.[14]

Charlie Marsh, a high school student who worked in Yosemite for the National Park Service during his summer vacation in 1942, remembers seeing Ansel's photographs at Best's Studio. He wanted to buy one, but even at the bargain price of $3.50 for a print made by Ansel's assistant, the cost was more than he could afford. He tentatively asked the salesgirl if she could make an exception on the price. A tall, black-bearded man suddenly appeared from a back room—was it Ansel? He whispered with the girl, who subsequently informed Charlie that he could have a special price of $2.50. The photograph hung on his wall for more than fifty years.[15]

In 1961 Ansel added *Moon and Half Dome* to the selection of Special Edition Prints, as they came to be known.[16] Alan Ross has printed the series since 1975.

Ansel Adams to Cedric Wright, c. 1929

Photographs of Half Dome made in 1916 on Ansel's first trip to Yosemite National Park

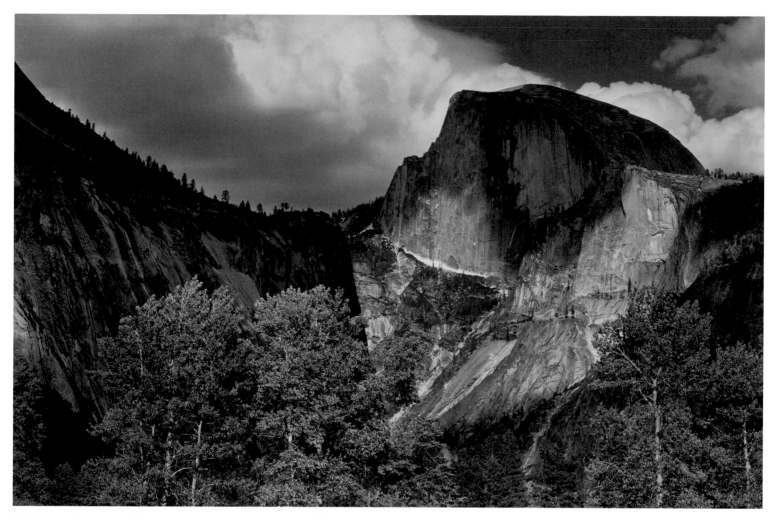

Half Dome, Cottonwood Trees, Yosemite National Park, California, 1932

He estimates that he has made almost one hundred thousand Special Edition Prints, and he continues to print them for The Ansel Adams Gallery in Yosemite.

Ansel's archive includes hundreds of photographs of Half Dome. His first were made with his Kodak No. 1 Brownie box camera when he was fourteen years old. He described them as a "visual diary" of what he saw on his first visit to the valley, and they are not memorable.

In his autobiography, Ansel recalled that on his first visit to Yosemite Valley he felt "there was light everywhere,"[17] and his photographs of Half Dome include every imaginable variety of light: soft

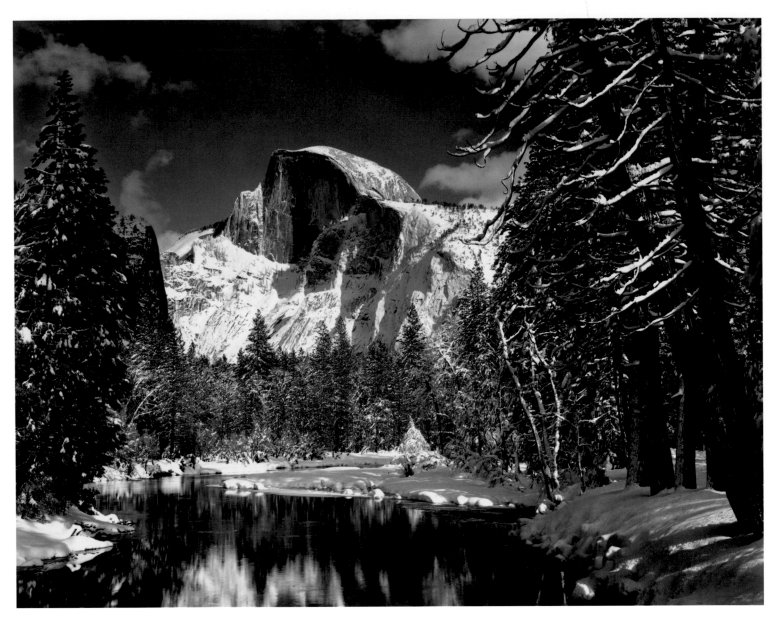

Half Dome, Merced River, Winter, Yosemite National Park, California, 1938

afternoon light in autumn; the hard brilliance of light after a snowstorm; and diaphanous light on a veil of blowing snow. Finally, in his last great photograph of Half Dome, Ansel photographed without atmospheric or compositional distractions—just Ansel, the moon, and Half Dome.

El Capitan is bigger, but it is Half Dome that is most closely associated with Yosemite National Park. Majestically looming over the magnificent valley, it was Ansel's lifelong companion—the archetypal symbol of his beloved home place. Frequent visits to Yosemite and the chance to live in the

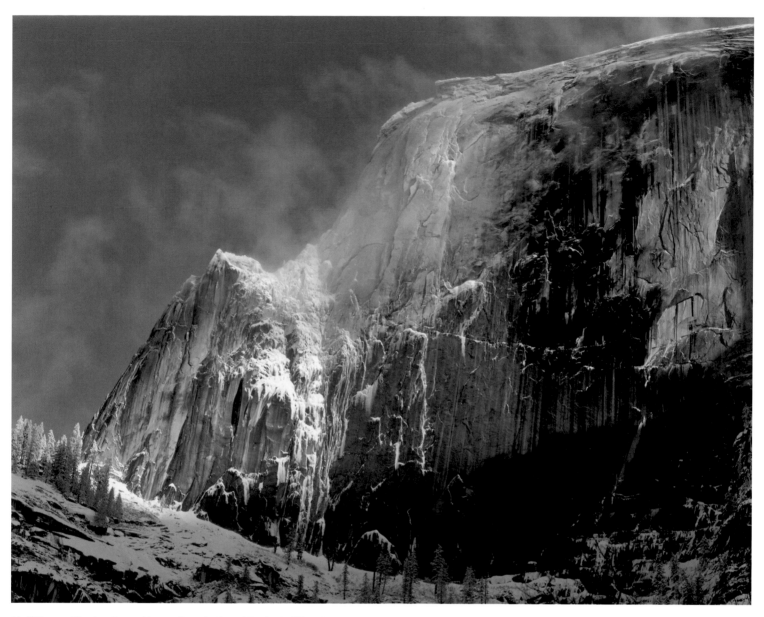

Half Dome, Blowing Snow, Yosemite National Park, California, c. 1955

valley full time from 1937 to 1942 afforded him the opportunity to photograph Half Dome repeatedly. He observed, "It is never the same Half Dome, never the same light or the same mood."[18]

In 1938 he hiked up the steep gully at its base. Afterward he wrote Dave McAlpin: "You can rest your hand on hard smooth granite which goes up two thousand feet above you in one straight line. And there is nearly three thousand feet below you to the floor of the Valley. This is quite a place, Dave—it is really quite something to live here!"[19]

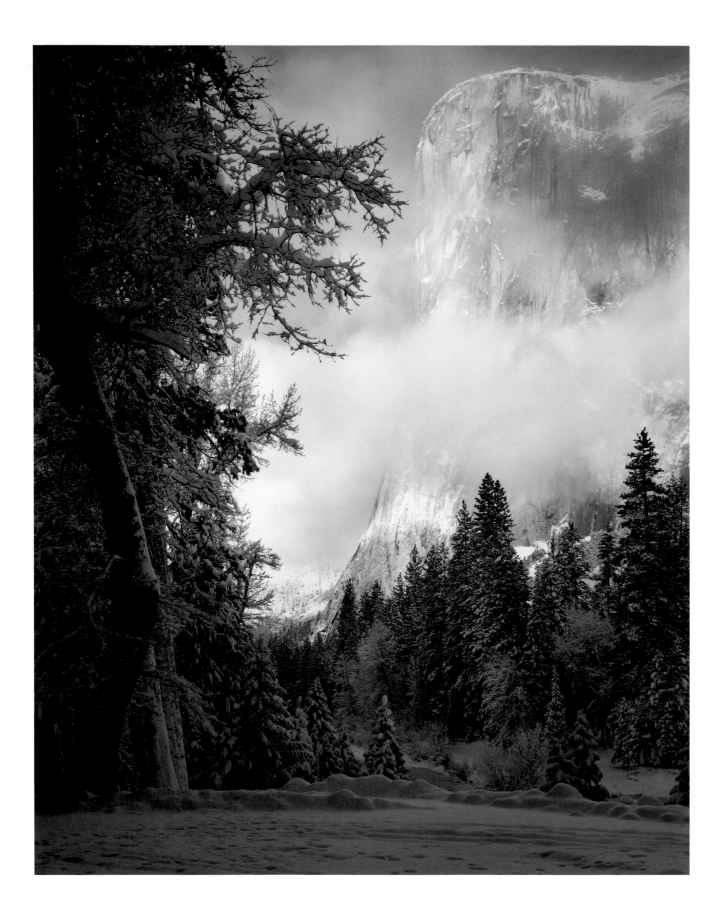

20 El Capitan, Winter, Sunrise, Yosemite National Park, California, 1968

THE GREAT ROCKS of Yosemite, expressing qualities of timeless, yet intimate grandeur, are the most compelling formations of their kind. We should not casually pass them by for they are the very heart of the earth speaking to us."[1]

When you stand in the middle of Yosemite Valley, you are surrounded by great rocks: Sentinel Rock, the Three Graces, Cathedral Spires and Peak, Eagle Peak, North Dome, Washington Column, the Three Brothers, and, most famous of all, Half Dome and El Capitan. El Capitan is a Spanish translation of "The Chieftain" from the American Indian name "Tu-toch-ah-nu-lah." It rises straight up over three thousand five hundred feet and dominates the western end of the valley, just as Half Dome dominates the east. In 1860 Thomas Starr King, the celebrated Unitarian minister, described El Capitan as "one block of naked granite, pushed up from below to give us a sample of the cellar-pavement"[2] of California.

Ansel first photographed El Capitan in 1916 on a family vacation, and he made his last well-known photograph of El Capitan fifty-two years later, on a winter morning in 1968. "The greatest glory of Yosemite is witnessed during the dawn following a snowstorm,"[3] he wrote. Driving around Yosemite "in search of photographs," Ansel came upon a "tremendously exciting"[4] view: El Capitan freshly coated with snow. "Snow was deep under foot,"

and it was not easy "to get the tripod securely placed in such conditions."[5] Time was of the essence: the minute the sun reaches the valley, it melts the snow on the trees and cliffs. Plus the clouds were changing rapidly.

Ansel visualized the finished photograph with the "opalescent glow" of the sun on the rock and a "rather deep"[6] value in the shadowed trees in the foreground. The balance of the bright tones in the swirling sunlit clouds with the dark surround of shadowed snow-covered trees was crucial. The right print was not easy to achieve, and on the protective paper envelope in which the negative is stored, Ansel typed the word *DIFFICULT*. He enlarged the negative and printed it on 16 x 20 inch paper with so much contrast that it looks more like a scene at sunset than sunrise.

Twenty years earlier Ansel made a very different photograph of El Capitan in snow. The glassy Merced River meanders in the foreground, and the snow-covered trees form lacy patterns on the left and right. The prints he made at the time were relatively small (8 x 10 inches) and very white, with a cold, icy feeling.

In 1920, when Ansel first encountered snow in Yosemite, he excitedly wrote his family, "I consider myself lucky to be here with the snow. Never saw anything like it before."[7] He arrived in late April to find snow still on the ground, including "a nice

```
4 - YW - 94 A
                                type 55 P/ N
                                DEc. 1938 [1968]
        EL CAPITAN, WINTER SUNRISE.

  DIFFICULT.
              Beseler at 18.5 inches
              150 mmlens at #3
              Selectol Soft 1.1
              KODABROMIDE 111  FDW
              HARD CODELIGHT   AT 50
              EXTRA HARD LIGHT ON
              develop 4-5 minutes at 75°
```

Negative envelope for *El Capitan, Winter, Sunrise* with Ansel's typed notations

pile"[8] right outside his window. Photographing a snow-covered landscape is not easy. "Perhaps snow subjects offer the most exasperating problems to be found in all Landscape photography," Ansel wrote in 1934. "The photographer is confronted with extremes of tonal value, and a minimum of texture."[9]

Furthermore, "the whiteness of snow is an illusion."[10] The photographer cannot rely on the white of the photographic paper to create "the suggestion of *white substance*."[11] He must create a light gray tone that suggests snow but is not so dark that it leads to a "hopeless blackening of the darker parts of the picture."[12]

The first large body of photographs Ansel made of snow in Yosemite consisted of publicity photographs for the Yosemite Park and Curry Company, which hoped to encourage winter visitation to the park. They commissioned Ansel to photograph winter sports, including ski joring (a skier pulled by a horse), dog sledding, and ice-skating. He also photographed skiing in the High Sierra.

For one assignment he ventured to Tuolumne Meadows on skis. He described the joyous experience of returning downhill, in an article in the *Sierra Club Bulletin*: "Down and down through the crisp singing air, riding the white snow as birds ride on the wind, conscious of only my free unhampered motion. Soon we are at the borders of icy Tenaya Lake—two thousand feet of altitude have vanished in a few moments of thrilling delight."[13] Unfortunately, most of the commercial photographs he made for the Yosemite Park and Curry Company were destroyed in a darkroom fire in 1937, and the images are known mainly through a few early prints.

The subjects of some of Ansel's best winter photographs are trees laden with new-fallen snow. In February 1935, the *Los Angeles Times* ran a full-page feature titled "Winter in Yosemite" that reproduced five of Ansel's photographs, including apple trees before Half Dome, which the editor described as "fantastically transformed." In all seasons Ansel photographed an oak tree (now gone) that stood alone in a meadow just off the road near El Capitan. His photograph of that tree in a snowstorm (page 222) is one of the most popular of the Special Edition Prints sold in Yosemite and when reproduced as a poster sold more than one hundred thousand copies.

El Capitan, Winter, Sunrise was made with 4 x 5 Professional Polaroid Land Instant Film. Ansel met the founder of the company, Edwin Land, in 1948,

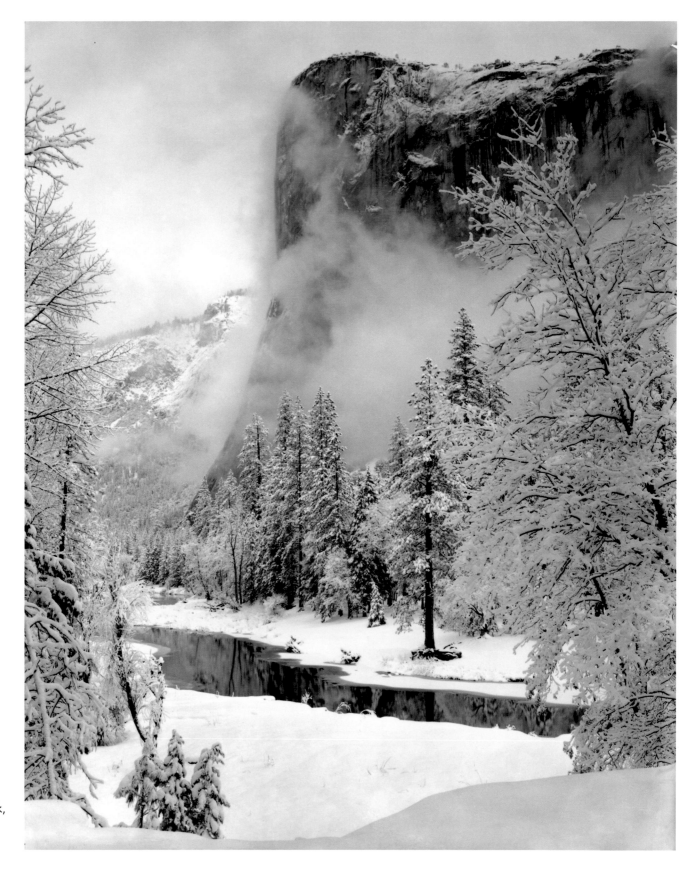

*El Capitan,
Winter,*
Yosemite
National Park,
California,
1948

Skier, High Sierra, Yosemite National Park, California, 1930

a year after Land first introduced Polaroid Land instant photography. Ansel immediately embraced the concept and began a lifelong friendship with the brilliant inventor. At Land's request, Ansel served as a consultant for the company. Over more than thirty years he sent thousands of memos evaluating technical aspects of their film and cameras and even wrote a technical manual, *Polaroid Land Photography.*[14]

He particularly championed the professional Polaroid Land Type 55 P/N positive-negative film that produced a unique contact print, as well as a negative that could later be printed in the darkroom. Many photographers were skeptical about

Polaroid film, but Ansel was a firm believer. Of *El Capitan, Winter, Sunrise* he wrote: "One look at the tonal quality of the print I achieved should convince the uninitiated of the truly superior quality of Polaroid Film."[15]

Just as Ansel made many photographs of Half Dome, he also returned again and again to photograph El Capitan. He preferred to work at dawn or dusk and often set up his camera just off the road at a turnout near the Merced River. Sometimes he included clouds. Sometimes he framed the view with trees on the left, or he combined trees and clouds. The scrim of trees on the left or right act like a frame or the wings on a stage set. Ansel

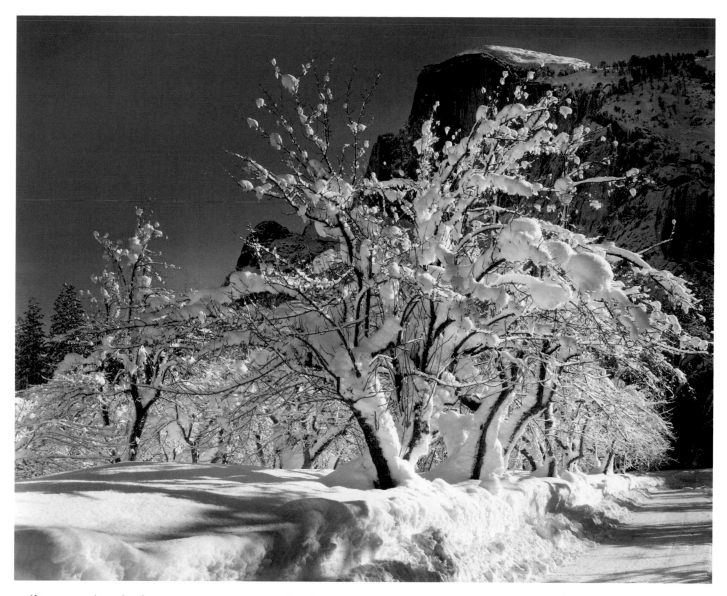

Half Dome, Apple Orchard, Winter, Yosemite National Park, California, 1920. The negative for this tender photograph burned up in Ansel's darkroom fire in 1937, and it is known through two prints probably made in 1920.

relied on this "near-far" device (as he called it) to focus the viewer on the center of the picture.

On the cold, snowy morning in 1968 when Ansel set out after a snowstorm to look for a photograph, he was sixty-six years old. No assistant was with him. The arthritis in his hands, combined with the frigid temperature, made it a challenge to set up the tripod, secure his 4 x 5 view camera, attach

the lens, and make the adjustments necessary before he could click the shutter.

For the previous few years he had spent less and less time making photographs and more and more time indoors. You could argue that he might have become a little awkward in the preparation, but you couldn't argue with his ability to make a blockbuster photograph. When John Szarkowski

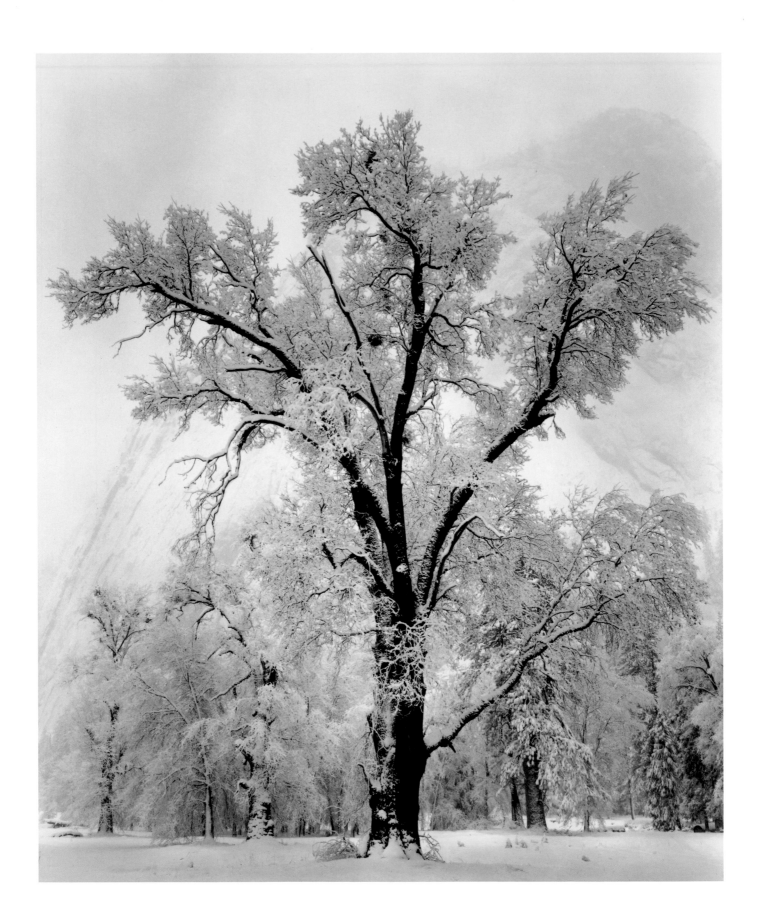

first saw the photograph in 1976, he wrote Ansel, *"El Capitan, Sunrise, Winter* is glorious—really one of your very best!"[16]

In 1974 Ansel published *Portfolio VI,* which contained twelve original photographs. *El Capitan, Winter, Sunrise* was one of eleven large photographs in each portfolio. The twelfth was an original Polaroid Land Type 52 4 x 5 inch print. For the first time in years, Ansel—accompanied by Alan Ross—went out in the field to make creative photographs. From June 1975 to May 1976 they photographed in the Southwest, along the northern California coast, even in New Hampshire, as well as national parks such as Kings Canyon, Sequoia, and Yosemite. What was thrilling was that Ansel had not lost his creative touch. Alan wrote:

> Ansel continually amazed me in finding strong images in places I would have thought were barren of potential. We might be driving down a country back-road of no apparent interest, and he would suddenly ask me to slow down and pull over. In the midst of rural chaos he would find order in an old cattle-run, an arrangement of some rocks, grasses and clouds, or weathered boards on the side of a barn. It had been years since he had been out on such an assignment, but it was emphatically clear that he had not lost his touch![17]

Not surprisingly, Yosemite yielded the most photographs, including eleven different views on one day alone—May 9, 1976.

Portfolio VII was dedicated to Ansel's friend and

OPPOSITE: *Oak Tree, Snowstorm,* Yosemite National Park, California, 1948

patron David McAlpin, whom Ansel had met through Alfred Stieglitz and Georgia O'Keeffe in 1936. McAlpin purchased Ansel's photographs, accompanied him on trips, visited his homes in Carmel and Yosemite, and, with Ansel and Beaumont Newhall, founded the world's first museum department of photography at the Museum of Modern Art in New York. Ansel and McAlpin enjoyed a close, personal friendship for over forty years, and it was McAlpin who arranged and paid for Ansel's first major museum exhibition, at the Metropolitan Museum of Art in New York in 1974 (through which I first met Ansel). In his foreword to the portfolio, Ansel reflected back over their long association: "Dedicating this portfolio to David Hunter McAlpin gives me the opportunity to pay homage to a great friend and a true benefactor of photography."

Typical of Ansel's positive thinking, he also looked ahead:

> I am both pleased and honored to have worked through more than half a century in the world of photography, and to have observed its ever-expanding potential as a medium of expression and communication. The original Polaroid Land print in this portfolio represents for me a voyage into the future. New aspects of seeing, new means of communication, new qualities of image, and new levels of subjective and intellectual comprehension lie ahead. While I have always worked with fairly conventional means and techniques, I anticipate new departures which, if I cannot examine them in my lifetime, will assure the power of future vision and accomplishment.[18]

One of Ansel's defining gifts—and perhaps one

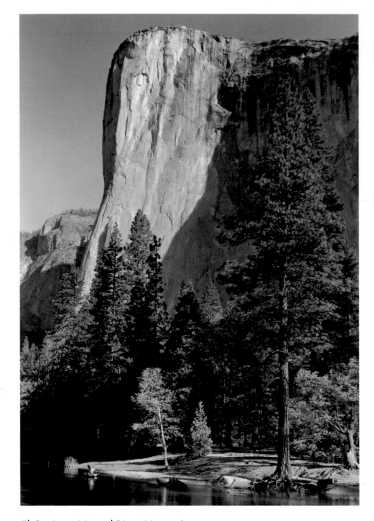

El Capitan, Merced River, Yosemite
National Park, California, 1948

El Capitan, Yosemite National Park, California, 1952

of the reasons he seemed young even at eighty years of age—was his ability to approach the new with curiosity and enthusiasm. A year before he died, in an interview in *Playboy* magazine,[19] Ansel expanded on his thoughts about the future of photography:

In electronics, the technology we have now can do far more than film. As the world's silver resources are depleted, these new technologies are particularly important.... Electronic

photography will soon be superior to anything we have now. The first advance will be the exploration of existing negatives. I believe the electronic processes will enhance them. I could get superior prints from my negatives using electronics. Then the time will come when you will be able to make the entire photograph electronically. With the extremely high resolution and the enormous control you can get from electronics, the results will be fantastic. I wish I were young again!

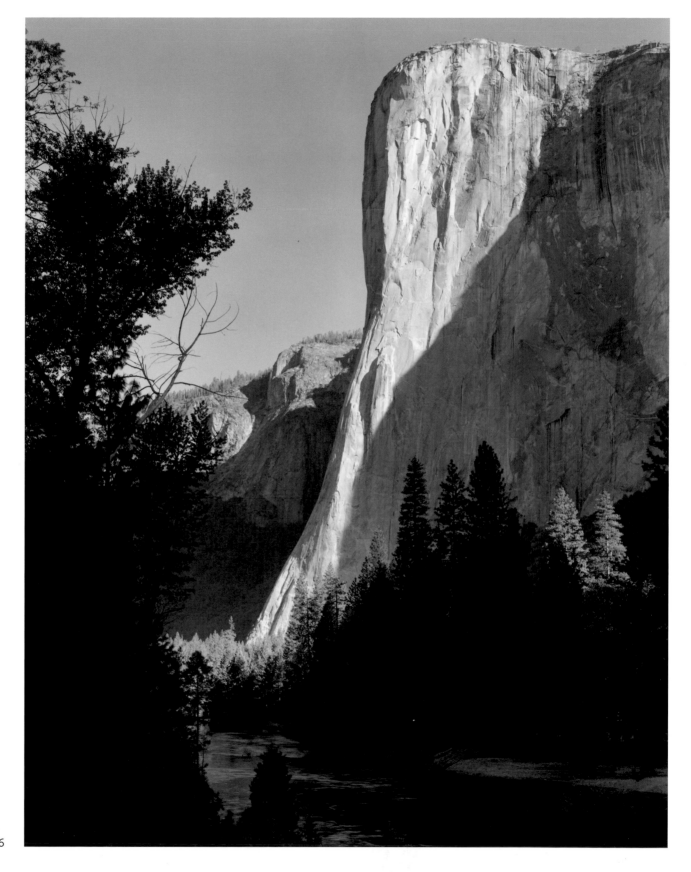

*El Capitan,
Sunrise,*
Yosemite
National Park,
California, 1956

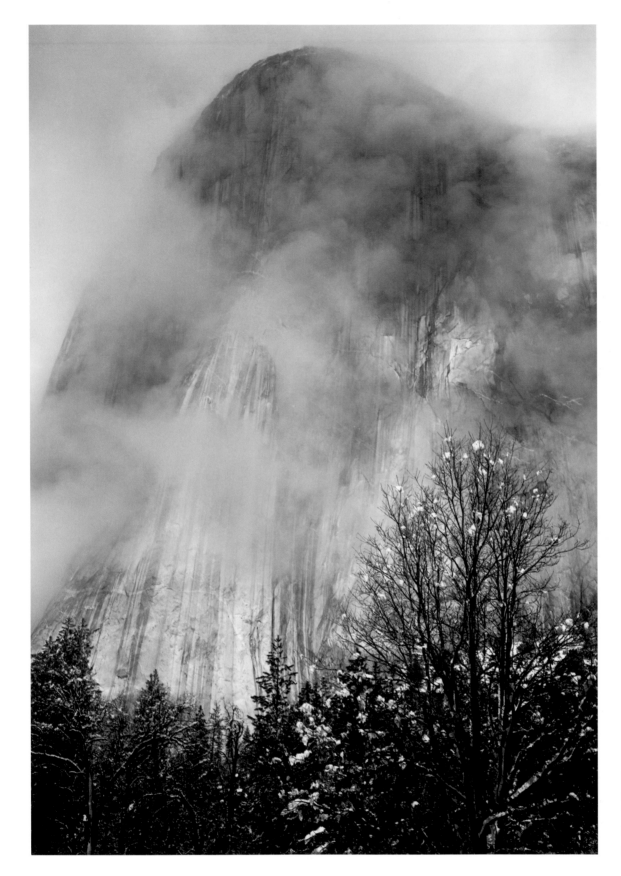

El Capitan, Cliffs and Tree, Winter, Yosemite National Park, California, c. 1940

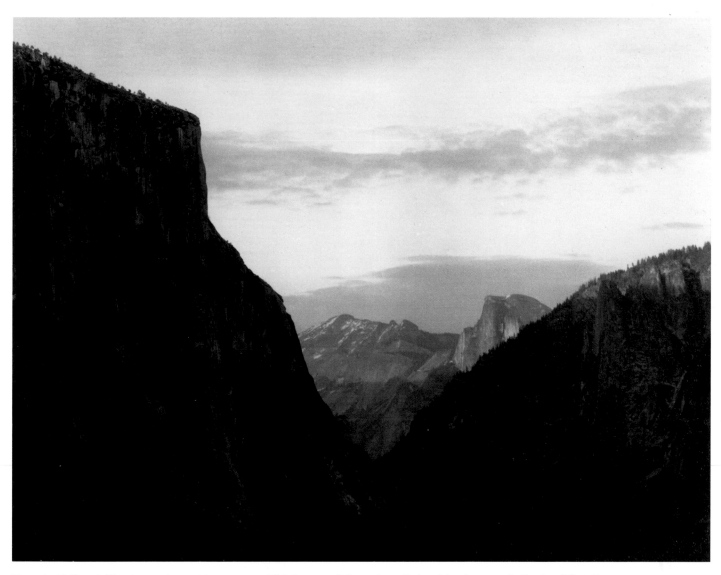

Yosemite Valley, California, made on May 9, 1976. This is one of the unique Polaroid prints made for *Portfolio VII.*

I am confident that if he were alive today he would embrace digital photography in all its aspects. Indeed, Ansel entered the digital age (albeit posthumously) in 2010 with an "app" that features forty of his photographs and commentary on them, plus letters, postcards, video clips, and other material.

Ansel was also endowed with an unsurpassed generosity of spirit and truly adhered to the belief in one's duty to "pass it on." He wrote, "I hope that my work will encourage self-expression in others and stimulate the search for beauty and creative excitement in the great world around us."[20]

Perhaps it is fitting that, after photographing in Yosemite National Park for more than a half century, Ansel's last truly great photograph was made in his beloved valley—and the subject was the magnificent granite monolith The Chieftain... El Capitan.

Author's Note

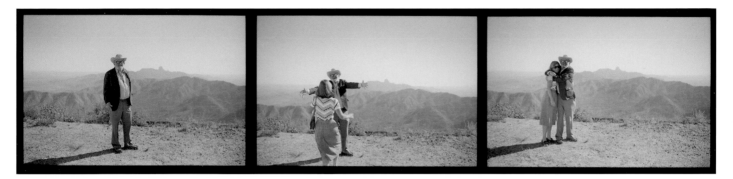

Ansel Adams and Andrea G. Stillman, Kitt Peak, Arizona, 1976. Photographs by Alan Ross.

IN THE SPRING of 1972 Ansel visited the Metropolitan Museum of Art to discuss a solo exhibition of his photographs. I was among the staff gathered to meet him. With his Stetson, his fluffy gray beard, and his twinkly eyes he looked a cowboy Santa Claus.

Over the next two years we worked on plans for the show. The photographs finally arrived in April 1974, and *Clearing Winter Storm* was one of the first to be unpacked. I remember standing in the gallery transfixed. I had assisted with exhibitions of work by artists such as Man Ray, Paul Strand, and Imogen Cunningham, but never before had I been so intensely drawn to a photograph. What struck me was not only its sheer beauty as an object but also the majesty of the landscape.

A few days later, I stood with Bill Turnage, Ansel's business manager, at the corner of 57th Street and Third Avenue. When Bill complained that he had a headache, I asked what might have triggered it. "Just listen," he replied. I suddenly became aware of the infernal din of trucks, buses, and taxis at one of New York City's busiest inter-

sections. The fact that I had simply blocked out the noise meant it was time for me to leave New York.

In May I flew to California to visit Ansel in Carmel—and made an excursion to Yosemite National Park and the Sierra. To experience them after becoming intimately familiar with Ansel's photographs was overwhelming. By June, I was at work in Carmel as his administrative assistant.

When people ask me what I did, I reply, "You name it, I did it." I handled the sale of hundreds of photographs to individuals and dealers; kept track of which negatives Ansel should print and when; checked the condition of each finished photograph and wrote the title on the back; edited his writings; assisted with the selection of photographs for books and exhibitions; traveled with him to press checks, exhibition openings, lectures, and on book-promotion tours; and organized his archive, which featured a massive correspondence and hundreds of photographs. Since his studio was in his home, I often ate lunch there and stayed for dinner. It was more than a full-time job.

Every Friday at 5:00 p.m. when I stepped into Ansel's office to say good-bye, he would ask hopefully, "Will I see you tomorrow?" With pangs of guilt, I would explain that I was taking the weekend off. The next morning, as I gardened behind my condominium, Ansel's smiling face would pop over the fence with the excuse, "I was just passing by."

My relationship with Ansel has informed my life. I love Edward Weston's sensuous photographs of vegetables and Paul Strand's elegant play of shadows on bowls. I admire the intellectual challenge of Alfred Stieglitz's equivalents. But I am most deeply affected by Ansel's gorgeous landscapes. Ansel and his work gave me a reverence for America's wild places and an understanding of the need to conserve our remaining wilderness. When I look at his photographs, I experience a range of emotions—joy, love, optimism, patriotism, admiration, respect, awe—and I sense his eternal presence.

Chronology

William A. Turnage, The Ansel Adams Trust, 2010,
with additions by Andrea G. Stillman, 2011

1902 Born February 20 at 114 Maple Street in San Francisco. Ansel is the only child of Charles and Olive Adams, relatively elderly, well-to-do parents.

1903 Family completes house beyond the limits of urban San Francisco. Ansel grows up amid the magnificent dunes, cliffs, and vistas of the Golden Gate. He will reside at 129/131 Twenty-fourth Avenue for nearly sixty years.

1906 The great San Francisco earthquake and fire occurs on April 18. The Adams house is badly damaged, but no one is injured. An aftershock causes Ansel to trip, striking the sidewalk and breaking his nose. A dramatically bent nose dominates his physiognomy for the rest of his life.

1907 Family lumber business fails, attributed to mill fires, burned and wrecked ships. Financial Panic of 1907 undoubtedly a factor. Ansel's father unsuccessfully devotes rest of his life to restoring family fortune.

1911 Attends Rochambeau School briefly and fruitlessly, having been previously tutored at home by his father and aunt Mary.

1914 Teaches himself to play piano and read music, then studies piano with various teachers for next decade. With music his principal passion until the late 1920s, he practices with great rigor, intending a career as concert pianist.

1915 In lieu of formal schooling, father buys Ansel a season pass for the Panama-Pacific International Exposition (World's Fair), which he visits almost daily. Highlights of the Exposition include his first serious experience with modern art—Cézanne, Monet, Gauguin, van Gogh—and encouragement of lifelong fascination with technology.

1916 At Ansel's behest, the family vacations in Yosemite where Ansel makes his first photographs. Returns to Yosemite annually until his death in 1984. In a very real sense, Ansel's life will center on this great "earth-gesture" of the Sierra Nevada.

1917 Formal schooling ends at eighth grade with diploma from the Kate M. Wilkins School. Never a willing student and always an unusual child, Adams was ultimately self-taught. Although he was probably dyslexic and certainly hyperactive, his genius was evident even in childhood.

1918 Learns the nitty-gritty of photographic darkroom work in two summers at Frank Dittman's commercial photofinishing business in San Francisco.

1920 Appointed caretaker of the Sierra Club's Yosemite headquarters, LeConte Memorial Lodge, and serves there for the following three summers as well. During this period, he photographs intensively, thoroughly exploring the High Sierra.

1921 Begins practicing piano at Best's Studio during summer in Yosemite and meets Virginia Rose Best at her father's studio.

1922 Publishes his first article, on the Lyell Fork of the Merced River, in the *Sierra Club Bulletin*.

1923 Makes his first important photograph, *Banner Peak and Thousand Island Lake*, during a clearing storm. Participates for one week in his first Sierra Club High Trip.

1924 Extended pack trip with Professor Joseph N. LeConte II and family, exploring the remote Kings River High Sierra.

1925 Pursuing a career as a pianist, Ansel purchases (on time payments and with his father's help) a very costly Mason & Hamlin grand piano.

1926 Meets Albert Bender, who soon becomes his most important patron. Bender will greatly help Ansel to believe in himself, both as a person and as an artist.

1927 Perhaps the pivotal year in Ansel's life: with Albert Bender's positive influence, he increasingly begins to see photography, rather than music, as his life's work. His first portfolio, *Parmelian Prints of the High Sierras* [sic], is published with Bender's support. Visits Santa Fe and Taos with Bender, meets Mary Austin, noted western author. In Yosemite, makes first "visualized" photograph, *Monolith, the Face of Half Dome*.

1928 Marries Virginia Best in Yosemite on January 2. Begins to earn living as a commercial photographer while continuing to pursue creative work. Travels with the Sierra Club to Canada to photograph the Canadian Rockies. This is his first trip outside America, and he does not travel abroad again until 1974.

1929 Photographs extensively in New Mexico and, through Mabel Dodge Lujan, meets Georgia O'Keeffe and John Marin, as well as many other Santa Fe–Taos artistic and literary figures. As Nancy Newhall was to write in *The Eloquent Light*, "For Adams in those days, Taos and Santa Fe were his Rome and his Paris."

1930 Paul Strand, whom Ansel visits in Taos, profoundly affects his way of "seeing." Ansel commits himself to "straight" photography. Publishes *Taos Pueblo*, his first photographic book, with text by Mary Austin. One hundred eight copies are handmade, with twelve original photographs bound in, each of which was printed by Ansel on Crane's paper specially coated with a photographic emulsion by W. E. Dassonville.

Has a solo exhibition at the Smithsonian Institution in Washington, D.C.

1932 Cofounds Group f/64 with Edward Weston, Imogen Cunningham, Willard Van Dyke, and others. Has an exhibition at M. H. de Young Memorial Museum in San Francisco.

1933 Goes on pilgrimage to renowned photographer Alfred Stieglitz in New York City. Ansel is deeply influenced by Stieglitz's ideas and passionate commitment to photography as a fine art. Becomes increasingly active as writer, lecturer, and teacher of photography, with Stieglitz as constant hero and role model. Son Michael is born.

1934 Elected a director of the Sierra Club and serves continuously for thirty-seven years. His rising leadership in conservation combines Sierra Club activism with many thousands of lectures, articles, and public statements. Perhaps his photographs—luminous icons of the American wilderness—are the primary source of his seminal role as America's twentieth-century environmental philosopher.

1935 Ansel's first technical book is published, a how-to manual entitled *Making a Photograph*. Immediately successful, it remains in print for nearly two decades. Ansel will become the twentieth century's most influential teacher and theoretician of photography. Daughter Anne is born.

1936 Alfred Stieglitz gives Ansel a solo show at his legendary New York gallery, An American Place—perhaps the proudest moment in Ansel's life as an artist. Represents the Sierra Club in congressional negotiations for a Kings Canyon National Park.

1937 Photographs with Edward Weston in the High Sierra. Ansel's close personal and professional friendship with Weston is of great importance in the 1930s and 1940s.

1938 *Sierra Nevada: The John Muir Trail* is published.

Another exceptional example of limited-edition bookmaking, it further enhances Ansel's reputation as an artist—and influences the successful campaign to create and preserve Kings Canyon National Park.

1939 Begins his most significant personal and professional relationship and collaboration, with Beaumont and Nancy Newhall. Has an exhibition at the San Francisco Museum of Modern Art, the first of several at his favorite museum.

1940 Joins David McAlpin and Beaumont Newhall in cofounding world's first museum department of photography, at New York's Museum of Modern Art. Extremely active teaching and lecturing at MoMA during the next five years.

1941 Makes *Moonrise, Hernandez, New Mexico*—his best-known photograph and among the best known made by any artist. While teaching at the Art Center School in Los Angeles, develops with colleague Fred Archer the legendary Zone System of photographic exposure and darkroom technique.

1942 Through a commission from Secretary of the Interior Harold Ickes, Ansel travels to and photographs the western national parks to create images for murals at the new offices of the U.S. Department of the Interior. The effort is curtailed by American involvement in World War II.

1943 Begins controversial documentary project in support of loyal Japanese Americans interned at Manzanar War Relocation Center in the Owens Valley, east of the Sierra Nevada. This will be Ansel's major venture into the world of the social documentary.

1944 Completes Manzanar project. A companion book, *Born Free and Equal*, is published (and effectively suppressed), and a brief exhibition of the photographs is presented at the Museum of Modern Art in New York. Ansel's work is seen by some as pro-Japan, despite his intended approach as pro-Japanese American and antirelocation.

1945 In order to support his creative work, Ansel remains active until the mid-1960s in commercial photography: his extensive list of clients ranges from the National Park Service to Kodak and Zeiss; IBM and AT&T; a small women's college; a dried-fruit company; and *Life, Fortune,* and *Arizona Highways*. In short, he completes commissions from portraits to catalogs to Kodak Coloramas. All are done at a very high level of proficiency.

1946 Founds the department of photography at the California School of Fine Arts (now the San Francisco Art Institute).

1947 Guggenheim Fellowships in 1946–1947 and 1948 allow Ansel to complete his long-intended project photographing America's national parks. He works extensively in the Southwest, traveling nearly ten thousand rugged miles by car. Makes his first visits to Hawaii's national parks and to the ultimate wilderness, Alaska. The fellowships result in a major book, *My Camera in the National Parks*.

1948 Begins publication of the Basic Photo Series, ultimately five volumes—the most influential and important books ever written on photographic technique; frequently revised, editions are still in print fifty years later. Publishes *Portfolio I*; six more portfolios of original prints follow in next three decades.

1949 Appointed consultant to Polaroid Corporation and develops a particularly close relationship with Edwin Land, Polaroid's founder and scientific genius.

1950 Ansel's mother, Olive Bray Adams, dies. Begins association with Victor Hasselblad and the remarkable Hasselblad camera system. Ansel plays a significant, albeit unpaid, role in the development and evolution of the Hasselblad.

1951 Father dies in August—a great blow, as Charles had been the key figure in Ansel's early life. Lengthy depression sets in.

1952 Cofounds *Aperture* with Minor White and Beaumont and Nancy Newhall. It becomes the most significant journal of creative photography.

1953 Collaborates with Dorothea Lange on an extended photo-essay on Mormon villages for *Life* magazine. Works extensively throughout the year in the Southwest.

1954 Ansel's ongoing friendship and collaboration with Nancy Newhall results in three books published in this year: *Death Valley, Mission San Xavier del Bac,* and *The Pageant of History in Northern California.*

1955 Collaborates with Nancy Newhall on *This Is the American Earth,* which begins as a Sierra Club exhibition and subsequently spawns the Club's noted series of Exhibit Format conservation photography books. The book is published in 1960; along with Rachel Carson's *Silent Spring* (1962), it is profoundly influential in inspiring America's modern era of environmental activism and progress.

1957 Major photographic expedition to Hawaii; work continues in 1958. Results in a book, *The Islands of Hawaii,* with text by Edward Joesting.

1958 Makes two of his most lyrical photographs—one horizontal, one vertical, and both entitled *Aspens, Northern New Mexico.* Awarded third Guggenheim Fellowship.

1959 Public television presents five-part series, *Photography: The Incisive Art,* with Ansel as primary protagonist. The series is rebroadcast from time to time over the next 40 years, attracting millions of viewers.

1960 Makes *Moon and Half Dome, Yosemite National Park*—the most important of the thousands of photographs Ansel made with the Hasselblad camera.

1961 Receives honorary Doctor of Fine Arts degree from the University of California, Berkeley; subsequently receives honorary degrees from Yale, Harvard, and other universities. Lacking formal education or even a high school diploma, Ansel is always intensely pleased and proud to be recognized by "higher academia."

1962 Moves from San Francisco to studio home overlooking the spectacular Big Sur coast, south of Carmel.

1963 Ansel's largest exhibition, with over three hundred photographs, "The Eloquent Light" is curated by Nancy Newhall for San Francisco's M. H. de Young Memorial Museum. Newhall's delightful biography of the first half of Ansel's life is published by the Sierra Club. Also entitled *The Eloquent Light,* the book is still considered the best biography of Ansel.

1966 Made a fellow of the American Academy of Arts and Sciences.

1967 With Beaumont and Nancy Newhall and others, founds the Friends of Photography—an organization intended to continue the Stieglitz-Adams battle for recognition of photography as a fine art. To a considerable degree, the battle was already won.

1968 Publishes *Fiat Lux,* in collaboration with Nancy Newhall, to celebrate the centennial of the University of California. Commissioned by the university, Ansel spends three years on the massive project, making six thousand photographs of the myriad campuses and people of the university. It is by far the biggest journalistic project of Ansel's career.

1969 In the painful and public culmination of the great internal schism that nearly destroys the Sierra Club, executive director David Brower is effectively voted out by the membership. Ansel leads the public fight to oust Brower, his former protégé, as a result of Brower's unwillingness to follow the board of directors' environmental and financial policies. Ansel, not one for personal antagonisms or battles, is heartbroken by Brower's confrontational tactics and personal denigrations.

1970 Chubb Fellow at Yale University. *The Tetons and the Yellowstone* is published; it is to be Ansel's last collaboration with Nancy Newhall.

1971 Receives the Fine Arts Medal of the American Institute of Architects. Retires as a director of the Sierra Club after thirty-seven years of continuous reelection and extraordinarily active leadership; continues, indeed expands, environmental activism.

1973 Begins an extraordinary association with Little, Brown and Company, which becomes his sole authorized publisher. Still dynamic after thirty-seven years, this remains the most successful single-artist program in publishing history, with well over 15 million books, posters, and calendars of the highest quality having been purchased by Ansel Adams fans.

1974 Has an important retrospective exhibition at New York's Metropolitan Museum of Art. Ansel, the inveterate traveler, makes his first visit to Europe at age 72, as the honored guest at the Arles Photography Festival.

1975 Cofounds the Center for Creative Photography at the University of Arizona and bequeaths his massive archive of photographs, negatives, papers, and correspondence to the university. Meets with President Gerald Ford at the White House. Ansel is the first environmentalist in several decades to talk seriously with a president about the national parks.

1976 Makes his second visit to Europe, lasting several weeks and including trips to London, Scotland, Paris, and the French and Swiss Alps. He continues to prefer the U.S. and cares only for European vistas that "remind [him] of California." With great pleasure, however, he attends the opening of a major exhibition of his work at London's Victoria and Albert Museum.

1977 Ansel and Virginia endow the Beaumont and Nancy Newhall Curatorial Fellowship at the Museum of Modern Art in New York—at the time, a rare example of a living artist financially supporting a museum. The $250,000 endowment is subsequently increased to $300,000.

1978 Begins work on new and entirely rewritten edition of his classic series of books on photographic technique—to this day, still the most important how-to books in the history of the medium.

1979 Major exhibition, "Ansel Adams and the West," curated by John Szarkowski, opens at the Museum of Modern Art. Arguably the most intelligent exhibition of Ansel's career, the opening is accompanied by the publication of his magnum opus, *Yosemite and the Range of Light*. To Ansel's great delight, the exhibition and the publication of the book put him on the cover of *Time* magazine.

1980 At the White House, President Jimmy Carter presents Ansel with America's highest civilian award, the Presidential Medal of Freedom. Later in the year, Carter signs the Alaska Lands Act, the most important land and nature conservation legislation in history and the last great wilderness preservation effort in which Ansel plays a key role.

1981 In collaboration with The Wilderness Society, Ansel leads a national campaign to repudiate the environmental policies of Secretary of the Interior James Watt and President Ronald Reagan. It will be Ansel's most vociferous campaign, as he perceives the Reagan administration's anti-environmentalism as the most extreme and damaging of the twentieth century. One-hour documentary *Ansel Adams: Photographer* airs nationally on public television.

1983 Invited to meet with President Ronald Reagan after Reagan reads (in a *Playboy* interview) Ansel's intense criticisms of the environmental policies of the president and Secretary of the Interior James Watt. Following the meeting, Ansel gives a front-page, lead-headline interview to the *Washington Post* in which he declares Reagan and his administration to be environmentally hopeless. Probably the strongest

direct public criticism of Reagan in the early years of his presidency.

1984 Ansel dies on Easter Sunday in Monterey, California, at age 82. Later that year, Congress establishes the Ansel Adams Wilderness: two hundred twenty-five thousand acres encompassing Ansel's favorite part of the High Sierra, between Yosemite and Kings Canyon National Parks, bordering the John Muir Wilderness.

1985 One year after Ansel's death, the U.S. Board of Geographic Names approves the name "Mount Ansel Adams" for a peak on the border of the Ansel Adams Wilderness. Ansel's son, Michael, scatters his father's ashes nearby.

1999 Virginia Best Adams dies at home.

2002 *Ansel Adams,* a one-hour documentary by Rick Burns, airs nationally on public television.

Since Ansel's death in 1984, there have been literally hundreds of exhibitions of his photographs all over the world. Two of the most important were:

2001 John Szarkowski, curator emeritus of the Department of Prints and Photographs at New York's Museum of Modern Art, curates "Ansel Adams at 100," marking the centenary of Ansel's birth. The exhibition opens at the San Francisco Museum of Modern Art and travels to museums around the world. It is accompanied by a catalogue: *Ansel Adams at 100* (Boston: Little, Brown and Company, 2001).

2005 The Lane Collection of Ansel's photographs is exhibited at Boston's Museum of Fine Arts and is accompanied by the publication of a catalogue: *Ansel Adams in the Lane Collection* (Boston: Museum of Fine Arts Publications, 2005).

The Ansel Adams Trust has published numerous books of Ansel's photographs and writings over the years, including, most recently, *Ansel Adams: 400 Photographs* and *Ansel Adams in the National Parks*. Ansel's legacy is also established in the digital realm. *Ansel Adams,* an application ("app") on Ansel and his photographs, was launched on iTunes in 2010. It includes forty of his images with commentary, as well as letters, postcards, and video clips. A second app for the Apple iPhone, *Ansel Adams: An Image a Day,* was released in fall 2011.

Glossary of Photographic Terms

John Sexton, January 2012

Aperture

The diameter of a lens's opening that controls the amount of light passing through the lens. The aperture settings on a lens are commonly referenced in f-stops. A change of one f-stop doubles or halves the light reaching the film (or paper, in enlarging), and thus is equivalent to doubling or halving the exposure time.

ASA

ASA is a numerical indication of a film's sensitivity to light. ASA refers to the American Standards Association. Today the term ISO (International Organization for Standardization) has replaced ASA as the most common reference of film speed. A doubling of the ASA or ISO number represents an emulsion of twice the sensitivity to light, requiring one-half the exposure.

Baryta

Baryta is a coating used on photographic paper, composed predominantly of barium sulfate, a white pigment in a gelatin binder. The Baryta layer influences the texture and color of the whites in a photographic paper. Ansel generally preferred smooth, air-dried, glossy surface, fiber-based photographic papers. These types of papers would all employ a Baryta coating.

Bracketing

A procedure for making exposures at several different exposure settings, with the hope that at least one of them will be correct. Ansel often thought this was a sign of inadequate knowledge of photographic craft.

Bromoil Print

The bromoil process was an early photographic printing method that was very popular with the pictorialists. The prints often have soft, painterly qualities. The process begins with a silver gelatin print, which is bleached. Then lithographer's inks are applied to the bleached print, giving the printmaker the opportunity to control the color, as well as the depth, of the image.

Brownie Camera

Ansel's first photographs were made in Yosemite using a Kodak No. 1 Brownie box camera. This simple camera used size 117 roll film and created 2¼ x 2¼ inch square negatives. It was a simple and popular camera of the era. It allowed very little adjustment in terms of control over the final image.

Burning

A procedure during enlarging that allows additional exposure to be given to areas of an image that otherwise would be too light in the print. Often a card with a hole cut in it is used to block out all but the light needed for the area in question during the burning exposure. Burning time is always in addition to the basic exposure. (See **Dodging**.)

Contact Print

A print made by placing a negative directly on a sheet of photographic paper and projecting light through the negative. The resulting print is exactly the same size as the negative; hence, contact printing is generally used for making finished prints only from large-format negatives. Contact prints are thought by some to produce prints of the highest possible quality.

Dodging

The opposite of burning. During the basic printing exposure, light is withheld from selected areas of the print that otherwise would appear too dark. The procedure is to cast a shadow from a disk or other shape attached to a wire wand and held (with constant motion) between the enlarg-

er's lens and the paper during a portion of the exposure. Dodging time is always factored into the basic exposure time. (See **Burning**.)

Enlarging
The making of a photographic print that is larger than its negative by projecting the image onto photographic paper using a photographic enlarger and lens. The size of the print can be changed by varying the distance between the enlarger head—which contains the negative and the lens—and the photographic paper.

Etching
The process of carefully removing layers of silver from the photographic emulsion of a print or negative. This is usually done using a very sharp knife, such as a surgeon's scalpel or dedicated photographic etching knife. Etching negatives removes density, so that the etched area will produce a darker shade of gray in the final print. Etching is most effectively done on large-format negatives, which require less magnification, during the enlarging process, than smaller pieces of film. It must be done with great care, as it is essentially an irreversible process.

Filter
Optical glass or gelatin filters containing color dyes are often used in black-and-white photography to modify the resulting tones in the image. A red filter, for example, withholds blue and green light, so that blue and green subject areas, like the sky or foliage, are rendered darker in the print than they would otherwise be. Kodak filters are identified with a Wratten number that has become a standard filter designation.

Glass Plates
Glass plates coated with a light-sensitive photographic emulsion were the medium for recording photographic negatives before the invention of transparent plastic film. Glass plates remained in common use among professional photographers for a short period of time after the invention of flexible film, as certain types of emulsion were available only on glass plates in the early part of the twentieth century.

Group f/64
Group f/64 was a loose association of California photographers who promoted a style of sharply detailed "pure" photography. The group, founded in 1932 in the San Francisco Bay area, represented a revolt against the popular pictorialist movement. It consisted of eleven photographers: Ansel Adams, Imogen Cunningham, John Paul Edwards, Preston Holder, Consuelo Kanaga, Alma Lavenson, Sonya Noskowiak, Henry Swift, Willard Van Dyke, Brett Weston, and Edward Weston. The name of the group was taken from the setting of a small camera aperture that gives great depth of field.

Intensification
A corrective or creative procedure for chemically increasing the density of a negative. Intensification is usually done to compensate for inadequate exposure and/or development of the negative. Ansel used a variety of intensification formulas over the years. Late in his life he felt that concentrated selenium toner produced the best results. (See **Selenium Toner**.)

Orthochromatic
Refers to a light-sensitive black-and-white emulsion that is sensitive only to blue and green—and not to red light. Many of Ansel's early photographs were made on orthochromatic glass plates or film, which gave a lighter value for blue sky than does a panchromatic emulsion, and often produced a luminous rendering of green foliage in the shade.

Panchromatic
Refers to a light-sensitive black-and-white emulsion that responds to all colors of light—the standard type of emulsion used in film-based photography today. Results will be similar to a grayscale interpretation of how the scene would be perceived by a human being. Panchromatic emulsions allow considerable manipulation using filters over the camera lens at the time of exposure. (See **Filter**.)

Photoshop
Adobe Photoshop is sophisticated image-editing software, developed and manufactured by Adobe Systems Inc. (ASI), and is one of the most widely used pieces of photographic editing software. Photoshop gives users considerable control over the final image and is very popular among professional photographers today.

Pictorialists

Photographers who followed an international style and aesthetic movement that was popular in the late nineteenth and early twentieth centuries. Followers often attempted to give photographic prints a painterly quality utilizing a variety of techniques, including combination printing from several negatives, soft-focus lenses, and manipulation of the negative, including scratching and painting on the negative.

Polarizer

A filter placed on the camera lens that causes light passing through to become polarized, that is, aligned in orientation. The polarizer is often used to remove glare and reflections from water, glass, etc., and can also be used to darken the sky and increase color saturation.

Polaroid Land Type 55 P/N Positive/Negative Film

A 4 x 5 inch Polaroid black-and-white film that yields both an instant black-and-white print and a usable negative. Several of Ansel's well-known images are printed from Polaroid Type 55 P/N negatives.

Protar Lenses

Dr. Paul Rudolph in Germany developed the Double Protar lens formula for Zeiss in 1894. The lens was also known as the Protar Series VII, and was a convertible lens, i.e., the two lens cells—one in front of the shutter and one behind— could be used together or separately to allow three different focal length options. It was produced by Zeiss until the end of WWII and was highly sought after for its exceptional performance. (See **Triple Convertible Lens.**)

Pyro Developer

Pyro is short for pyrogallol (or pyrogallic acid), which was the most widely used film developing agent in the early years of photography. Pyro is referred to as a "staining" film developer. The warm-colored stained image can produce enhanced highlight definition and edge sharpness with some films. Many of Ansel's early negatives were developed using pyro film developers.

SEI meter

The SEI Exposure Photometer was made by Salford Electrical Instruments in the United Kingdom. The SEI Photometer was a precision light-measuring instrument for both the photographer and the illumination engineer. The field of view of this spot meter was a very narrow one-half degree (compared to most other spot meters, which had one-degree measurement). Ansel used the SEI Photometer in the 1950s and 1960s, until he changed to the Pentax spot meter for most of his photography.

Selenium Toner

A chemical formula often used in processing prints that changes the image color and slightly increases density and contrast. Selenium toner also adds to the archival permanence of a photographic image. Ansel used selenium toner for all of his prints during the last three decades of his life. (See **Intensification.**)

Shutter

A mechanical device that is part of the camera or lens and controls the exposure time when making a negative.

Silver-Bromide Emulsion

A photographic emulsion that contains light-sensitive silver-bromide crystals suspended in gelatin. The emulsion is coated onto paper that is used for making black-and-white photographic prints in the darkroom. Silver-bromide crystals are used either alone or in combination with silver-chloride. The type of crystals used affects the sensitivity to light, the contrast, and the tone of the photographic paper.

Spotting

The application of dyes or pigments to photographic prints to remove dust spots, as part of the finishing and retouching process. In traditional photographic printmaking, any dust on the negative produces light spots on the print. These are removed with the skillful application of retouching dyes, using a very fine brush. This technique can also be used to darken small areas of a print for aesthetic purposes.

Triple Convertible Lens

View-camera lenses, especially early models, often provided more than one focal length, depending on whether the entire lens was used or one component was removed. A triple convertible lens has two cells—one in front of the shutter and one behind—each a different focal length and both

different from the combined effective focal length, thus allowing one lens to produce three different focal lengths. (See **Protar Lens.**)

View Camera

A type of camera that was first developed in the early years of photography and is still in use today by some photographers. View cameras normally use sheet film rather than roll film. Popular view-camera sizes include 4 x 5 inch, 5 x 7 inch, 8 x 10 inch, and larger. The camera is comprised of a flexible bellows that forms a light-tight seal between two standards, one of which holds the lens and the other a film holder. Commonly, these two standards are adjustable, allowing movements, referred to as tilts and swings, to control the shape and focus of the photographic image.

Visualization

The process of "seeing" the final print while viewing the subject and organizing an image before making an exposure. With practice, the photographer can anticipate the various influences of each stage of the photographic process and adjust for these intuitively in visualizing a finished image.

Visualization is the cornerstone of the Zone System. (See **Zone System.**)

Water-Bath Development

A method for developing film that allows the developer solution to soak into the negative, followed by a period of immersion in a plain water bath. The result is a great reduction in contrast of the negative. Ansel used this procedure to successfully render scenes of extremely high contrast. Late in his life, using modern technology films, Ansel preferred to use developers with extremely weak dilutions to accomplish a similar effect.

Zone System

A framework for understanding exposure and development and visualizing their effect prior to making an exposure. Areas of different brightness in the subject are related to exposure zones, and these in turn are related to approximate values of gray in the final print. The difference in exposure between each adjacent zone is exactly one f-stop. Ansel and Fred Archer codified the Zone System between 1939 and 1941.

Acknowledgments

MANY PEOPLE have helped bring this book to fruition. Chief among them are David Young and Jean Griffin at Hachette Book Group. In addition, Little, Brown editor Michael Sand ably edited my text and kindly shepherded me through the publication process. The production team included chief copy editor Michael Neibergall; editorial assistant Melissa Caminneci; production supervisor Sandra Klimt, who once again guided the production with skill and friendship; Thomas Palmer, whose scans capture the subtle nuances of Ansel's photographs; designer Lance Hidy, with whom I have happily worked for more than thirty years; and Mondadori printers in Italy.

In addition, I would like to thank: my twin sister Adrienne Hines; Evelyne Thomas; Peter Bunnell; Laura Bayless and Anne Larsen of the John Sexton Studio; David Kennerly; Meg Partridge; Peter Farquhar; Mike Mandel; Charles Kramer; Nathan Schnitt of Getty Images; Vasilios Zatse; Denise Gose and Sue Spencer of the Center for Creative Photography; Nancy Norman Lasselle; the Beinecke Rare Book and Manuscript Library, Yale University; the family of David H. McAlpin; David Scheinbaum, Janet Russek, and Andra Russek of Scheinbaum and Russek; Christopher Mahoney of Sotheby's; Ellen Byrne, librarian of the Sierra Club; Susan Snyder, the Bancroft Library; Andy Smith and the Andrew Smith Gallery; Peter MacGill and Kimberly Jones of Pace MacGill Gallery; Maria Friedrich and Julie Graham; Suzanne Smeaton of Eli Wilner & Co.; David Arrington, Susan Mikula, Karen and Kevin Kennedy, and Michael Mattis and Judith Hochberg, who generously allowed me to reproduce photographs from their collections.

Working at Ansel's house in the 1970s I was privileged to know and work with two outstanding photographers, Alan Ross and John Sexton, who served as Ansel's photographic assistants. Both have helped me inordinately with their technical knowledge, their photographs, and our shared insights into working with Ansel. This book is richer because of their willing participation. In addition, John served as technical consultant and authored the Glossary of Photographic Terms.

Thanks to Leslie Squyres at the Center for Creative Photography, who—with good humor and miraculous speed—can locate almost any letter or photograph in Ansel's archive. And thanks to Michael and Jeanne Adams and Anne Adams Helms for their kind support and their willingness to share not only their knowledge of Ansel, but also photographs from their collections.

Without Bill Turnage this book would not exist. Bill was intimately involved with every aspect of the publication, from the concept to word-by-word editing. As with all of our projects together over nearly forty years, his help and guidance were essential.

Finally, my grateful thanks to Ansel. Working with him and his photographs profoundly affected my life. His loving friendship, noble spirit, and beautiful photographs will forever resonate in my heart.

Endnotes

Introduction

1 Nancy Newhall to Ansel Adams, April 27, 1948.
2 Interview with the author, October 31, 1980.
3 William A. Turnage, "Ansel Adams: Environmentalist," *Ansel Adams in the National Parks* (Boston: Little, Brown and Company, 2010), 327.
4 Ansel Adams to Beaumont and Nancy Newhall, September 22, 1946.
5 Ansel Adams to Nancy Newhall, April 18, 1951.
6 Ansel Adams, *An Autobiography* (Boston: Little, Brown and Company, 1985), 110.
7 Ansel Adams, notes for his autobiography, May 27, 1980, 6D.
8 John Marin in an interview with Nancy Newhall, 1945; quoted in Nancy Newhall, *The Eloquent Light* (San Francisco: Sierra Club, 1963), 60.
9 Beaumont Newhall to Nancy Newhall, August 18, 1951.
10 Ibid.
11 Ansel Adams, *An Autobiography* (Boston: Little, Brown and Company, 1985), 67.
12 Ansel Adams to Virginia Best, June 6, 1926.
13 Ansel Adams to Alfred Stieglitz, October 9, 1933.
14 Peter J. Gomes, *The Good Book* (New York: Harper San Francisco, 2002), 214.
15 Interview with the author, October 23, 1980.
16 Nancy Newhall to Ansel Adams, December 28, 1951.
17 David McAlpin to Virginia Adams, October 19, 1941.
18 Alfred Stieglitz to Ansel Adams, April 18, 1938.

Chapter 1

1 Ansel Adams, "Lyell Fork of the Merced" (San Francisco: *Sierra Club Bulletin,* 1922), 315.
2 Ansel Adams to Charles Adams, April 27, 1920.
3 Ansel Adams, *An Autobiography* (Boston: Little, Brown and Company, 1985), 59.
4 Ansel Adams to Virginia Best, September 5, 1921.
5 Ansel Adams, *Examples: The Making of 40 Photographs* (Boston: Little, Brown and Company, 1983), 49.
6 John Szarkowski, Introduction, *The Portfolios of Ansel Adams* (Boston: Little, Brown and Company, 1977), viii.
7 Bromoil is a time-consuming process with which Ansel only briefly experimented around 1923. The process involves bleaching and tanning a black-and-white photograph, then soaking it in water, and finally applying lithographic ink, often with a brush.
8 Ansel Adams to Beaumont Newhall, January 6, 1950.
9 Ansel Adams to Peter Steil, January 11, 1978.
10 Ansel Adams, "Lyell Fork of the Merced," *Sierra Club Bulletin,* 1922, 316.

Chapter 2

1 LeConte Memorial Lodge in Yosemite, where Ansel worked as caretaker beginning in 1920, was named for Professor LeConte's father, the first professor of geology and natural history at the University of California, Berkeley, and a cofounder of the Sierra Club, with John Muir.
2 Ansel Adams, "Clouds," 1923.
3 Ansel Adams, *Examples: The Making of 40 Photographs* (Boston: Little, Brown and Company, 1983), 67.
4 Ibid.
5 Ansel Adams to Patsy English, postmarked September 26, 1937.
6 Ansel Adams, "Landscape: An Exposition of My Photographic Technique," *Camera Craft,* February 1934, 73.
7 Ansel Adams, *An Autobiography* (Boston: Little, Brown and Company, 1985), 149.
8 Ansel Adams, *Sierra Nevada: The John Muir Trail* (Berkeley: The Archetype Press, 1938).
9 James T. Gardiner, journal entry for July 12, 1866 (in the Farquhar Papers at the Bancroft Library).
10 Charles W. Michael, "First Ascent of the Minarets" (San Francisco: *Sierra Club Bulletin* 12, No. 1, 1924), 31.
11 Arno B. Cammerer to Ansel Adams, February 26, 1940.
12 Georgia O'Keeffe was Alfred Stieglitz's wife.
13 Alfred Stieglitz to Ansel Adams, December 31, 1938.
14 Ansel Adams, *Sierra Nevada: The John Muir Trail* (Boston: Little, Brown and Company, 2006).
15 Interview with the author, June 10, 1980.
16 Interview with the author, March 1980.

Chapter 3

1 See Chapter 2, pages 33–34 and page 238 in the Glossary of Photographic Terms.
2 Ansel Adams, *Examples: The Making of 40 Photographs* (Boston: Little, Brown and Company, 1983), 3.
3 Ibid., 4.
4 Ansel Adams, *The Negative* (Boston: Little, Brown and Company, 1981), 5.
5 Ansel Adams, *An Autobiography* (Boston: Little, Brown and Company, 1985), 76.
6 Ansel Adams to Virginia Best, May 1925.
7 Ansel Adams, *Examples: The Making of 40 Photographs* (Boston: Little, Brown and Company, 1983), 5.
8 Ansel Adams, *The Camera* (Boston: Little, Brown and Company, 1980), 1.
9 "Conversations with Ansel Adams," an oral history conducted in 1972, 1974, and 1975 by Ruth Teiser and Catherine Harroun, Regional Oral History Office, The Bancroft Library, University of

California, Berkeley (1978).

10 Tom Cooper and Paul Hill, "Interview: Ansel Adams," *Camera* 55, no. 1 (January 1976), 21.

11 Ansel Adams to Beaumont Newhall, January 6, 1950.

12 Nancy Newhall to Ansel Adams, January 20, 1950.

13 Plus fours are pants for sporting occasions that come to four inches below the knee. Ansel wore them often—even to his wedding ceremony.

14 John Sexton to the author, April 2011.

Chapter 4

1 Ansel Adams, *Examples: The Making of 40 Photographs* (Boston: Little, Brown and Company, 1983), 91.

2 Ibid.

3 See Chapter 2, pages 33–34 and page 238 in the Glossary of Photographic Terms.

4 Ansel Adams, *Examples: The Making of 40 Photographs* (Boston: Little, Brown and Company, 1983), 91–92.

5 Ibid., 93.

6 Interview with the author, January 1980.

7 Ansel Adams to Virginia Adams, 1928.

8 Ansel Adams to Albert Bender, April 1929.

9 Ibid.

10 Folio-sized books are quite large, and *Taos Pueblo* measures 17 x 13 inches. The word *folio* refers to a sheet of paper printed with two pages of text on each side, which is then folded to form two leaves or four pages.

11 Ansel Adams to Albert Bender, April 1929.

12 Ansel Adams to Beaumont Newhall, January 6, 1950; in contrast, most of the photographs by Ansel in circulation today are enlargements made with considerable manipulation in the darkroom.

13 Ibid.

14 Ibid.; see Chapter 5 for a discussion of Ansel's rejection of pictorial photography.

15 Ansel photographed Tony Lujan in San Francisco, not at Taos Pueblo.

16 Mary Austin to Ansel Adams, postmarked November 3, 1930.

17 Ansel Adams to Albert Bender, January 15, 1931.

18 The only other books that include original photographs by Ansel are *Trackless Winds,* a volume of poems by John Burton (San Francisco: Jonck & Seeger, 1930) and *Poems* by Robinson Jeffers (San Francisco: The Book Club of California, 1928), each with an original photograph of the author (signed by Ansel) bound in.

19 Ansel Adams to Mary Austin, November 1, 1930.

20 Ansel Adams to Virginia Adams, April 1928.

21 Ansel Adams to Charles Adams, April 4, 1929.

22 Ansel Adams to Virginia Adams, April 1928.

23 Ibid.

24 Ibid.

25 Ansel Adams to Virginia Adams, April 1928.

26 Ibid.

Chapter 5

1 Ansel Adams to David McAlpin, February 3, 1941.

2 "Conversations with Ansel Adams," an oral history conducted in 1972, 1974, and 1975 by Ruth Teiser and Catherine Harroun, Regional Oral History Office, The Bancroft Library, University of California, Berkeley (1978).

3 Ibid.

4 Ansel Adams, Unfinished manuscript, c. 1934.

5 Ansel Adams, "Practical Hints on Lenses," *U.S. Camera,* no. 15, 1941, 15.

6 Ansel Adams, *The Negative* (Boston: Little, Brown and Company, 1981), 185.

7 Ansel Adams, *Examples: The Making of 40 Photographs* (Boston: Little, Brown and Company, 1983), 33.

8 Interview with the author, October 23, 1980.

9 Ansel Adams to Alfred Stieglitz, May 16, 1935.

10 Ansel Adams, *Making a Photograph: An Introduction to Photography* (London: The Studio Publications, 1935).

11 Alfred Stieglitz to Ansel Adams, May 13, 1935.

12 Tom Maloney was the editor of *U.S. Camera,* a magazine that reproduced Ansel's photographs and published his writing for many years.

13 Ansel Adams, *An Autobiography* (Boston: Little, Brown and Company, 1985), 315.

14 *Portfolio V,* a portfolio of ten original photographs by Ansel Adams, published by Parasol Press, 1970; *Portfolio VI,* a portfolio of twelve original photographs by Ansel Adams, published by Parasol Press, 1974.

Chapter 6

1 Ansel Adams, *An Autobiography* (Boston: Little, Brown and Company, 1985), 145.

2 Francis P. Farquhar, *History of the Sierra Nevada* (Berkeley: University of California, 1965), 228.

3 John Szarkowski, "Kaweah Gap and Its Variants," *Untitled* [a quarterly], 1984, 13–14 (Carmel: Friends of Photography).

4 Hollis T. Gleason, "The Outing of 1932," *Sierra Club Bulletin* 18, no. 1 (February 1933), 5–19.

5 Ibid.

6 Ibid.

7 Ansel Adams, *An Autobiography* (Boston: Little, Brown and Company, 1985), 144.

8 Ansel Adams to the author, July 21, 1981.

9 Ansel Adams, *Making a Photograph: An Introduction to Photography* (London: The Studio Publications, 1935), 63.

10 Ansel Adams, *Examples: The Making of 40 Photographs* (Boston: Little, Brown and Company, 1983), 12.

11 Ibid.

12 Ansel Adams, *Examples: The Making of 40 Photographs* (Boston: Little, Brown and Company, 1983), 13.

Chapter 7

1 Ansel Adams to Virginia Adams, late November 1936.

2 Ansel Adams to Katherine Kuh, October 21, 1936.

3 Ansel Adams to the author, 1980.

4 Ansel Adams to Patsy English,

November 1936.

5 Nancy Newhall to Ansel Adams, January 13, 1951.

6 Ansel Adams, *An Autobiography* (Boston: Little, Brown and Company, 1985), 187.

7 Ansel Adams to the author, June 23, 1981.

8 Interview with the author, January 1980.

9 Ansel Adams to David McAlpin, February 3, 1941.

10 Interview with the author, November 7, 1980.

11 Interview with the author, 1980.

12 Ansel Adams to Patsy English, November 11, 1936; Patsy said that it was she who convinced Ansel to shave off his beard.

13 Ibid.

14 Ansel Adams to Patsy English, November 1936.

15 Ansel Adams to Patsy English, postmarked November 27, 1936.

16 Ansel Adams to Patsy English, July 28, 1978.

Chapter 8

1 Ansel Adams to Alfred Stieglitz, September 21, 1937.

2 Ansel Adams to David McAlpin, August 12, 1937.

3 Ansel Adams, *Examples: The Making of 40 Photographs* (Boston: Little, Brown and Company, 1983), 154.

4 Ansel Adams to Cedric Wright, August 15, 1935.

5 Ansel Adams, "My First Ten Weeks with a Contax," *Camera Craft* XLIII, no. 1 (January 1936), 16.

6 Ansel Adams, *Examples: The Making of 40 Photographs* (Boston: Little, Brown and Company, 1983), 156.

7 Ansel Adams, "My First Ten Weeks with a Contax," *Camera Craft* XLIII, no. 1 (January 1936), 16.

8 Ansel Adams, *Examples: The Making of 40 Photographs* (Boston: Little, Brown and Company, 1983), 156.

9 Ansel Adams, *An Autobiography* (Boston: Little, Brown and Company, 1985), 226.

10 Ansel Adams, "My First Ten Weeks with a Contax," *Camera Craft* XLIII, no. I

(January 1936), 16–17.

11 Ansel Adams, *The Camera* (Boston: Little, Brown and Company, 1980), 9.

12 Ansel Adams, *Examples: The Making of 40 Photographs* (Boston: Little, Brown and Company, 1983), 155.

13 Ansel Adams to Albert Bender, April 1929.

14 Interview with the author, 1980.

15 Ansel Adams, *An Autobiography* (Boston: Little, Brown and Company, 1985), 230.

16 Hilton Kramer, "Ansel Adams: Trophies from Eden," *New York Times*, May 12, 1974.

Chapter 9

1 Ansel Adams, *Examples: The Making of 40 Photographs* (Boston: Little, Brown and Company, 1983), 103.

2 Ansel Adams, "Yosemite," *Travel and Camera Magazine*, October 1946. Inspiration Point is one thousand feet above the floor of Yosemite Valley. The panorama that Ansel recorded is also known as the Tunnel View.

3 Ansel Adams, "Yosemite," *Travel and Camera Magazine*, October 1946.

4 Lafayette Bunnell, *The Discovery of Yosemite* (New York: F. H. Revell Company, 1892, 3rd edition), 63.

5 Ansel Adams, *Yosemite and the Sierra Nevada* (Boston: Houghton Mifflin Company, 1948), xiv.

6 Ansel Adams, *An Autobiography* (Boston: Little, Brown and Company, 1985), 241–242.

7 Ansel Adams, *Examples: The Making of 40 Photographs* (Boston: Little, Brown & Company, 1983), 103.

8 Ibid., 104.

9 Ibid., 105.

10 Ansel Adams, "The Zone System," *The Negative* (Boston: Little, Brown and Company, 1981), 47.

11 Ansel Adams, *Examples: The Making of 40 Photographs* (Boston: Little, Brown and Company, 1983), 105.

12 Undeveloped photographic paper must be kept in the dark or it will "fog" or turn gray; only a special light is safe for illumination.

13 Ansel Adams, *Examples: The Making of 40

Photographs* (Boston: Little, Brown and Company, 1983), 103.

14 Ansel Adams to Beaumont Newhall, April 15, 1961; a fire in Ansel's darkroom in July 1937 burned many negatives; smoke and water damaged others.

15 Ansel Adams, "Landscape: An Exposition of My Photographic Technique," *Camera Craft*, February 1934, 72.

16 Ibid.

17 Consult www.yosemitehikes.com by Russ Cary, who provides useful information coupled with terrific humor.

Chapter 10

1 Ansel Adams, *Examples: The Making of 40 Photographs* (Boston: Little, Brown and Company, 1983), 41.

2 Ansel Adams, *An Autobiography* (Boston: Little, Brown and Company 1985), 273–274.

3 Ibid., 273.

4 Ansel was relying on his newly formulated Zone System, which divides any image into ten zones from white to black.

5 Ansel Adams, *An Autobiography* (Boston: Little, Brown and Company, 1985), 273.

6 Wallace Stegner, foreword to *Ansel Adams: Images 1923–74* (Boston: Little, Brown and Company, 1974), 18.

7 Water-bath development results in a reduction of contrast of a negative.

8 Ansel Adams, *Examples: The Making of 40 Photographs* (Boston: Little, Brown and Company, 1983), 42.

9 Ansel Adams, *An Autobiography* (Boston: Little, Brown and Company, 1985), 274.

10 Ansel Adams, *Natural Light Photography* (Boston: Little, Brown and Company, 1976), 127.

11 Ibid.

12 Ansel Adams, *Examples: The Making of 40 Photographs* (Boston: Little, Brown and Company, 1983), 42.

13 Kodak's formula IN-5 uses silver nitrate as an intensifying agent.

14 Ansel Adams to Nancy Newhall, December 17, 1948.

15 Ansel Adams to Beaumont and Nancy

Newhall, December 31, 1948.

16 Beaumont Newhall to Ansel Adams, December 31, 1948. "The Negative" refers to Ansel's second volume in his Basic Photo Series; "the Muir" refers to *Yosemite and the Sierra Nevada,* with text by John Muir and photographs by Ansel; "Portfolio One" refers to Ansel's first portfolio of photographs, published in 1948.

17 "Ansel Gives Moonrise to Hernandez," *The New Mexican,* 1980.

18 Nancy Newhall to Ansel Adams, February 28, 1953.

19 John Szarkowski, wall label from "Ansel Adams and the West," Museum of Modern Art, New York, 1979.

20 "The Rise, Fall, and Gravitational Pull of the Moon," *Art & Auction,* April 1981, 12.

21 Ibid.

22 Charles Hagen, "Why Ansel Adams Stays So Popular," *New York Times,* November 10, 1995.

23 Ansel Adams, *An Autobiography* (Boston: Little, Brown and Company, 1985), 274.

24 Ibid., 275.

25 Ansel Adams, *Singular Images* (Dobbs Ferry, New York: Morgan & Morgan, Inc., 1974), in the "Statement" by Ansel Adams (unpaginated).

26 Ansel Adams, *Examples: The Making of 40 Photographs* (Boston: Little, Brown and Company, 1983), 43.

27 *Ansel Adams: Photographer,* a one-hour documentary film by FilmAmerica, 1981.

28 Ansel Adams, *Examples: The Making of 40 Photographs* (Boston: Little, Brown and Company, 1983), 41.

29 Interview in *The New Mexican,* June 9, 1980.

30 Nancy Newhall to Ansel Adams, January 6, 1949.

31 Wallace Stegner, foreword to *Ansel Adams Images: 1923–74* (Boston: New York Graphic Society, 1974), 18.

32 Peter Bunnell, "An Ascendant Vision," *Untitled* [a quarterly] 37, 1984, 56 (Carmel: Friends of Photography).

33 Ansel Adams, "An Approach to a Practical Technique," *U.S. Camera,* no. 9, May 1940, 81.

Chapter 11

1 Ansel's first car platform was mounted on his 1941 woodie Pontiac station wagon in the spring of 1943. The elevation of the platform provided a better vantage point from which to photograph.

2 Ansel's photographic assistant, John Sexton, heard Virginia Adams describe on more than one occasion how—over her protests—she had to move the car slightly while Ansel stood on top with his camera, in order to achieve the desired composition.

3 Ansel Adams, *Examples: The Making of 40 Photographs* (Boston: Little, Brown and Company, 1983), 164.

4 Nearby Manzanar War Relocation Center was established in 1942 to house Japanese American citizens during World War II. See Chapter 14.

5 Ansel Adams, *Examples: The Making of 40 Photographs* (Boston: Little, Brown and Company, 1983), 164.

6 Nancy Newhall, *The Eloquent Light* (San Francisco: The Sierra Club, 1963), 13.

7 Ansel Adams, *An Autobiography* (Boston: Little, Brown and Company, 1985), 262.

8 David McAlpin to Ansel Adams, January 27, 1944.

9 Alan Ross to Gary George, June 14, 2010.

10 Conversation with the author, 1979.

11 Large-format negatives are generally understood to be produced by cameras that use film larger than 120 roll film; for Ansel this was most often a 4 x 5 inch, 5 x 7 inch, 6½ x 8½ inch, or 8 x 10 inch camera.

12 Wallace Stegner, foreword to *Ansel Adams: Images 1923–74* (Boston: New York Graphic Society, 1974), 19.

13 Ansel Adams in Nancy Newhall, *The Eloquent Light* (San Francisco: The Sierra Club, 1963), 17.

Chapter 12

1 Nancy Newhall to Beaumont Newhall, June 7, 1944.

2 Ibid.

3 From Ansel Adams, *Examples: The Making of 40 Photographs* (Boston: New York Graphic Society, 1983), 7.

4 Ansel Adams to the author, June 23, 1981.

5 Albert Bender to Ansel Adams, April 4, 1933.

6 Ansel Adams to the author, June 23, 1981.

7 "Conversations with Ansel Adams," an oral history conducted in 1972, 1974, and 1975 by Ruth Teiser and Catherine Harroun, Regional Oral History Office, The Bancroft Library, University of California, Berkeley (1978).

8 Conversation with the author, 1981.

9 Ibid.

10 Ansel Adams to Alfred Stieglitz, May 16, 1935.

11 Ansel Adams to Virginia Adams, late August 1930.

12 Ansel Adams to Alfred Stieglitz, November 24, 1939.

13 James Alinder, "Ansel Adams: 50 Years of Portraits," *Untitled* [a quarterly] 16, 1978, 48 (Carmel: Friends of Photography).

14 Alfred Stieglitz to Nancy Newhall, July 23, 1945.

15 Ansel Adams, *Portfolio I,* a collection of twelve original photographs published in 1949 in an edition of seventy-five.

16 Ansel Adams to Nancy Newhall, December 17, 1948.

17 Ansel Adams to Nancy Newhall, September 15, 1948.

18 Nancy Newhall's notes for the unpublished second volume of Ansel's biography, *The Enduring Moment,* Folder 4.

19 Alfred Stieglitz to Edward Weston, September 3, 1938.

20 Ansel Adams to Beaumont Newhall, March 15, 1938.

Chapter 13

1 Dorothy Norman, ed., *Twice a Year: A Book of Literature, the Arts and Civil Liberties* XII–XIII, 1945, 323.

2 Ansel Adams, *The Print* (Boston: Little, Brown and Company, 1983), 185.

3 Ibid.

4 Ansel Adams to David McAlpin, June 30, 1945.

5 Margery Mann, "View from the Bay," *Popular Photography,* May 1971, 130.

6 Ansel Adams, "Portraiture: An Exposition of My Photographic Technique," *Camera Craft* XLI, no. 3 (March 1934), 12.

7 Wallace Stegner, foreword to *Ansel Adams: Images, 1923–74* (Boston: New York Graphic Society, 1974), 15.

8 Ansel Adams to Wallace Stegner, December 19, 1973.

9 Ansel Adams to Alfred Stieglitz, October 9, 1933.

10 James Alinder, "Ansel Adams: 50 Years of Portraits," *Untitled* [a quarterly] 16, 1978, 47 (Carmel: Friends of Photography).

11 Ansel Adams, "Portraiture: An Exposition of My Photographic Technique," *Camera Craft* XLI, no. 3 (March 1934), 118.

12 Ansel Adams, *Examples: The Making of 40 Photographs* (Boston: Little, Brown and Company, 1983), 37.

13 Ibid.

14 Conversation with the author, October 23, 1980.

15 James Alinder, "Ansel Adams: 50 Years of Portraits," *Untitled* [a quarterly] 16, 1978, 53 (Carmel: Friends of Photography).

16 Ansel Adams, "Portraiture: An Exposition of My Photographic Technique," *Camera Craft* XLI, no. 3 (March 1934), 116.

17 Ibid.

18 James Alinder, "Ansel Adams: 50 Years of Portraits," *Untitled* [a quarterly] 16, 1978, 51 (Carmel: Friends of Photography).

19 Ibid, 50.

20 Ansel Adams, "Portraiture: An Exposition of My Photographic Technique," *Camera Craft* XLI, no. 3 (March 1934), 116.

21 James Alinder, "Ansel Adams: 50 Years of Portraits," *Untitled* [a quarterly] 16, 1978, 52 (Carmel: Friends of Photography).

Chapter 14

1 Ansel Adams, *Born Free and Equal* (New York: Camera Craft, 1944), 12.

2 Ansel Adams, *An Autobiography* (Boston: Little, Brown and Company, 1985), 260.

3 Ansel Adams, *Examples: The Making of 40 Photographs* (Boston: Little, Brown and Company, 1983), 68.

4 Ansel Adams to Beaumont Newhall, April 15, 1961.

5 Ansel Adams, *Examples: The Making of 40 Photographs* (Boston: Little, Brown and Company, 1983), 69.

6 Ansel Adams to Edward Steichen, December 17, 1954.

7 "Conversations with Ansel Adams," an oral history conducted in 1972, 1974, and 1975 by Ruth Teiser and Catherine Harroun, Regional Oral History Office, The Bancroft Library, University of California, Berkeley (1978).

8 Ansel Adams to Nancy Newhall, fall 1943.

9 Ansel Adams to David McAlpin, April 16, 1943.

10 Ansel Adams to Nancy Newhall, fall 1943.

11 Ansel Adams, *An Autobiography* (Boston: Little, Brown and Company, 1985), 257.

12 Ansel Adams to David McAlpin, April 16, 1943.

13 Ansel Adams, *An Autobiography* (Boston: Little, Brown and Company, 1985), 260.

14 Ansel Adams, *Born Free and Equal* (New York: Camera Craft, 1944), 7.

15 Ibid., 12.

16 Ansel Adams to Steve Griffith, May 23, 1982.

17 Suzanne Reiss, *Dorothea Lange: The Making of a Documentary Photographer* (University of California Regional Oral History Office, 1968), 190.

18 "Conversations with Ansel Adams," an oral history conducted in 1972, 1974, and 1975 by Ruth Teiser and Catherine Harroun, Regional Oral History Office, The Bancroft Library, University of California, Berkeley (1978).

19 John Szarkowski, "Ansel Adams at 100" (New York: Museum of Modern Art, 2001), 46.

20 Ansel Adams to Nancy Newhall, July 23, 1944.

21 Ansel Adams, *An Autobiography* (Boston: Little, Brown and Company, 1985), 260.

22 Ansel Adams, *Born Free and Equal* (New York: Camera Craft, 1944), 110.

Chapter 15

1 James Alinder, "Ansel Adams: 50 Years of Portraits," *Untitled* [a quarterly] 16, 1978, 49 (Carmel: Friends of Photography).

2 Ansel Adams, *Examples: The Making of 40 Photographs* (Boston: Little, Brown and Company, 1983), 145.

3 Ibid.

4 Nancy Newhall, *The Eloquent Light* (San Francisco, The Sierra Club, 1963), 68.

5 Ansel Adams, *An Autobiography* (Boston: Little, Brown and Company, 1985), 237.

6 Ansel Adams, "Photography," *The Fortnightly* (December 18, 1931), 21.

7 James Alinder, "Ansel Adams: 50 Years of Portraits," *Untitled* [a quarterly] 16, 1978, 47 (Carmel: Friends of Photography).

8 Ansel Adams to Patsy English, June 14, 1938.

9 Ansel Adams to David McAlpin, April 16, 1943.

10 Ansel Adams to Edward Weston, shortly after April 2, 1943.

11 Edward Weston to Ansel Adams, September 28, 1945. The stenographer Weston refers to was Lee Benedict, who started to work for Ansel that year, equipped with a genuine stenographic machine to take dictation (see page 194 for a photograph of Benedict typing at an outdoor makeshift office in Yosemite).

12 Ansel Adams to Edward Weston, September 28, 1945.

13 Edward Weston to Ansel Adams, postmarked October 2, 1945.

14 Ansel Adams, draft of article for *Aperture* on Edward Weston's death, January 8, 1958, 3.

15 Ibid.

16 Ansel Adams to Edward Weston, c. November 18, 1945.

17 Ansel Adams to Beaumont and Nancy Newhall, March 8, 1948.

18 Ansel Adams to Nancy Newhall, February 8, 1949.

19 Ansel Adams to Nancy Newhall, April 3, 1951.

20 Ansel Adams, *My Camera in Yosemite Valley* (Yosemite: Virginia Adams, and Boston: Houghton Mifflin Company), 1949.

21 Edward Weston to Ansel Adams, January 9, 1945.

22 Ansel Adams, "Edward Weston," *Infinity* magazine, February 1964, 26.

23 Ansel Adams, *An Autobiography* (Boston: Little, Brown and Company, 1985), 253.

24 Ansel Adams to Edward Weston, November 29, 1934.

25 Ansel Adams to Edward and Charis Weston, December 1940.

26 Ansel Adams, "Edward Weston," *Aperture* magazine, January 8, 1958.

27 Ansel Adams, *An Autobiography* (Boston: Little, Brown and Company, 1985), 254.

28 Dedication and foreword for *Portfolio VI* (Parasol Press Ltd.: New York, 1974).

29 From Nancy Newhall's unpublished notes.

30 Ansel Adams to the editor, *Westways* magazine, September 28, 1939.

Chapter 16

1 Ansel Adams, *An Autobiography* (Boston: Little, Brown and Company, 1985), 284–285.

2 Ansel Adams, *An Autobiography* (Boston: Little, Brown and Company, 1985), 285.

3 Ibid.

4 *Portfolio I* was actually Ansel's second portfolio, as he had published *Parmelian Prints of the High Sierras* in 1927 (see Chapter 3).

5 Ansel Adams, *The Print* (Boston: Little, Brown and Company, 1983), 166.

6 Alan Ross to the author, October 2011.

7 Ansel Adams to Nancy and Beaumont Newhall, July 21, 1948.

8 Ibid.

9 Ansel Adams, *An Autobiography* (Boston: Little, Brown and Company, 1985), 286.

10 Ibid., 287.

11 Ansel Adams to Beaumont and Nancy Newhall, July 21, 1948.

12 Ansel Adams to Nancy and Beaumont Newhall, July 7, 1948.

13 Ansel Adams, *An Autobiography* (Boston:

Little, Brown and Company, 1985), 236.

14 Ibid., 288–289.

15 Ansel was the first photographer to make the official portrait of a sitting president.

16 John Sexton to the author, January 5, 2012.

17 Ansel Adams to President Jimmy Carter, July 16, 1980.

Chapter 17

1 Ansel Adams, *Examples: The Making of 40 Photographs* (Boston: Little, Brown and Company, 1983), 57–58.

2 Ibid.

3 Ansel Adams, *An Autobiography* (Boston: Little, Brown and Company, 1985), 247.

4 Alan Ross, "A Morning in the Dunes with Ansel Adams," *View Camera*, May/June 2003, 26–29; the subsequent quotes are from the same article.

5 The color transparency has suffered profound color shifts due to aging and is now "a pretty horrid overall magenta," according to Alan Ross.

6 Edward Weston received a Guggenheim Fellowship in 1936.

7 Ansel Adams to Edward Weston, early April 1946.

8 Edward Weston to Ansel Adams, April 12, 1946.

9 Alfred Stieglitz to Ansel Adams, April 15, 1946.

10 Ansel Adams to Beaumont and Nancy Newhall, January 23, 1947.

11 Ansel Adams to Minor White, January 1947.

12 Ansel Adams, *An Autobiography* (Boston: Little, Brown and Company, 1985), 246.

13 Ansel Adams and Nancy Newhall produced a series of articles for *Arizona Highways* beginning in June 1952; the article on Death Valley was published in the October 1953 issue.

14 Nancy Newhall to Beaumont Newhall, April 1, 1952.

15 Ansel Adams and Nancy Newhall, *Death Valley* (Redwood City: 5 Associates, 1954).

16 Ansel Adams, Basic Photo Series (Hastings-on-Hudson, N.Y.: Morgan & Morgan, 1948–1956).

17 Ansel Adams, *Yosemite and the Sierra Nevada* (Boston: Houghton Mifflin Company, 1948).

18 Ansel Adams, *The Land of Little Rain* (Boston: Houghton Mifflin Company, 1950).

19 Ansel Adams, *My Camera in Yosemite Valley* (Yosemite: Virginia Adams, and Boston: Houghton Mifflin Company, 1950).

20 Edward Weston, *My Camera on Point Lobos* (Boston: Houghton Mifflin Company, and Yosemite: Virginia Adams, 1950).

21 Brett Weston, Ansel's friend, a photographer, and son of Edward Weston.

22 Ansel Adams to Nancy Newhall, June 20, 1952.

23 Ansel Adams to Beaumont and Nancy Newhall, September 30, 1952.

24 Ansel Adams to Nancy Newhall, April 3, 1951.

25 Ansel Adams to Nancy Newhall, July 3, 1951.

26 Ansel Adams to Nancy Newhall, July 23, 1951.

27 Ansel Adams to Nancy Newhall, July 3, 1951.

28 Ansel Adams to Beaumont Newhall, April 26, 1952.

29 Ansel Adams to Nancy Newhall, November 26, 1955.

30 Ansel Adams to Beaumont Newhall, June 23, 1958.

Chapter 18

1 Ansel Adams, *Examples: The Making of 40 Photographs* (Boston: Little, Brown and Company, 1983), 61.

2 Ibid.

3 Ansel Adams, *The Negative* (Boston: Little, Brown and Company, 1981), 219.

4 Ansel Adams, *Examples: The Making of 40 Photographs* (Boston: Little, Brown and Company, 1983), 62.

5 Ansel Adams, *An Autobiography* (Boston: Little, Brown and Company, 1985), 175.

6 It was the same trip described in Chapter 8 during which Ansel made the memorable photograph of Georgia O'Keeffe at Canyon de Chelly.

7 Ansel Adams to Alfred Stieglitz, September 21, 1937.

8 Nancy Newhall to Ansel Adams, December 1950.

9 In conversation with the author, 1978.

10 Ansel Adams, *The Negative* (Boston: Little, Brown and Company, 1981), 219.

11 John Sexton to the author, January 8, 2012.

12 Ansel Adams, *Examples: The Making of 40 Photographs* (Boston: Little, Brown and Company, 1983), 62.

13 Nancy Newhall and Ansel Adams, *This Is the American Earth* (San Francisco: Sierra Club, 1960).

14 Ansel Adams, *An Autobiography* (Boston: Little, Brown and Company, 1985), 35.

Chapter 19

1 Ansel Adams, *Examples: The Making of 40 Photographs* (Boston: Little, Brown and Company, 1983), 133.

2 Ibid., 134.

3 Ansel Adams, *The Camera*, Basic Photo Series (Boston: Little, Brown and Company, 1980), 21.

4 See Chapter 8 for an instance where Ansel was unable to make a second safety negative.

5 Bracketing involves making multiple exposures of the same composition with different camera settings in the hope that one of the resulting images will be satisfactory.

6 "Conversations with Ansel Adams," an oral history conducted in 1972, 1974, and 1975 by Ruth Teiser and Catherine Harroun, Regional Oral History Office, The Bancroft Library, University of California, Berkeley (1978).

7 Ansel Adams to Beaumont and Nancy Newhall, May 20, 1951.

8 Ansel Adams, *Examples: The Making of 40 Photographs* (Boston: Little, Brown and Company, 1983), 134.

9 Ansel Adams, *An Autobiography* (Boston: Little, Brown and Company, 1985), 102.

10 Ibid., 103.

11 Ansel Adams to Arthur Demaray, director of the National Park Service, April 1938.

12 Ibid.

13 Ron Partridge was Ansel's photographic assistant from 1937 to 1939; he is the son of Ansel's friend and fellow photographer, Imogen Cunningham.

14 Interview with the author, October 31, 1980.

15 Interview with the author, July 2011.

16 Ansel signed his name on each print until 1972, when he switched to signing his initials only. In 1974 he ceased initialing the prints to avoid confusion between his signed fine prints, which sold for hundreds of dollars, and the inexpensive Special Edition Prints made by his assistant.

17 Ansel Adams, *An Autobiography* (Boston: Little, Brown and Company, 1985), 53.

18 Ansel Adams, *Examples: The Making of 40 Photographs* (Boston: Little, Brown and Company, 1983), 135.

19 Ansel Adams to David McAlpin, July 2, 1938.

Chapter 20

1 Ansel Adams, *My Camera in Yosemite Valley* (Yosemite: Virginia Adams, and Boston: Houghton Mifflin Company, 1950), first page of foreword (unpaginated).

2 Thomas Starr King, *A Vacation among the Sierras* (San Francisco: Book Club of San Francisco, 1962), 49.

3 Ansel Adams, *An Autobiography* (Boston: Little, Brown and Company, 1985), 302.

4 Ansel Adams, *Examples: The Making of 40 Photographs* (Boston: Little, Brown and Company, 1983), 45.

5 Ibid.

6 Ibid., 46.

7 Ansel Adams to Ma, Pa, and Aunt Mary, April 18, 1920.

8 Ibid.

9 Ansel Adams, "Landscape: An Exposition of My Photographic Technique," *Camera Craft*, February 1934, 76.

10 Ansel Adams, "Landscape Photography: The Procedure for Snow," *Zeiss Magazine* IV, no. 3 (March 1938), 67.

11 Ansel Adams, "Landscape: An Exposition of My Photographic Technique," *Camera Craft*, February 1934, 76.

12 Ibid., 76–77.

13 Ansel Adams, "Ski-Experience," *Sierra Club Bulletin,* 1931, 45.

14 Ansel Adams, *Polaroid Land Photography* (Boston: Little, Brown and Company, 1978).

15 Ansel Adams, *An Autobiography* (Boston: Little, Brown and Company, 1985), 302.

16 John Szarkowski to Ansel Adams, June 28, 1976.

17 Alan Ross to the author, January 9, 2012.

18 Ansel Adams, foreword to *Portfolio VII* in *The Portfolios of Ansel Adams* (Boston: Little, Brown and Company, 1977), unpaginated.

19 Milton Esterow, "Playboy Interview: Ansel Adams," *Playboy* magazine, May 1983.

20 Ibid.

Credits

Photography

All Ansel Adams photographs not credited otherwise are courtesy of the Center for Creative Photography, University of Arizona, Arizona Board of Regents.

Cover and front of dust jacket: Reproduced through the kindness of the family of Rondal Partridge and the Rondal Partridge Archives, copyright © 2012 Rondal Partridge Archives.

Back flap of dust jacket: Copyright © 2012 Vasilios Zatse. All rights reserved.

Page 12: Copyright © Arnold Newman / Arnold Newman Collection / Getty Images.

Page 19: Copyright © c. 1951 Beaumont Newhall, copyright © 2012 the Estate of Beaumont Newhall and Nancy Newhall. Permission to reproduce courtesy of Scheinbaum and Russek Ltd., Santa Fe, NM.

Pages 21, 129: Reproduced through the kindness of the family of Cedric Wright.

Page 26: Copyright © 2012 Vasilios Zatse. All rights reserved.

Page 48: Copyright © 2012 Vasilios Zatse. All rights reserved.

Pages 51 (upper) and 89 (lower): Copyright © 2012 John Sexton. All rights reserved.

Page 54: Georgia O'Keeffe: *Ranchos Church No. 1,* 1929, oil on canvas, 18¾ x 24 inches, CR 664, Norton Museum of Art, West Palm Beach, Florida. Copyright © Georgia O'Keeffe Museum.

Page 55: Copyright © Aperture Foundation, Inc., Paul Strand Archive.

Page 57: Copyright © 2012 Vasilios Zatse. All rights reserved.

Page 63: Copyright © 1978 Alan Ross. All rights reserved.

Page 66: *Death of Hypatia,* 1926, by William Mortensen, courtesy of the Center for Creative Photography, University of Arizona, Arizona Board of Regents.

Page 72: Reproduced through the kindness of the family of Francis P. Farquhar.

Page 92: Courtesy of the Bancroft Library, University of California, Berkeley.

Page 96 (lower): Copyright © 1940 Beaumont Newhall, copyright © 2012 the Estate of Beaumont Newhall and Nancy Newhall. Permission to reproduce courtesy of Scheinbaum and Russek Ltd., Santa Fe, NM.

Page 106: Copyright © 1979 John Sexton. All rights reserved.

Pages 107, 108 (both), 109 (upper), 135: Copyright © 1982 John Sexton. All rights reserved.

Page 110: Copyright © 1976 Alan Ross. All rights reserved.

Page 119 (lower): Copyright © 2012 Alan Ross. All Rights reserved.

Page 145: Alfred Stieglitz, American, 1864–1946: *From My Window at the Shelton, North,* 1931; Gelatin silver print; image 24.2 x 19 cm (9½ x 7½ inches); Princeton University Art Museum. Gift of Ansel Adams in honor of David Hunter McAlpin, Class of 1920; x1974-36; copyright © 2011 Artists Rights Society (ARS), New York / photo: Bruce M. White.

Page 148: Dorothea Lange, American (1895–1965). *Migrant Mother, Nipomo, California,* 1936; printed early 1960s. Gelatin silver print, 13 3/8 x 10¼ inches (34 x 26 cm). Courtesy of the Nelson-Atkins Museum of Art, Kansas City, Missouri. Gift of Hallmark Cards, Inc., 20005.27.305. Photo credit: Jamison Miller, copyright © the Nelson-Atkins Museum of Art.

Page 157 (right): From *Time* magazine, September 3, copyright © 1979 Time Inc. Used under license.

Page 160: Digital image © the Museum of Modern Art / licensed by SCALA / Art Resource, NY.

Page 161: Department of Interior, National Park Service Historic Photograph Collection, Harpers Ferry Center.

Page 165: From the *New York Times,* April 24, copyright © 1984 the *New York Times.* All rights reserved. Used by permission and protected by the Copyright Laws of the United States. The printing, copying, redistribution, or retransmission of this Content without express written permission is prohibited.

Pages 168 (upper), 169, 171 (lower right), 172: copyright © 1981 Center for Creative Photography, University of Arizona, Arizona Board of Regents.

Page 173: Copyright © the Brett Weston Archive, www.brettwestonarchive.com.

Page 191: Copyright © 1947 Beaumont Newhall, copyright © 2012 the Estate of Beaumont Newhall and Nancy Newhall. Permission to reproduce courtesy of Scheinbaum and Russek Ltd., Santa Fe, NM.

Page 229: Copyright © 1976 Alan Ross. All rights reserved.

Text

Various text excerpts, quotes, and letters by Beaumont and Nancy Newhall copyright © 1944, 1948, 1949, 1950, 1951, 1953 Beaumont Newhall, copyright © 2012 the Estate of Beaumont Newhall and Nancy Newhall. Permission to reproduce courtesy of Scheinbaum and Russek Ltd., Santa Fe, NM.

Excerpts from the oral histories of Ansel Adams and Dorothea Lange are reproduced courtesy of the Regional Oral History Office, the University of California, Berkeley.

Excerpts from *The Sierra Club Bulletin* are reproduced courtesy of the Sierra Club, San Francisco, California.

Excerpts from the *New York Times* copyright © 1974, 1995 the *New York Times.* All rights reserved. Used by permission and protected by the Copyright Laws of the United States. The printing, copying, redistribution, or retransmission of this Content without express written permission is prohibited.

Pages 119, 123: Copyright © 2010 The New Mexican, Inc., reprinted with permission. All rights reserved.

Page 147: Excerpt from *Twice a Year: A Semi-Annual Journal of Literature, the Arts and Civil Liberties,* Double Number XII–XIII, 1945, page 323; reproduced with the kindness of Nancy Norman Lasselle.

Index

About the Author

ANDREA G. STILLMAN worked with Ansel Adams as his photographic assistant in the 1970s. Prior to that, she was on staff at the Metropolitan Museum of Art in New York City. She has edited many books about Ansel's work, including *Ansel Adams: 400 Photographs*, *Ansel Adams: Letters and Images 1916–1984*, *Ansel Adams in Color*, and *Ansel Adams in the National Parks*. She lives in New York City.

Colophon

Design by Lance Hidy
Duotone separations by Thomas Palmer
Production supervision by Sandra Klimt
The typeface is Magma, designed by
Sumner Stone for the Stone Type Foundry.
The paper stock is 150 gsm Gardamatte.
Looking at Ansel Adams was printed and bound
by Mondadori Printing in Verona, Italy.